I Am Not Myself: The Art of African Masquerade

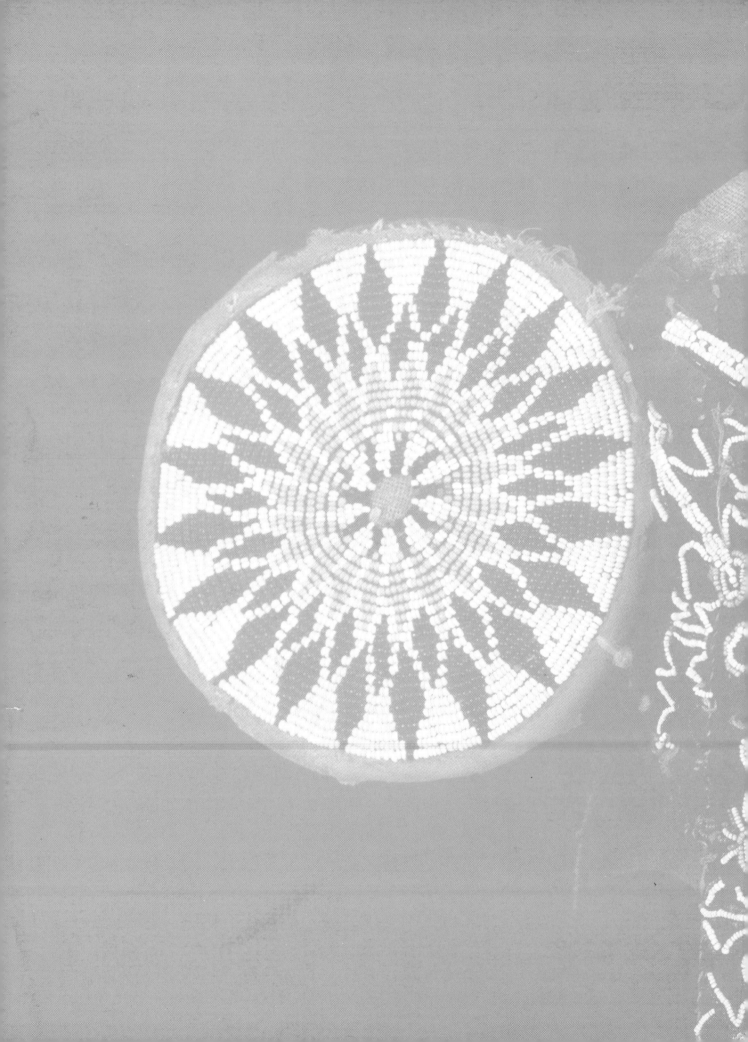

I Am Not Myself: The Art of African Masquerade

Edited, with an introduction by Herbert M. Cole

Museum of Cultural History, University of California, Los Angeles
Monograph Series, Number Twenty-Six

As part of the academic program of the Museum of Cultural History, essays by scholars and advanced graduate students are published in the Monograph Series on significant segments of the collections or in conjunction with exhibitions at the Museum's gallery. This series reflects the Museum's commitment to the University of California's teaching and research activities.

The publication and exhibition were made possible by funding from the University Art Museum at the University of California, Santa Barbara; Saddleback College, Mission Viejo; the Ahmanson Foundation; Mr. and Mrs. Theodore Lowenstein; the National Endowment for the Humanities; the Alexander-Kitnick Philanthropic Fund; and Manus, the support group of the Museum of Cultural History.

Published in conjunction with an exhibition of the same name displayed at:

Saddleback College Art Gallery
Mission Viejo, California

University Art Museum
University of California, Santa Barbara

Museum of Cultural History Gallery, Haines Hall
University of California, Los Angeles

COVER. Cameroon elephant mask (Bamileke?), detail. Cloth, raffia, plantain fiber, hemp, glass beads, 60.9 cm. UCLA MCH X82-568, anonymous gift. See also Plate 6.

International Standard Book Number 0-930741-02-1
Library of Congress Catalog Card Number: 84-062940

Table of Contents

Preface

Herbert M. Cole

No comprehensive treatment of African masks or masquerades has yet been published. The subjects are too vast, the masks too numerous and diverse, their contexts and purposes too complex. The enormous continent of Africa is a land of many hundreds of distinct ethnic (language) groups whose peoples have long created striking masquerades to manifest metahuman and otherwise intangible spirit forces. Publication of this study is therefore undertaken with some trepidation and the knowledge that it is at best only a small step forward.

The idea for an exhibition and collection of essays was initiated by Gregory J. Bishopp, dean of the arts faculty at Saddleback College, Mission Viejo. It was carried out in a graduate art history seminar at the University of California, Santa Barbara, in the spring of 1983. The effort was an altogether cooperative one, with all members commenting upon and editing various sections. It was seminar member Dick Blades, for example, who suggested our title, which was embraced by all of us as being very apt.

The work of the seminar became a realistic exhibition and publication after discussions with Doran Ross, associate director of the Museum of Cultural History, who has been most encouraging and helpful at every stage. The same is true of the entire museum staff, and we would like to single out Bob Childs, collection manager, Sarah Kennington, registrar, and Benita Johnson, conservator, for exceptional efforts on our behalf. Susan Swiss has most skillfully handled myriad editorial problems, and Bob Woolard has done a masterful job with photography and design under severe time constraints. Greg Bishopp and David Farmer, director of the University Art Museum in Santa Barbara, are heartily thanked for their special efforts, along with Lynn Gamwell, curator of the Saddleback Gallery, and Paul Prince, master exhibition designer at U.C.S.B.

Our examination of masking phenomena here makes no claims to completeness. The introductory essay is a general, conceptual, and cross-cultural look at African masking, drawing especially on the author's field experience among the Igbo of Nigeria. It is followed by chapters with specific elucidations of fourteen other African cultures,[1] their masks and masquerades, by seminar members. The environment and social structure of each people are first introduced in the student essays, with emphasis given to religion, the role of visual arts, and particularly masking organizations and contexts. After these chapters three additional masks from the Museum of Cultural History collection are briefly discussed. Special thanks to Prof. Arnold Rubin of UCLA who contributed one of the final short essays. The selection of masks and cultures illustrated and discussed is somewhat arbitrary; the masks represent a small segment of the holdings of the UCLA Museum of Cultural History, custodian of all but a few of those illustrated. By including both general and specific masking situations, we hope that the richness and vitality of African masks and the ideas behind them will be evident.

Acknowledgments

As part of the Museum of Cultural History's continuing efforts to involve students in research on the Museum's collections, it has been a great pleasure working with a graduate seminar from the University of California, Santa Barbara, led by Dr. Herbert M. Cole. The student participants have performed with a professionalism that is rare among even the most advanced scholars. We thank the following for their commitment and dedication: Richard Blades, Elizabeth Evanoff, Jennifer Haley, Judith Hunn, Kairn Klieman, Debbie Randolph, Robbie Reid, Gail Wallace, Bonnie E. Weston, Jeri B. Williams, and John Wills. In addition, UCLA Professor Arnold Rubin generously provided an essay based on his own field research.

At a time when his schedule was already overcrowded, Professor Cole has enthusiastically followed through on his 1983 seminar with a careful reading of the papers and a vital and insightful introduction. His continuing involvement in the Museum's exhibition, publication, and acquisition programs has ensured the success of many projects.

The complexities of word processing, editing, and proofreading the manuscript were beautifully managed by Susan Swiss. Robert Woolard executed the photography and the design and production of the publication with characteristic efficiency and sensitivity. The contributions of both are warmly appreciated. We are grateful as well to E. Nii Quarcoopome for lending his eyes, and for not being himself, and also to Al Bardwell for his expertise in conserving several objects in the show.

We also acknowledge with grateful thanks contributions of information and photographs, often at the last minute, by the following scholars and friends: Daniel Biebuyck, Jean Borgatti, Arthur Bourgeois, René Bravmann, Daniel Crowley, Pascal James Imperato, G. I. Jones, Christopher Roy, Arnold Rubin, Thomas Seligman, and Susan Vogel. We acknowledge too the previously published photographs of the late William R. Bascom and Paul Gebauer.

It is also a pleasure to collaborate in the exhibition with Professor Gregory Bishopp and Dr. Lynn Gamwell of Saddleback College, Mission Viejo, and with Dr. David Farmer, Director, UCSB University Art Museum. It is delightful to have a Museum of Cultural History exhibition in such good hands.

We are pleased to thank the following good friends of the Museum who kindly lent objects from their collections to fill in some key gaps: Lee Bronson, Daniel and Pearl Crowley, Joe and Barbara Goldenberg, Jerome L. Joss, Barry and Jill Kitnick, and Robert and Helen Kuhn. To these names should be added the many donors (acknowledged in the illustration captions) who have enhanced the Museum's collections with their generosity.

Christopher B. Donnan, Director
Doran H. Ross, Associate Director

Color Plates

PLATE 1. Igbo masker, *Okoroshiojo*, called "God's Power," *Ike chi*, brandishing a whip; Ejemekuru, Nigeria. Photo: Herbert M. Cole, 1982.

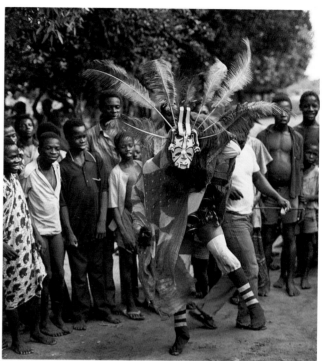

PLATE 2. Igbo "Pretty Waterspirit," *Okoroshioma*, performing in a public arena; Ogbaku, Nigeria. Photo: Herbert M. Cole, 1982.

PLATE 3. Baule masker, *Kpan Pre*, in a *Goli* dance; Aitu, Ivory Coast. Photo: Susan M. Vogel, 1983.

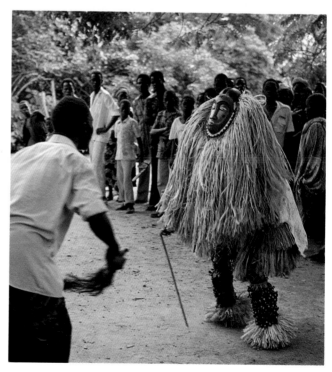

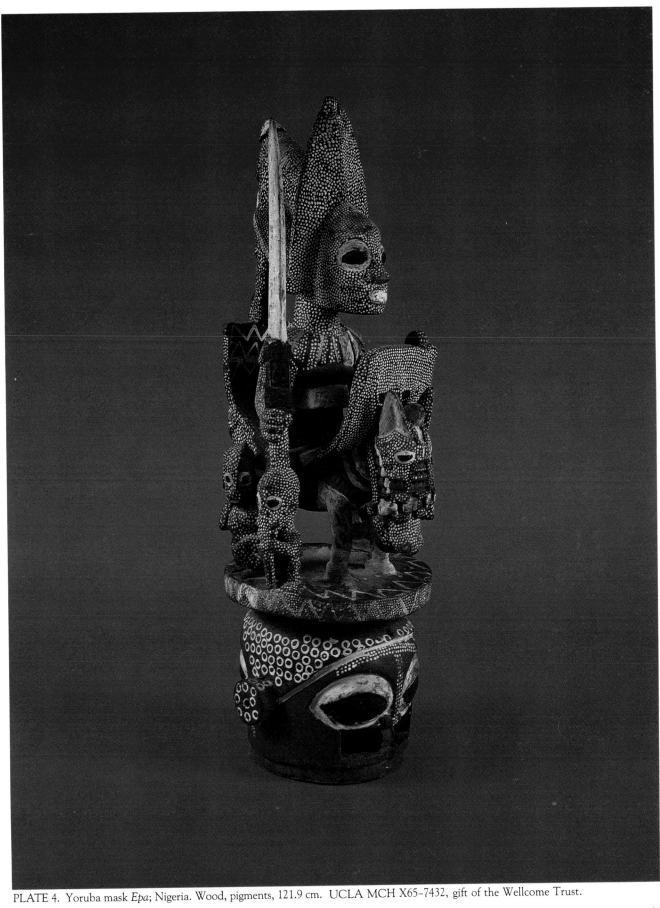

PLATE 4. Yoruba mask *Epa*; Nigeria. Wood, pigments, 121.9 cm. UCLA MCH X65–7432, gift of the Wellcome Trust.

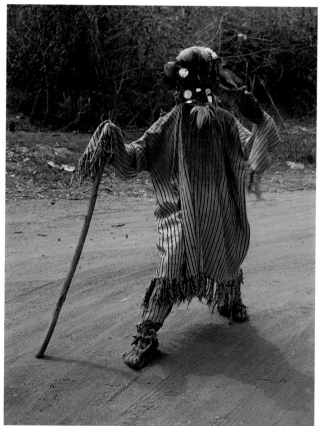

PLATE 5. Northern Edo festival herald, *Anogiri*; Okpella, Nigeria. Photo: Herbert M. Cole, 1973. (A similar mask and costume are in the exhibition: UCLA MCH X76–1706 and X76–1733a and b, gifts of Mrs. W. T. Davis in memory of W. Thomas Davis, collected by Jean Borgatti.)

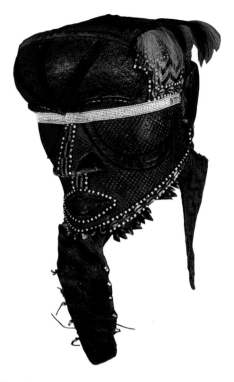

PLATE 8. Kuba mask, *Bwoom*; Zaïre. Wood, glass, shells, fiber, seeds, skin, copper, 33 cm. UCLA MCH X83–200, anonymous gift.

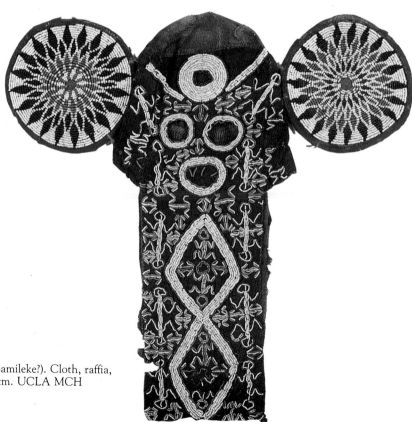

PLATE 6. Cameroon elephant mask (Bamileke?). Cloth, raffia, plantain fiber, hemp, glass beads, 60.9 cm. UCLA MCH X82–568, anonymous gift.

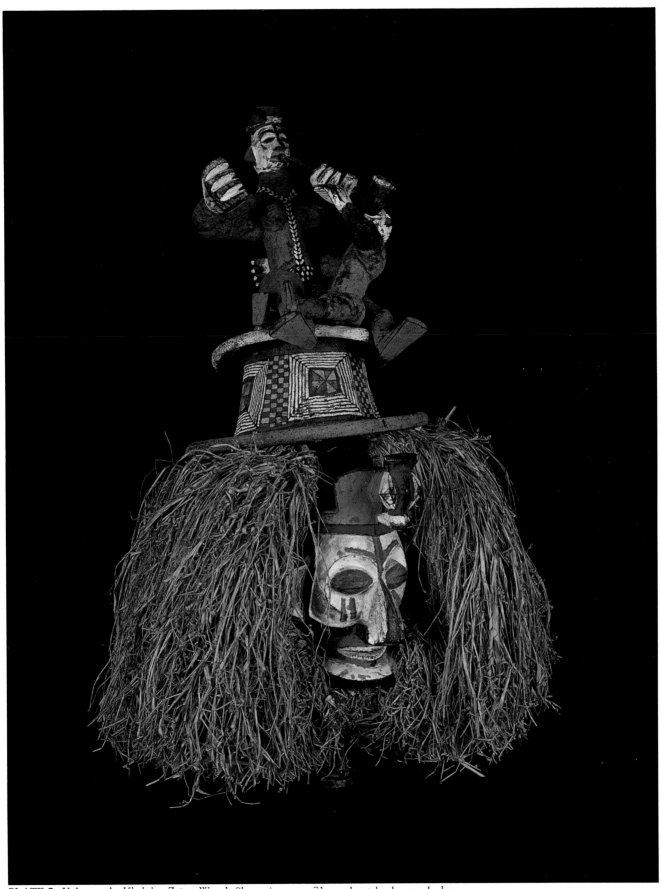

PLATE 7. Yaka mask, *Kholuka*; Zaïre. Wood, fiber, pigments, 71 cm. Lent by Jerome L. Joss.

MAP. Modern nations and selected peoples of Africa.

14

Introduction: The Mask, Masking, and Masquerade Arts in Africa[2]

Herbert M. Cole

Clearly the mask, masking, and masquerade are interlocking aspects of one of Africa's most significant artistic phenomena. A physical object of specific materials, shape, and size, the *mask* is normally designed to cover the face or head. *Masking* is the active presence of one or more fully costumed character(s). *Masquerades* are important events involving varied masked dancers, musicians, and their audiences. Each character, its attributes, songs, and dances, has many meanings usually expressed in no other manner.

Of all the varied arts of Africa wrought in gold, ivory, brass, terracotta, and other materials, especially wood and fiber, it is the mask that is preeminent. Masks are known from all cultures and continents, but those of Africa come to mind first for many people.

Masking History and Myth

How did African masking originate? Were animal skins and heads (Fig. 1) first used to embody, and then to deceive, sought-after prey and/or to placate their spirits? We cannot know, despite the logic that suggests ancient hunting and its rituals as early motivations for such transforming disguises. The earliest recorded arts of Africa—the rock paintings of the Tassili-N-Ajjer and nearby sites of the Hoggar, now in the middle of the vast Sahara Desert—show masks and masquerades (Figs. 2,3). These date back a mere four or five millennia, in all likelihood tens of thousands of years later than mankind's invention of such transformations. The images of masks and dances in the Sahara—painted when the area, which is now dry and deserted, supported numerous peoples—are well developed and quite similar to those recorded elsewhere in Africa far more recently. In fact the true origins of masked dances are so historically remote as to be impossible to recover except by undocumentable guesswork.

Mythology on the origins of masking, on the other hand, survives. Many such myths collected in different parts of Africa share a single and rather puzzling theme: that *women* first had the secrets of masks. Sometimes, too, women are said to have been the first masked dancers, after which the masks and their rituals were taken over entirely by men, who then normally excluded women from all such rites except as onlookers. So run the myths of Dogon, Senufo, Baule, Kuba, Igbo, and other people. Distributed widely in Africa (and elsewhere in the world as well), this recurrent myth seems to reflect male fears of female powers, especially women's reproductive capacities. Joseph Campbell believes that women were instrumental in developing cultivation and settled agriculture, which won them both magico-religious and social advantage whereupon "the complex of matriarchy took form" (1959:32).[3] Fearing themselves to be superfluous and inferior, it would seem, men avenged this awesome feminine power by forming secret associations and taking control of cults, some of which used masks. This hypothesis answers by no means all questions about the origin of masks, but it does provide a rationale for the apparent "takeover" by men of some female pre-

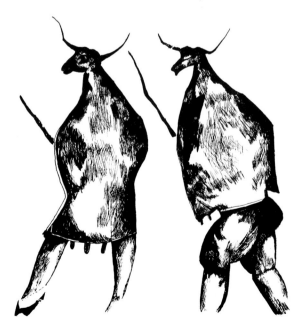

FIGURE 1. Bushman painting of men wearing animal skins and heads; Drakensberg. Drawn by Charlene Miller after Willcox 1965.

rogatives, masking among them. The myths generally speak of some sort of mistake by women to explain their exclusion from masking ritual and to account for it as an exclusively male activity.

In regard to the history of masking, we must also note that masquerades have long been and continue to be subject to change. Some of the masks discussed below may not still exist in Africa; most do. Masquerades are probably Africa's most resilient art form, continually evolving to meet new needs. In some areas, too, urban masquerades have sprung up, based in part on earlier forms yet reflecting modern social realities and employing plastic, aluminum, and other new products. Masking is sufficiently deeply embedded in African cultures for us to predict with some certainty that it will continue with vitality—and more changes—in the years to come.

Art and Form in Masking

The arts of transformation in Africa range along a continuum from slight modifications of a visible face and body to wholesale alteration of the human form through its enclosure in a "costume" of nonhuman character. Our concern here, of course, is with these latter, spirit-associated transformations which cancel or obliterate the wearer's personality, even his humanity, by superimposing a wholly new form. The change is often into another human character—a pretty girl, old man, mother, hunter, or stranger—but something essential has happened; this being is also a *spirit*. Its visible face— the mask—is inanimate, with immobile features. This *is* and *is not* a human being. So transformed, the new being is saying: "I am not myself." Ambivalence and ambiguity exist in the presence of maskers, who are often behaviorally ambiguous, for example, being both playful and serious. The creative and playfully executed Igbo mask in Plate 1 is a case in point. Called "God's Power," *Ikechi*, it is among the hundreds of serious masks that come out each year during the rainy season to promote the growth of staple crops. It also behaves equivocally, chasing and mildly harassing people and at the same time providing entertainment for many, even most of those chased. "Child of Diviner," *Nwa Dibia* (Fig. 4), is a character in another Igbo masquerade who points up this ambiguity even more dramatically. His serious role is to lure a leopard masker from the bush, that he may be killed, so that "safety may overcome terror." Yet the hunchbacked "Diviner" is also a buffoon who wears tattered clothing, has a large hernia (considered amusing), and playfully pursues women in the audience with funny sexual pantomime. "Diviner" is a spirit masker and simultaneously a clown.

Masking arts may also quite drastically *alter* human forms. Under a disguise the bodily armature can be bulked out to nonhuman shapes and sizes with hoops or pads; it may be armless and extended upward on a frame or pole, its face amplified with exaggerated quasi-human, zoomorphic, or bizarre features (Fig. 5). Appearance and behavior are also extraordinary, otherworldly. The being glides, walks on or spits fire, speaks in a foreign or nonsensical tongue. The masker neither talks nor acts like a true human and, as he careens wildly through the village, seems to be outside human laws.

Mask-carvers and costume-makers (only occasionally the same person) have over the centuries evolved thousands of imaginative spirit beings, invoking many disparate materials in creative and striking ensembles. The overwhelming majority of masks are wood, carved

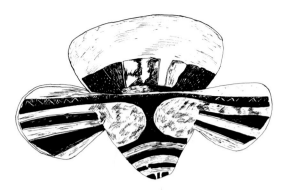

FIGURE 2. Painting of a mask; Tassili; Sefar, Algeria. Drawn by Charlene Miller after Lajoux 1963.

FIGURE 3. Rock painting of masqueraders; Tassili; Tin Tazariff, Algeria. Drawn by Charlene Miller after Lajoux 1963.

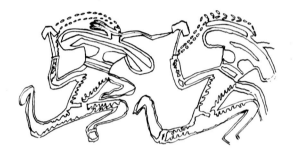

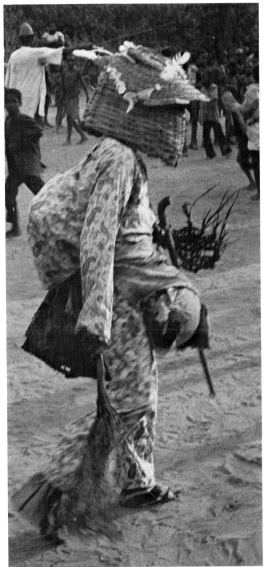

by professional carvers or blacksmiths who normally serve long apprenticeships learning their skills by studying, copying, and improving upon the corpus of locally admired mask types and forms. Other materials are also used for making masks, and quite a number are composite, multimedia constructions. Often, too, the substances used to make or decorate masks have local symbolic values and thus contribute to the "message-system" of a masquerade. These valued materials—skins, cloth, beads, fiber, metal, and so forth—will be identified in the chapters to follow.

Masquerading is the province of males of all ages, and artists themselves are also participants in these activities. Elaborate performances must, of course, be organized, choreographed, and rehearsed by members of the masking cults. In some cases artists even dance masks, or masked characters are named for them. Carvers, tailors, and other mask-makers may become quite famous locally, and their names have occasionally become well-known to the world beyond. Scholars of the Yoruba, for example, have been recognizing specific artists for years in an effort to take the "anonymity" out of African art—a laudable pursuit. From the view of most African peoples, on the other hand, such emphasis on a carver's individuality is misplaced. Africans are most concerned with the entire costumed character, including its dances and songs, not just the mask or headpiece. Many people besides the professional carver are involved in successful masked theater. In many cases, too, nonprofessional cult members carve masks or headdresses or fabricate costumes from cloth or vegetal fibers.

Masks in an exhibition or a book, of course, are situated far from their original cultural settings. Yet they can still be appreciated as independent sculptures or, in the case of fully costumed maskers, displayed on mannequins, as assemblages of different materials: wood, fiber, cloth, mirrors, rattles, plus objects held in the hand(s). In Africa masks are genuine "mobiles," never fixed in place like an Alexander Calder sculpture. Shapes, textures, colors, and patterns of varied masking ensembles move within a kaleidoscope of balances and oppositions of motion and speed, activating the visual field in which they appear. What once appeared simple emerges as complex. Thus masks can be seen as works of art both within and outside their parent cultures. Nevertheless, appreciation is enhanced when cultural

FIGURE 4. Igbo *Ekeleke* masker, "Child of Diviner" (*Nwa Dibia*), performing in Agwa, Nigeria. Photo: Herbert M. Cole, 1983.

FIGURE 5. Kaka (Mbem group), leopard society members dancing in painted net costumes before (or after) the hunt; Cameroon. Photo: Paul Gebauer, 1930s.

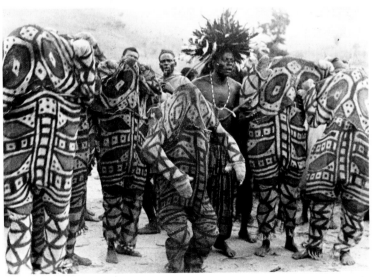

backgrounds and meanings are understood.

It is worthwhile to set forth some of the principles underlying the forms and styles of masks and headpieces. First, nearly all African sculptors work with an *idea* when carving rather than re-creating the face of a particular individual. This idea is a local convention—the expected form—of a particular character's mask. Thus the heads and facial features (and costumes) of masks are strongly conventionalized to conform with a culturally specific ideal for any given character. In formal terms these conventions include simplification, distortion, and exaggeration. The idea behind some characters requires the artist to combine several creatures in the same carving: antelope, bird, warthog, and human. Explicit animal masks too are often distorted; they conform to the accepted *convention* for an antelope or elephant rather than imitating exact natural forms. In most cases this is because the intention is to represent a *spirit* rather than a real antelope or a flesh-and-blood Mrs. Jones. Portraiture in the sense Americans and Europeans know it is therefore almost entirely absent. A few masks, it is true, are locally designated as representations of Mrs. Jones, but she will be recognized from her facial markings or favorite hairstyle rather than subtle physiognomic details and idiosyncrasies. If African sculptors wanted to make highly naturalistic, fleshy, and realistic masks, they most certainly would have done so. Usually they chose not to.

It follows that various locally autonomous groups of people came to appreciate, expect, and request specific forms for masks of characters well known to them. Such forms have often existed for many generations, many perhaps for centuries. While every mask is different from its antecedents because it is newly carved, those of one type (generally under one organizing cult) are often only variations upon the "memory image" of that type and are thus similar to other examples. A series of masks of one type share many characteristics of form—size, face/eye/ear/mouth shape, decorative details, color, weight, and other, more subtle details. When all of these traits are added together, we speak of *style*.

The existence of a style does not in the least nullify the creative artist as innovator. An exceptional individual indeed may have established the style we know or effected a change from the one previously accepted, in form and/or subject matter. Changes in mask types (i.e., characters) have in fact been numerous in the last several decades, reflecting the impact of colonialism and other imported ideas. Recent masks are executed in new or changed styles, but most show marked continuity with those of the past. What is clear, however, is that most African sculptors have not attempted to change—in any abrupt or radical way—the form or style they first learned. This is one reason why African art is conservative—its styles tend to change rather slowly.

Masks from one village generally share the same style, even if they are intended to represent different characters or come from different masking cults. Neighboring village styles encompass slight variations (if carved by different sculptors), those of an entire people (language and culture group) reflect still more differences. When looked at from a distance, the collective styles of one ethnic group are generally distinct from those of neighbors speaking a different language, even though the styles are often mixed on the borders and therefore confusing. Masks illustrated in the following pages will make these notes

on form and style clearer. What must be kept in mind is the fundamental idea behind every mask: it embodies a spirit.

Spirits Made Tangible

The dramatic art of African masking brings the essentially mysterious world of nature and the supernatural into the known and more predictable community of humans. Many African belief systems require men (very rarely women) to materialize spirits by impersonating them so that these spirits may act upon the human realm and, equally, so that people may respond to—thank, placate, entertain—the forces upon which life depends. Regardless of mask or costume type or style, the artistic transformations that create "spirit dancers" (maskers) are a major unifying force among the myriad arts of sub-Saharan Africa, from the western savanna and forests to the East African coast. A number of cultures, however, make marginal use of masks, and some have none at all.[4]

Spirit transformations are complex phenomena, especially when compared to the minor and vestigial roles played by masks and masking in the modern Western world. Western masks, although they hint at a banished sacred era since they appear at holidays—holy days—Halloween and Mardi Gras, for example, are largely playful and secular today, mere disguises. Rarely are they taken very seriously. To this day in much of Africa, however, spirit impersonation is highly serious despite industrialization, bureaucratic government, Christianity, Islam, school education, modern medicine, and the like. Masqueraders certainly entertain African people still, as they have done in the past. In contrast to those in the West, however, African spirit dancers may also intervene forcefully and mysteriously in human affairs, redirecting social action, punishing wrongdoers, educating the young, or helping to raise a man to a higher status by dramatizing timeless moral and ethical values. Not all African masks have powerful and "heavy" spiritual roles. In fact they range along a continuum from these to more lighthearted beings whose primary purpose is entertainment. In the 1980s maskers may no longer have the legal sanction to execute people and burn houses, yet in many places they are still highly regarded and everywhere they still have the power to affect the quality of life.

A subject that has not yet received the attention it deserves is masking by uninitiated children. This is found nearly everywhere adult masking is important and is a crucial aspect of youthful male socialization. Young boys create many masks from leaves, gourds, and other things (Figs. 6,7), though rarely from the same materials used for adult masks—for these are proscribed. They mimic their seniors, singing songs, dancing, and chasing girls and still younger boys. They learn to organize themselves, create rules, hold mock rituals, and identify their own leaders in a kind of "preschool" that anticipates later, more formal education and masking during and/or after their initiations. These children's masquerades, like their adult counterparts, are seriously undertaken and at the same time provide boys and the larger community a lighthearted release from mundane concerns. In part because of this early playing at masks that are not considered true spirits, boys are prepared for the rigorous disciplines and ordeals of their initiations into serious masking and for the adult social roles they will soon assume.[5]

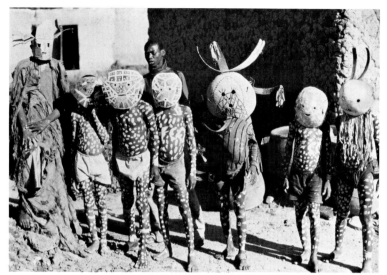

FIGURE 6. Dyula children prepared for their masked *dodo* dance at Ramadan in Bobo Dioulasso, Bourkina Fasso. Photo: René A. Bravmann, 1972.

Most African languages do not have a word which translates accurately as "mask": BaKwele say *buoobkuk* ("face of the forest spirit"); Igbo say *isi mmuo* ("head spirit"); Lega say *lukuwakongo* ("death gathers in"); Jukun say *bakindo* to indicate a broad supernatural category including the high god, ancestors, forest or bush creatures, and other spirits both visible and tangible as well as invisible.[6] For most Africans, the word or name associated with a "mask" both evokes and incarnates the living personage. Kalabari Ijaw say, for example, "The spirits stay and come in their names" (Horton 1965:10). In English, however, we interpose an extra word—"mask" —suggesting that by means of mask and costume a spirit is *represented*. This is not the African attitude. For villagers a real and often powerful spirit being is now embodied and made manifest, ready to act, to inspire awe and fear, to stimulate laughter, reverence, or revulsion. With appropriate costuming and ritual preparation to cancel out the human wearer's personality, a spirit being is *created*. For us of the Western world who are not prone to accept incarnation, it is perhaps incomprehensible that Africans *do* believe in the spirits they have created, but it is nonetheless true.[7] The masker, the wearer who is now "ridden" or imbued by the spirit, also believes in his own new and altered state. His personal character and behavior are modified, fused with those of the spirit he creates and becomes. Human individuality is lifted from him. He is not himself. There are occasions in some cultures when the mask wearer becomes truly possessed by spirits, and thus disassociated from his normal personality and being. People cannot and do not remain unmoved by these and other spirit forces when they roam the community. Thus our neutral, inanimate, material noun "mask" is quite inadequate for this meta-human force, this incarnation now at large.

A host of creatures, forces, and characters appear as masks for a short time. One may be an agile antelope spirit, another a threatening, lumbering bush buffalo or elephant, a benign water spirit, or a dead ancestor returned temporarily to the village. The myriad personalities of the world of mankind are supplemented by masked beings who are really concepts (the Igbo character "Power of God," above [Pl. 1]) or feared and revered powers of nature—e.g., life-giving rain or a threatening and destructive composite bush creature. These spirit-ideas return only temporarily to the village. It is important that

FIGURE 7. Igbo male children, one wearing "play-*Okoroshi*" mask of materials (leaves and grasses) different from those of adult masks; Agwa, Nigeria. Photo: Herbert M. Cole, 1983.

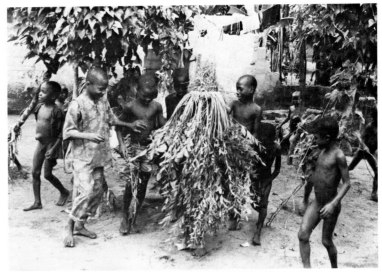

masquerades are *not* present during most of the year. Transience is one of the characteristics of masking; the spirits are here for a week or a month but absent for the next several. When the spirits have gone, only then do their masks assume a more static, material form, and still they are sacred. Sometimes they must be ritually put to sleep, whereupon they can be treated as objects to be wrapped carefully and stored away for future revitalization. A few masks accumulate such strong spiritual charges that they become too dangerous for a man to wear. This is the case with certain "night society" masks among the Bangwa (Brain and Pollock 1971:131) and a few law-making and judging masks among the Mano of Liberia (Harley in Sieber 1962:10). In these cases masks are "power objects" and, in effect, strong deities. The point is that "masks," for African peoples, are not carvings exhibited in museums or living rooms. This kind of display is unthinkable to African people. Their appreciation of masquerades follows from their heritage, in which full-fledged spirit personalites have long held decisive roles in village affairs.

It follows that spirit manifestations must be defined as total beings; their faces are but one, albeit critical, element of the total character. Cloth and raffia costumes with attached decorations—often musical—headpiece elements, jewelry, medicinal amulets, rattling anklets, hand-held flywhisks, and weapons all also help to form a spirit. Crucial, too, are gestures and dance steps, songs or guttural utterances, and not infrequently special attendants who direct the spirits or act as their foils. Thus masquerades are usually composites of materials and more ephemeral artistic media such as dance, music, and verbal elements.

These varied arts are invoked to establish the credibility of an illusion—a drama separated from everyday life in time and space. Such a theatrical setting in turn promotes the spiritual and social efficacy of a masked protagonist and its performance (Pl. 2). The mask and costume arrest or fix a spirit and establish its presence; they create an image of a transcendent being. Thus, partially to counteract the Western tendency to isolate the "mask" both as an exhibition object and as a concept, we include contextual photographs for most of the culture-groups surveyed in the following chapters. A full costume fleshes out the otherworldly image by altering the human wearer's shape, extending it into space, and by adding unusual, often

unexpected materials. Rattles or bells remove the character from normal humanity, their sounds dovetailing with or in counterpoint to a separate musical ensemble that serves to create a special mood, releasing dance movements and gestures uncommon in daily life, if not wholly strange. An environment is thus established in which dramatic activity can unfold. Varied arts combine to separate a spirit character (or indeed a whole troupe of them) and its behavior from the real, workaday world, to spotlight and dramatize the new being, and to make forceful its actions and its messages to the audience.

Audiences and Levels of Understanding

There can be no spirit being nor performance, of course, if no audience is present to see and appreciate the character(s) which, in turn, keeps the audience enthralled. Some extremely powerful masked spirits forbid the *physical* presence of all but a few elder male supporters, but a significant "audience" is nevertheless nearby listening behind closed doors to their thunderous orders and judgments. In all cases the masking arena requires a willing suspension of disbelief, for spirits are now abroad. Audiences, like masked spirits, are pluralistic, varying from intimidated children to elders who know all the secrets, having seen masquerades for two or three generations. The anonymity of mask wearers and the secrecy of all the attendant rituals are often dramatized by male organizations sponsoring them, and women (and other noninitiates) are particularly sanctioned against this knowledge. This may also be true of most males when a masker embodies a force particularly powerful in social and political regulation. Yet women are the willing supporters of many masked spirits, sometimes helping to fashion costumes, even lending items from their own wardrobes. Among the Igbo and several other West African peoples, some postmenopausal women are inducted into male masking cults, where they serve as "mothers" of the ancestral maskers (the "collective incarnate dead"; Henderson 1972:351). Most women probably know much more about masquerades than they, or their men, will admit, even to the point of being able to identify sons, nephews, or brothers under concealing costumes. They will reveal this knowledge to other women only. And as the chapters to follow indicate, maskers' identities are by no means always concealed. In a few cases the wearer may even unmask himself in public view, but normally such unveiling calls for severe sanctions.[8]

Men and women alike know that a human being moves beneath the cloth or raffia, yet they believe in the spirit character. In part this is because performers and audience in Africa interact in a manner quite different from our "staged" dramas with their real and psychic distances between actors and the more-or-less passive listeners (proscenium arch and fixed audience seats are among the separating devices). Closer American analogies might be less restrained popular performances such as rock concerts or, even better, certain rural church services in the South which invoke and depend upon audience interaction. *The Holy Ghost People*, a film, shows worshipers speaking in tongues, possessed, and handling poisonous snakes without being hurt. Such rituals are for their participants quite similar to African masquerades, primarily it seems, because life-changing spiritual power is involved. In Africa, as in some Western church rituals, spirit dance and drama are integral to life, not an or-

nament to it nor a diversion from it. The masked play is serious, as church is for some. People in the African masquerade audience are *moved*; often they are physically moved about within the fluid "stage" of the village square; a few are whipped or otherwise abused, perhaps by being named and criticized for socially or politically deviant behavior. Members of an audience are thus vital if sometimes reluctant participants in the drama. The spirit is *part* of this local African world, while simultaneously being *apart* from it. Something "other" is present that normally does not live in this world. It exists to intervene in human affairs or, at least, for the purpose of reflecting, extending, or altering human concerns.

Masked Spirits as Mediators

Masked spirits are often mediators between two or more opposing classes or realms: culture and nature (village and bush), mankind and the supernatural, men and women, initiated and uninitiated, leaders and followers, life and death. In these mediating roles, masked spirits occupy a *liminal* place and take on attributes of either or both of the opposing groups/realms/ideas. Thus a masked being partakes of god and man alike, yet is actually neither; it is in-between. A masker is deputized by leaders or unseen gods, but being a tangible creature fabricated by men's imaginations and hands, again it is neither a human leader nor a real god. "I am not myself." It represents the wild and unruly powers of nature and the bush but appears in the village square and actually has predictable characteristics—one of which may be unpredictability. Some strong Igbo masking spirits of the *Mgbedike*-type ("Time of the Brave"; Fig. 8) are good examples. They wear enormous snaggle-toothed masks and

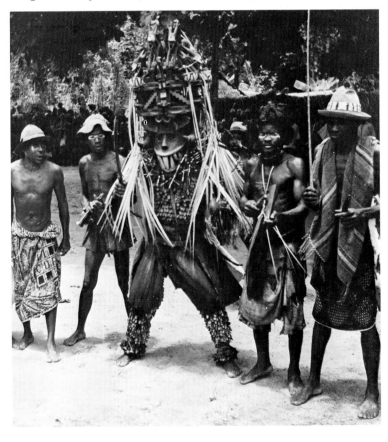

FIGURE 8. Igbo masker of the *Mgbedike* ("Time of the Brave") type with elder attendants; near Awka, Nigeria. Photo: G. I. Jones, ca 1935.

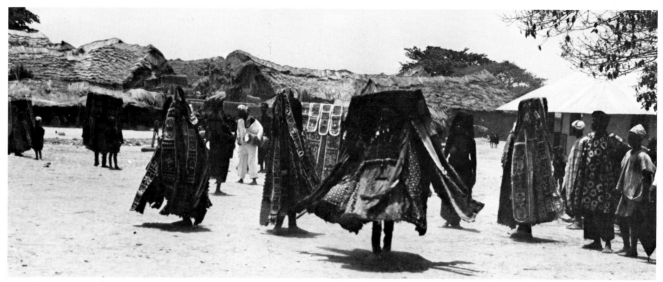

FIGURE 9. Yoruba *Egungun* ancestral maskers; Oyo area, Nigeria. Photo: William Bascom, 1950s(?).

rough costumes hung with seedpods and studded with porcupine quills; they are often restrained with ropes by their attendants so as to forestall violence against persons and the destruction of property.

Hence the mystery. Spirit characters vibrate between opposing forces and transcend them. The structural integrity of these binary oppositions, moreover, is in part defined by spirits who separate the two while simultaneously bringing them together. Ultimately, it seems, the mediator bridges the gulf between opposites and creates of them a kind of spiritual, conceptual, and cosmic unity. Many specific masking situations can be cited to exemplify this role of spirit as mediator and, finally, unifier.

"Ancestral" maskers bring the "incarnate dead" into the realm of the living, linking these worlds and showing them to be one. The land of the dead, for example, is an extension of the very earth from which the living take their harvest. Ancestors help control the productivity of the fields and therefore the wealth of living family members. When ancestors return as splendidly attired maskers (Fig. 9), the richness of both human and spirit worlds is implied; the dead are thanked and fed while the living are entertained and reassured that dead fathers and mothers still protect, guide, and nurture them.

Initiated and uninitiated Chokwe, Yaka, and Pende men—during their respective *nkanda* (or *mukanda*) initiation rituals (see below)—are in part defined and given meaning by spirit maskers. An initiated male, as spirit (a masker), abducts boys from their mothers, terrifying both. A masked beast spirit may seem to "swallow" the initiates, while others will instruct the boys, bring them food, and perform other duties. Later in this "bush school," initiates learn that maskers are really men whose secrets about spirits and masks are a means of maintaining the subservient positions of women and children. At the end of the cycle, the same initiates, now men, become the masked spirits that perform before mothers, other people, and younger siblings as part of the young men's reentry into the community as adults. Those who know the secrets of masks are *men*. Masked spirits have helped to educate these youths, to lead them out of boyhood into the adult world. Here, as always, the spirit characters are real forces, genuinely fearful and/or mysterious, while to initiation leaders they are at the same time a serious bluff, a game

played by these village men at the expense of women and the uninitiated.

Thus many masked spirits mediate between the unknown, obscure, wild world of nature and the known, organized, civilized realm of the village. Baule and Dan masked dances make clear the opposition and interaction of bush and village realms. Both are present in performances inasmuch as maskers appear from the bush wearing raw plant costumes and woven cloth, yet their dancing takes place in the village; furthermore, some maskers are strongly humanoid (village) while others are distinctly fierce and beastly (bush), yet each wears components of the "opposite" realms.

Okoroshi, an Igbo water-spirit masquerade of southeastern Nigeria, shows masks as mediators between women and men and between the ascribed beauty of the former and the ugliness of the latter. Thus light-colored, delicately featured masks represent women (Pl. 2), while dark ones with twisted and exaggerated features are considered male (Pl. 1). In the month of *Okoroshi* dancing, only a few feminine masks appear, playing off against many dozen dark ones; yet when the entire cast of masked characters—as many as 100—are reviewed one by one, the simple white/black opposition breaks down. Actually the maskers form a continuum, with a number being quite neutral, or in-between, partaking of both worlds (Fig. 10). As a whole, this masquerade seems to be saying that life is comprised of good *and* evil, that nothing is wholly beautiful nor totally ugly. Grays are in reality more characteristic of people and events than the polar extremes of white and black. The masking cult is exclusively male; yet it dramatizes the need for cooperation and unity between men and women, as well as their separate identities and roles. *Okoroshi* maskers hold a mirror up to life, celebrate it, reorganize it, portray it as harsh, laugh at it, and then disappear to allow the New Yam Festival to take place. They dance at the height of the rainy season, encourage the crops to grow, and prepare for the harvest. *Okoroshi* masquerades touch upon many aspects of Igbo village life while creating playful breaks from the toil of the daily round (Cole and Aniakor 1984).

This masquerade, like most others, communicates a multitude of simultaneous and overlapping messages. The masking arts are to life what poetry is to prose: compressed, intensified, symbolic, and metaphorical. World views and basic human values are acted out in striking visual forms at once entertaining, spiritually powerful, and crucial to the continuity and equilibrium of life.

Masking Arts in Specific African Cultures

The cultures selected for specific treatment in the chapters following represent a fair sampling of varied African peoples in terms of sociopolitical organization, ecology, religion, and world view. Yoruba and Cameroon societies are politically centralized, while the Baule, Mende, Dan and We, and others are decentralized. Chokwe, Bamana, Pende, and Yaka, having strong chiefs, fall between those extremes. Even where there are chiefs or kings, however, political authority is typically concentrated among councils of elder males and religious specialists. Ecologies range from the dry savannas of Bamana and Voltaic peoples to the rolling grasslands of Cameroon and the humid tropical rain forest of the Yoruba, Pende, and Lega. The Bidjogo live on islands and have a world view and masks reflecting this

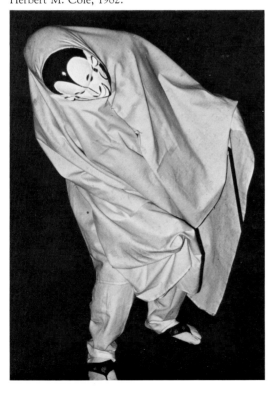

FIGURE 10. Igbo *Okoroshi Amara* masker, "Paddle," a character considered both a foolish virgin and a wise elder; Mgbala Agwa, Nigeria. Photo: Herbert M. Cole, 1982.

aquatic setting. Nearly all peoples surveyed here are primarily agriculturalists. Indeed it is rare to find any masks at all among pastoral or nomadic people, and none are discussed here.

Religious values among each of these peoples include belief in a remote, largely unapproachable "high god" or creator and a strong reliance upon both tutelary deities associated with aspects of nature and varied other spirits. Men often dance masquerades that personify natural forces. The power accorded ancestors in most parts of tropical Africa stresses the unbroken links between the living, the dead, and the yet-to-be born, and masking often reiterates this theme as masked spirits visit the human community during festivals in honor of the ancestors, as if the dead "reincarnate" for these events. Witchcraft and other "magical" practices prevail, and blood-sacrifice is important in most areas as a means of maintaining correct relationships between people and their deities. Masks embodying spirits are frequently given such offerings. Initiations are formalized in most areas, especially for men, and several of the cultures discussed below (Yaka, Pende, Chokwe) share variants of a prevailing initiatory institution called *nkanda* or *mukanda*. Women's initiations are normally less formal, yet among the Mende (and contiguous peoples) an important female "bush school" exists and, with it, the unusual phenomenon of women's masquerading.

Our survey covers a lot of geography but in a discontinuous manner. We begin with the Bamana and Voltaic peoples of the Western Sudan, then move south to the Bidjogo of the Bissagos Islands of the Atlantic coast, then to the forested inland regions of the Guinea Coast (i.e., Mende, Dan/We, Baule, Yoruba, and Northern Edo). Selected West African masking cultures are discussed first, and then we proceed eastward to Cameroon, the meeting place of the two great language-families of tropical Africa, the Niger and Congo groups. The vast drainage system of the River Zaïre (formerly the Congo) is next encountered (Chokwe, Yaka, Pende, Lega), and then we jump a considerable distance to the east, concluding with the Makonde of Mozambique. The order of this geographic perambulation is somewhat arbitrary, as is the choice of cultures to be discussed. The latter depends in large measure on mask collections in the Museum of Cultural History with which previous publications have not dealt. Our intention is to provide a reasonably broad yet focused overview, a survey which does justice to the diversity of mask forms and functions from several sub-Saharan African cultures.

Among the Bamana peoples we encounter extensive creation mythologies that help to account for masks and their relationship with essential economic pursuits, namely agriculture and work of blacksmiths, who are carvers and ritual specialists. The use of masks as "power objects" is demonstrated in the Bamana section. They, and the Voltaic peoples to their south, employ masks in funerary rites designed to maintain the continuity of life, also a dimension of masking among many peoples discussed subsequently. The Bidjogo of the Bissagos Islands continue this theme, for example, while dramatizing in mask iconography the importance of two contrasting realms: the sea (shark masks) and the land (bovine headdresses). Bidjogo masking, like most, also concerns the transition rites—initiations—of boys passing into responsible adulthood. Mende masquerades focus on the ideals and unusual masking activities of women, while the Dan have a hierarchy of mask roles from enter-

tainment to policing and judging deities. A leitmotif of this study, that African masks often incarnate powerful spirit presences, is especially manifest in Dan masks at the upper end of this hierarchy. Baule masking stresses the interaction of men and women, bush and village, chaos and civilization—a world view also shared by other peoples discussed, e.g., the Dan and We and the Igbo, as mentioned above. Yoruba masking cults reveal the centrality of ancestors in maintaining cultural balance (*Egungun*), the importance of honoring women's powers (*Gelede*), and the need for young men to shoulder the burden of cultural transmission (*Epa*). Masks and masquerades in Cameroon are deputized by kings and their councils to inculcate and enforce laws and behavioral norms, and to entertain as well. Cameroon, Northern Edo, and many other masquerades discussed below also appear at important annual agricultural festivals—especially those "first fruit" rituals which encourage and celebrate large harvests the spirits themselves have helped to provide.

Moral and other educational instructions of male initiation societies are found in Chokwe, Yaka, and Pende masquerades, which often include satirical plays that hold a mirror up to life, especially as it should *not* be conducted. Some of these peoples' masks also have important duties in regulating behavior; as such they are extensions of chiefly authority. Lega masks—in contrast to most of those discussed here—are seldom worn to cover the head or face; rather, most are display emblems that stress the values, traits, and teachings of the higher initiatory grades of the men's society. Makonde masks, like most others, provide entertainment through the mirroring of life situations, and their primary context seems to be—again like many—to dramatize the crucial rite of passage that is undergone when children become adults; maskers often embody ancestors who are present to witness these events.

This thumbnail sketch of some of the specific masking situations to be encountered below points up the high valuation placed on this form of ritual and artistic activity in many parts of the continent. Masking clearly occupies a critical place in the life-sustaining activities of millions of African people. As we stated at the outset, masks and masquerades are among Africa's most cherished and compelling artistic phenomena.

Bamana

Jennifer Haley

The Bamana (often called Bambara) occupy western and central Mali. A Mande-speaking people numbering approximately one and a half million, they are the largest culture-group in the Western Sudan. Bamana are agriculturalists, and the necessity of wrenching crops from poor, dry land has resulted in the elevation of farming to an honored and glorified vocation. In most Bamana religious beliefs, agricultural concerns—rain, fertile fields, and strong, productive farmers—are stressed alongside the establishment and preservation of basic social ideals and institutions (Goldwater 1960:10–12; McNaughton 1979:8). These same themes are reflected continually in Bamana art.

Traditional Bamana religious, social, and political institutions are based on male initiation societies called *jow* (*jo*, sing.),[9] which are age-graded masking associations. The most important *jow* for all Bamana are *N'tomo, Koré, Kono, Nama, Nya,* and *Komo* (McNaughton 1979: 8). Other *jow*, such as *Chi Wara*, assume local importance in some areas as well. *Kono, Nama, Nya,* and *Komo* may be grouped together as "powerful associations" (McNaughton 1979:8);[10] one is always present in a community to provide social control and to maintain order and harmony (McNaughton 1979:8). Every village has several *jow*, but few have all of them, and each community values the *jow* differently.

Art plays an integral role in *jow* activities. As McNaughton notes, "Any major enterprise undertaken by an association involves almost by definition a leader working in consort with sculpture" (1979: 13–14). The converse is also true: almost all Bamana wood sculpture and metalwork are associated with the ritual activities of the *jow*. Even such mundane items as door locks are carved by sculptor-smiths to represent a male and female couple whose union symbolizes marriage and fertility (Fraser 1974:84), primary concerns of many *jow*. Iron staves forged into representations of standing women and men on horseback are placed by altars as power symbols by individuals and cults (Vogel 1981:28–29). And the most important Bamana sculptures are *jow* power objects; these include an altar (*boliw*), horns (*buruw*), and of course, masks (*kunw*, "heads"). Despite the great variety in style and form found among the artworks associated with various *jow*, all (especially masks) have a single goal: encouraging and controlling crop fertility and, by extension, the fertility of the human community.

As time goes on, more and more Bamana communities are converting to Islam. This trend, combined with influence from the Western world, is weakening masking societies. Masks today are often relegated to community entertainment instead of being focal elements in elaborate ritual enactments of cosmology and history (Imperato 1970:13). Often masquerades cease altogether as the *jo* controlling them disintegrates from lack of purpose.

N'tomo

N'tomo is organized into five year-long age grades through which boys must pass before they are circumcised[11] and emerge as educated men (Goldwater 1960:14). The *jo* teaches principles of communal farming, judges disputes, and provides protection against evil spirits. Physical courage is also stressed—each initiate owns a whip made of a long branch. If a boy cries or complains under a ritual blow from a peer, he is considered a coward, and the stigma remains for the rest of his life (Dieterlen 1951:173).

Uncircumcised (and unexcised) Bamana children are considered androgynous; according to Zahan, "They represent the human being as he was when he first left the Creator's hands" (1974:16). The uncircumcised are filled with a powerful and chaotic energy called *wanzo*, which is opposed to fertility and makes one unable to live with or even tolerate anyone else (Dieterlen 1951:64). A primary role of *N'tomo* is the control and containment of *wanzo*. *N'tomo* is "the mother of the *wanzo* of the uncircumcised" (Dieterlen 1951:174); the effectiveness of its ritual objects stems from the force of *wanzo*. After circumcision, boys are considered fertile and responsible adults—the chaotic *wanzo* energy is transferred and deposited in masks (Fig. 11), simultaneously augmenting the power of these masks and protecting the community from disorder.

N'tomo masks are said to be the most ancient of the *jo's* ritual objects. The wooden mask takes the form of a humanoid face topped by a "comb" of long vertical horns or spikes. The number of projections varies between four and ten; six horns surmount this example. Regardless of their actual number, the projections recall the "eight primordial seeds created by God for the building of the universe" (Dieterlen in Goldwater 1960:14). The specific number of horns indicates whether a mask is male, female, or androgynous. In Bamana numerology, the number three and its multiples indicate masculinity; four and eight have to do with femininity; and two, five, and seven are associated with androgyny (Zahan 1960:76). Thus, our mask is a masculine example.

This mask demonstrates the Bamana penchant for clear geometric treatment of forms. Semicircular ears protrude to the sides of a large hemispherical forehead. Square holes form the eyes, and a long trapezoidal nose is set above the jutting chin, with a small oval hole for the mouth. Parallel lines cut into the unencrusted wood on both sides may represent scarification marks. String is attached to two holes on the side of the face; the mask is worn tied over a cloth which conceals the masker's head.

The masker wears a red cloth costume that personifies the "sower of discord" who stole the primordial seeds of creation (Dieterlen in Goldwater 1960:14). Cowrie shells decorating the mask are symbols of "the reorganizer of the universe," who defeated the "sower of discord" and regained these seeds (Dieterlen in Goldwater 1960:14; cowrie shells are also traditional African symbols of wealth.) Both the shells and the red kise seeds scattered among them are affixed to the wood by a latex gum. The red seeds may be a further reference to the character the masker portrays or may symbolize the blood of sacrificial offerings. Red is an important color of power and energy. (Dieterlen notes that another name of *N'tomo—Ceble*—translates literally as "red man" [1951:70].) *N'tomo* masks may be used to beg gifts of food and millet during the dry season.

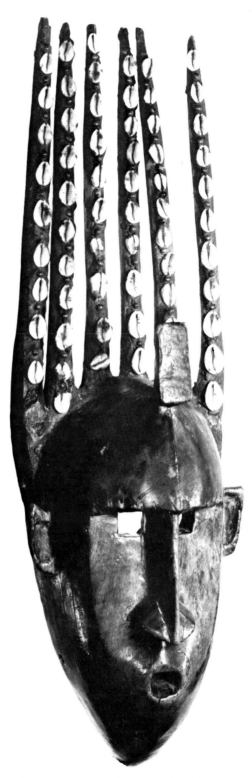

FIGURE 11. Bamana *N'tomo* mask; Mali. Wood, cowrie shells, kise seeds, latex, 56.5 cm. UCLA MCH X67–2111, gift of Dr. and Mrs. George G. Frelinghuysen.

Koré

The *Koré jo* is associated with the cardinal directions, space, the sky, and the atmospheric manifestations of the god *Faro*, especially rain (Dieterlen 1951:166). The principle rites of *Koré* are held at the end of the dry season around a special tree in the *jo*'s sacred grove outside the village. The spirits who attack the sky and thus bring rain to earth descend into this grove to receive men's offerings. Thunder and lightning are signs of their combat in the heavens. Although its sacred grove is closed to noninitiates, *Koré* masquerades are openly visible to the community (Dieterlen 1951:166). Every seven years new initiates are inducted. The masked performances are particularly concerned with sowing, bringing rain, and the fertility of the fields. Earlier writers describe them as lascivious, ludicrous, and cruel. In actuality, the masquerade satirizes humanity and the world; through biting mockery and grotesque imitation, *Koré* members not only convey the absurdity of life but also reaffirm the solidarity of the community (Zahan 1974:23; McNaughton 1979:5–6).[12] *Koré* has eight grades, each distinguished by a mask or other ritual object (whip, carved plank, etc.). The mask in Figure 12 is most likely a hyena (*souroulou*). Hyena masks vary in proportion and details, but the major elements are consistent. The overall Bamana aesthetic of clear geometric forms and crisp planes is evident. A bulbous forehead projects shelflike over a long, angular nose which in turn reflects the sweeping curve of the narrow, protruding muzzle. Circular holes set close to the nose form the eyes, and the mouth is a larger, square opening. In this example, short triangular ears are placed at the top of the head, and a crestlike form is at the center of the crown. (Hyena masks may also have extremely long ears.) The right ear of this piece is damaged. Three diagonal incisions are cut into the cheeks of the muzzle, reinforcing the prevailing angularity of the mask. The blackened coloration of the wood results from the sculptor-smith blowing flame, soot, and ash from the embers of the forge against the surface of the sculpture. A dark patina results when the wood is rubbed (Imperato 1970:74) and, of course, after long use.

Chi Wara

Chi Wara headdresses are the best known Bamana art forms and perhaps the best known African art objects (Fig. 13). The major styles correspond to three regions: the vertical ones from Segu, the horizontal from Beledugu, and the abstract examples from the Ouossulu area (Zahan in Vogel 1981:22). The headdresses represent composite animals (antelope-aardvark-human) and are danced only by men; however, they always perform as a male/female pair. Figure 13 is a vertical-style female.

Headdresses are worn lashed to basketry caps with long fiber fringes covering the masker's face. Male headpieces are associated with the sun and female with the earth, while the element of water is represented by the mud-dyed plant fibers of veil and costume. Masqueraders dance bent over, leaning on two short sticks of *sunsun* wood (Fig. 14). They do not straighten during the entire performance. Both dancers imitate the movements of antelopes, but the male's dance is more athletic, having energetic leaps and fast running passages accompanied by rapid drumming. Males may make loud screeching sounds, while females remain silent (Imperato

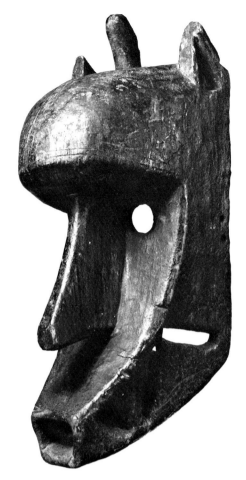

FIGURE 12. Bamana *Kore* mask; Mali. Wood, 32 cm. UCLA MCH X78–121, anonymous gift.

FIGURE 14. Bamana male and female *Chi Wara* dancers posed in a large plowed field; Mali. Photo: Pascal James Imperato, late 1960s.

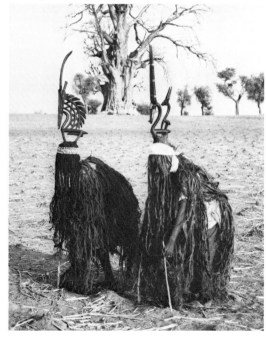

30

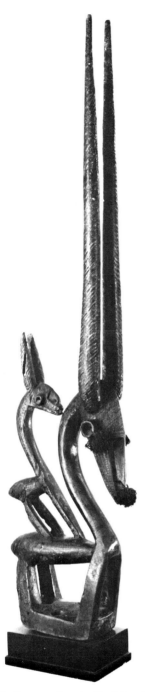

FIGURE 13. Bamana female *Chi Wara* headdress;
Mali. Wood, fiber, 78.3 cm. Anonymous loan.

1970:78). During the masquerade no one may separate the two or walk in front of them. In some areas this idea of male/female union is extended, and a woman walks behind each dancer to fan him, cooling the performer and diffusing the power he generates during the dance (Imperato 1970:76; Brink in Vogel 1981:25).

Chi Wara perform during planting and harvest seasons. The maskers dance in the fields during hoeing contests and in the village square. Although originally seen only by *jo* members, performances are now open to everyone in the village, including women. Indeed, women now sing songs to accompany the dance.

There are varying local interpretations of the meaning of this masquerade. "*Chi wara*" means "excellent farmer" and is used to describe the man who works all day under the sun with unflagging determination—the champion farmer. The literal translation is different, "*chi*" means "work" or "farming," and "*wara*" means "wild animal," "farming wild animal," referring to the myth of the supernatural offspring of the union the first being created, a certain woman, and a snake. This half human, half animal introduced agriculture to man, tilling the ground with his claws and a *sunsun* stick and magically changing weeds into corn and millet (Imperato 1970:8), In areas where the legend is remembered, the male dancer is thought to represent *Chi Wara*. Women's songs praise him, ask his aid, and encourage men to imitate his example. In most regions, however, this mythology is forgotten, the performances are largely secular, and the dancers are not considered to embody legendary beasts. Women's songs then refer to a wholly human champion farmer and compare their men unfavorably to this ideal figure (Imperato 1970:13,71,89).

Chi Wara headdresses recall mythology in their form. Like all vertical females, Figure 13 represents the legendary farming beast seen as an antelope with her child. The wood has a dark patina from smoke and usage. Again the Bamana predilection for geometric shapes is apparent in the simplified form. The exaggeratedly long horns refer not only to the animals but also the growth of millet (Zahan in Vogel 1981:22). The schematic body is somewhat chunky and squat under the long necks and horns of the animals, and its shape may allude to the aardvark and its habit of digging in the earth. Oval ears reflect the *jo*'s association with the sense of hearing. Upon hearing ancestral deeds, men are encouraged to match legendary virtues (Imperato 1970:72). The human aspect of the composite animal is obvious in the female's posture of carrying her child on her back. The delicate heads with the metal nailhead eyes show further anthropomorphic elements, along with pierced ears and noses for the insertion of metal jewelry. The profile of the baby antelope is especially human.

Chi Wara headpieces link humans with the earth, sun, and water; reflect the union and cooperation of male and female; stimulate the growth of grain; and exemplify the virtues of primordial farming success and its repetition today. As Imperato notes, "The Bamana believed that it was primarily through agriculture that they were put into contact with all the elements of the cosmos" (1970:71).

Komo

The *Komo jo* possesses enormous authority in Bamana society. Described as "the political arm of the sculptor-smiths" (McNaughton

1979:21),[13] *Komo* acts as a policing agent, identifying and eliminating antisocial behavior. *Komo* leaders (*Komotigi*; all of whom are members of the blacksmith clan) not only practice divination but also function as judges and counselors. In past times, *Komo* trained men in fighting skills and war strategies as well.

The wellspring of *Komo's* strength is the leader's personal power and knowledge, his ability to activate and manipulate vast amounts of the raw energies of life (*nyama*) through the various agents of ritual, performance, and sculpture (especially the mask [Fig. 15]). All these elements are vital; McNaughton notes that "the name *Komo* identifies the leader, the sculpture and the dance," while a sculptor-smith defined *Komo* as "a dance used to kill" (1979:21). Ultimately the tremendous forces called into play by *Komo-tigi* are directed toward quieting the destructive energies of a discordant society. *Komo* seeks balance and stability, spiritual peace and social harmony.

Komo's authority is so feared and respected that entire communities withdraw behind closed doors during its annual festivals. Some idea of *Komo* power is conveyed by excerpts from an initiation ceremony:

> If you speak of it, may your abdomen swell
> may he kill you
> May the *Komo* take away your heart and organs

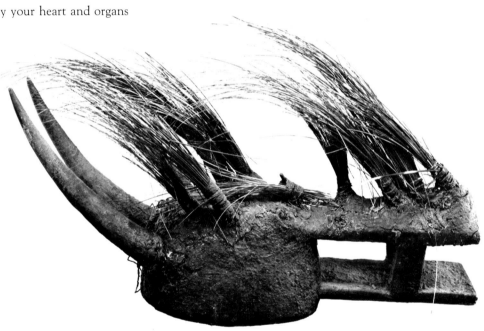

FIGURE 15. Bamana *Komo* mask; Mali. Wood, mud, quills, grass, horns, sacrificial materials, 38.1 cm (not including horns). UCLA MCH X77–392, gift of Dr. and Mrs. Joel Breman.

may he crush your head without your brains coming out
without your blood coming out
 (Henry in McNaughton 1979:22).

Held at night until dawn, weekly performances are secret, closed
to noninitiates. Accompanied by drums and flutes, *Komo* leaders
work to solve the problems of initiates and other community
members by dancing the mask (Fig. 15) and directing the forces thus
awakened to constructive solutions.

The mask is the most important power object owned by each *Komo
jo*. Not only is it a focus and channeling agent for *nyama*, but the
mask itself is powerful, capable of absorbing and storing tremendous
amounts of energy. Even to say the name of a *Komo* mask is dan-
gerous; to see a smith making one is believed to result in death.

A *Komo* mask is constructed secretly in the bush. While actual
carving takes a few hours, completing the mask is elaborate and
formalized, involving sacrifice as well and the location and prepara-
tion of special wood, herbal, and animal components. Great amounts
of *nyama* are simultaneously released and bound into the mask dur-
ing the process. The smith employs many secret procedures (*daliuw*,
singular, *daliu*) in making the mask. Each *daliu* is a personal "recipe"
of materials, ritual, and knowledge designed to "marshal and direct
power" (McNaughton 1979:25); each invests the mask with a dif-
ferent ability.[14]

Komo mask forms are designed to reflect the vast energies harnessed
within. Intended to be terroristic, appalling, and unnerving, the
roughly zoomorphic mask has an open and overtly aggressive mouth.
No specific animal is portrayed, but rather "animal nature" is con-
veyed, the dangerous and wild forces of the bush. On this example,
two horns jut out from the back of the center helmet, and the top
of the mask bristles with bundles of porcupine quills; called "arrows,"
horns and quills are symbols of violence and the aggressive power
of bush animals. Their threatening meaning is obvious, yet both are
also symbols of wisdom in Bamana thought. Horns especially may
be used to conceal medicines and amulets. The surface of the mask
is coated with mud and sacrificial materials which render its form
ambiguous. A mask's power increases with age as the surface builds
up from successive sacrifices.

Both in form and technique, *Komo* masks are quite different from
the usual Bamana aesthetic of geometric clarity in art. Instead they
constitute a strong anti-aesthetic of ambiguous forms, amorphous
surfaces, and disharmonious elements. The arcane knowledge and
tremendous power wielded by the *Komo-tigi* for the good of society
is symbolized by the mask; thus, as McNaughton states, "*Komo*
masks depict 'obscurity fighting obscurity,' '*dibi-kele-dibi*'" (1979:44).

Voltaic Peoples

John Wills

The nation of Upper Volta (recently named Bourkina Fasso, "Land of Upright Men"), located in the Western Sudan, embraces a number of different peoples (language groups) often called Voltaic. Most are agriculturalists, farming millet, sorghum, and a variety of other vegetable crops. The Mossi, by far the largest group (about two million), have a centralized political system hierarchically organized and ruled by the *Mogho Naba*. The Bobo, Bwa, Nuna, Ko, and Gurunsi, in contrast, are decentralized, divided into clans or villages governed by councils of elders, sometimes through a headman or chief. These groups total less than one million.

Although masking traditions vary from group to group, most hold their masking rituals between October and May, during the dry season when fields become barren, dusty, and susceptible to erosion. All Voltaic cultures also share the same mask- and art-producing organization, the blacksmith caste. As among the Bamana, smiths are a distinct people, living apart from the farmers in separate quarters or villages and marrying only among themselves. They are ritual specialists and artisans, producing jewelry, metalwork, wood carvings, and pottery.

Main Voltaic groups (apart from the Mossi; see below)—Bobo, Bwa, and Gurunsi—share a common religious cult centered around *Do*, a spirit of the bush. All masks represent *Do* or its children. The masks of these peoples, and the Mossi, are stylistically related, all consisting of rather simplified, abstract faces or animal heads with geometric surface decorations in red, white, and black. These groups also produce wooden sculptures of human figures, jewelry, and brass figurines made by the lost wax process. The production of all these art forms, as well as tools and other artifacts, is in the hands of the respected and feared caste of blacksmiths.

Mossi

The Mossi live in central Upper Volta. Their society is divided into two distinct classes, the nobles, *nakomse*, and the commoners, *tengabisi*, which include farmers, *nyonyose*, and blacksmiths, *saaba*. The noble *nakomse* invaded the region from the east during the fifteenth century and established secular and political hegemony over the indigenous populations. Both classes are aware of the "stranger" status of the *nakomse*, and the plebian *tengabisi* resent the secular power of the *nakomse*, who, in turn, fear the magical abilities of the commoners (Roy 1979b:18–19).

Mossi believe in a supreme creator, *Wende*, whose force animates all aspects of the environment. They are not preoccupied with theological speculation but accept the supernatural order and are concerned only with dealing with it efficiently. If people strictly follow "the way of the ancestors," *Wende* will be generous and make the fields fertile, the rains abundant, and the harvest rich (Hammond 1966: 164–165). In addition, if traditions are followed, the ancestors

themselves will respond by manipulating natural forces for the benefit of the living. Maintaining good relations with the ancestors is the major concern of masking rituals.

Mossi art consists of metal sculpture, headpieces, and masks, as well as figural sculptures in wood, used by the noble *nakomse* as symbols of political power (Roy in Vogel 1981:35). Three major Mossi mask styles and two substyles exist, each reflecting one of the indigenous ethnic groups that have been integrated into Mossi (*nakomse*) society.[15] All masks are embodiments of collective clan ancestors and are considered their "eyes." Masks may also represent the totemic animal of the owner's clan. Mossi believe that totemic animals are associated with the souls of all clan members (both living and dead), so whatever happens to one will also happen to the other. Thus if a totemic animal is killed, a person will also die (Roy 1979b:157).

There are five basic uses for Mossi masks. They escort the body of a deceased male or female elder to the grave, thus helping the soul travel to the ancestral spirit world. Later in the year, during the dry season, maskers appear at funerals to honor the deceased. Before the onset of the rainy season, other masked dancers accompany sacrifices offered to ensure a good harvest. Maskers also act as agents of social control during the "hungry season," between sowing and the first harvest, to protect immature crops and fruits from being picked. Finally, masks serve as personal shrines or altars for families (as in Ougadougou) or clans (as in Boulsa), providing a direct line of communication with ancestors (Roy 1979b:76).

Figure 16 is a fine Mossi mask, *wango* (perhaps a *Karanga*), probably from the Yatenga area. More typical Yatenga masks have tall vertical planks along with concave faces, the latter a style diagnostic of this region. Since our mask lacks the long plank, it may have originated in the Risiam style area, where some Yatenga-style masks are found. In front of the short plank and springing from the top of the concave face are two short, S-shaped, curving horns, the diagnostic for small *nyaka* antelope, a common totemic clan animal. Like other Voltaic groups, the Mossi claim no symbolic or cosmological meanings for the geometric surface decorations. Perhaps they are not meaningful, or if so, people are unwilling to reveal secret knowledge. Then too, the original meanings of the symbols may have been lost to time. In any case, masks continue to be painted with these traditional designs, which are renewed before each use.

The "cheeks" (lower sides) of this mask are pierced by holes through which is passed a stick that the dancer clamps between his teeth to steady the mask on his head. A thick cowl of loose fiber strands is normally tied around the rim of the mask covering the wearer's head, shoulders, and chest. The masquerader wears a traditional tailored Mossi shirt (*fugu*) and short, baggy trousers (*kurga*), over which a skirt of knotted and twisted cotton strands is worn with small iron rattles attached. Today, masked dancers may also appear in secondhand Western-style clothing.

This costume is very different from the heavy fiber costumes worn in other areas of Mossi country (and Upper Volta), and no attempt is made to hide the identity of the mask wearer, nor the fact that he is human. Masks and masking societies are generally not secret nor hidden from women or children, although the knowledge that masks are carved by human beings *is* a very closely guarded secret of the clans owning masks.

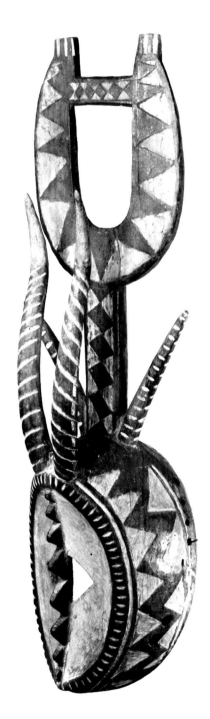

FIGURE 16. Mossi mask; Bourkina Fasso. Wood, pigments, 70.2 cm. UCLA MCH X67–2110, gift of Dr. and Mrs. George G. Frelinghuysen.

According to Schweeger-Hefel, each family has a myth that explains the origin of its mask. Usually, the legend begins with a catastrophe that leads a ghost, animal, or even God to give a mask to an ancestor. The inherent power of the mask restores order to the world. After that ancestor's death his mask takes on a new function, serving as a body for its deceased owner (Schweeger-Hefel in Vogel 1981:34).

When performing, the masquerader often carries a goat-tail flywisk in his left hand and an iron clapper in his right. Clappers, hung from one finger, consist of two parallel iron blades joined at one end to a ring struck with a heavy iron thumb ring (Roy 1979b:138).

In the funeral ceremony for a deceased elder the masquerader dances, accompanied by drum music, for about ten minutes, two days in a row. He moves between the drummers and the door to the deceased's house, using two basic steps. Holding shoulders and head steady while twisting and rotating hips rapidly, the masker moves towards the drums, his skirt flying wildly about. When he reaches the drummers he quickly swivels his head around, as if to surprise someone behind him. Then, moving away, he takes long strides and throws his cowl over his face[16] with his forearms as he returns to the door of the deceased's house (Roy 1979b:164).

Bobo

The Bobo are located in southwestern Upper Volta in autonomous farming villages concentrated around the city of Bobo-Dioulasso. Among the Bobo, helmet-shaped masks with flattened cheeks, rectangular faces, and blocky, T-shaped brows are physical manifestations of *Do*. Worn only by smiths in earlier times and still worn by them in funeral ceremonies (Le Moal in Skougstad 1978:6), they are now also danced by farmers in initiations. The Bobo are also known for their mural arts and small three- and four-legged stools with handles carved in human and animal forms.[17]

The two Bobo masks illustrated here, Figures 17 and 18, represent an unknown character and a chameleon, respectively. The first is carved from dense, hard wood and bears the characteristic Bobo black, white, and red geometric patterns on its surface. Two horns, presumably those of an antelope, spring from an essentially human-oid head with sharply cut features. The second mask (Fig. 18; probably Gurunsi or Nuna and not Bobo) features a stylized chameleon or lizard, face down, and integrally carved with an ovoid convex face which covers that of the wearer. It is likely that the chameleon was the totemic animal of the people who owned and danced this mask at agricultural festivals and the funerals or second burials of important people. Christopher Roy tells us that chameleons are associated with change (pc:1984), with the transformation of a person from this world to that of the spirits. Chameleon masks would thus be especially appropriate in a funeral or second burial context. Neither type, unfortunately, is elucidated in LeMoal's (1980) full discussion of Bobo masks, and they presumably came from regions in which he did not work.

Secrets of masks and masking are kept from Bobo women and children, in contrast to practices among the Mossi of the Yatenga area (Cremer in Skougstad 1978:23). Like the masking costumes of the neighboring Bwa and Gurunsi peoples, Bobo examples are made of native fiber dyed either red, black, or white. Costumes are often

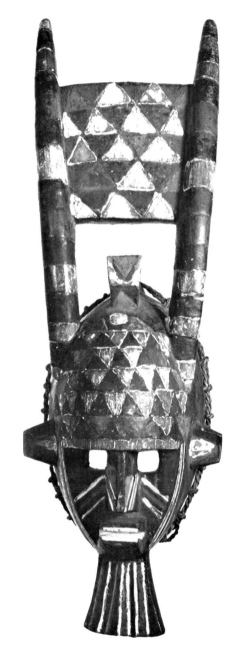

FIGURE 17. Bobo mask; Bourkina Fasso. Wood, pigments, fiber, 74 cm. UCLA MCH X64–80, gift of W. Thomas Davis.

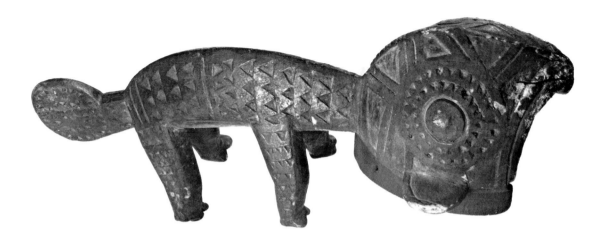

FIGURE 18. Nuna (Gurunsi) chameleon mask; Bourkina Fasso. Wood, pigments, 64 cm. UCLA MCH X67–2091, gift of Dr. and Mrs. George G. Frelinghuysen.

FIGURE 19. Bwa mask; Bourkina Fasso. Wood, pigments, 42 cm. UCLA MCH X76–706, gift of Dr. and Mrs. Joel G. Breman.

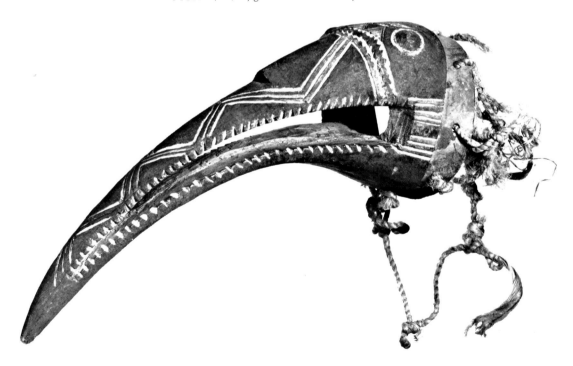

covered with bird feathers, cowrie shells, or bird skins, and the masks are sometimes extended by a cloth embroidered with cowrie shells, which falls over the dancer's shoulders (Lem 1949:29).

Bwa, Ko, and Gurunsi

Bwa, Ko, and Gurunsi peoples are widely dispersed, living in small farming communities in western Upper Volta and adjacent areas of Mali. The three types of masks associated with these groups are animal forms, "plank" masks (with a vertical superstructure mounted on a flat animal or disc-like head) and a heterogeneous group with ovoid heads, round eyes, diamond-shaped mouths, and disc-shaped crests (Skougstad 1978:15).

The Bwa dance two types of masks. The first are made of straw and grasses and are used for initiation into the *Do* society and at the beginning of the rainy season to reintroduce man into the natural environment. Like many other African peoples, the Bwa believe in a bush-village dichotomy; the bush is chaotic and untamed, while the village is ordered and civilized. Therefore man, who is civilized and separate from nature, must be reintegrated into civilized village society to be fully human again. The reintegration is accomplished through the dancing of wooden masks (*Wo Koponu*; Fig. 19). Masks are worn by men belonging to senior grades of *Do*, and maskers also dance at funeral ceremonies and act as agents of social control (Roy 1979a:30).

The *Wo Koponu* mask in Figure 19 represents a bird head, *simba*, (perhaps a hornbill, which is frequently depicted on masks of the Bwa and neighboring Gurunsi). A suggestion of a human nose on the beak reflects the anthropomorphizing of animals and nature by Voltaic peoples. This mask was lashed to the wearer's forehead, projecting forward, and his dances presumably simulated the movements of the bird depicted. Other animals commonly represented include hyena, warthog, monkey, ram, crocodile, bush cow, snake, and antelope. It is still unknown why specific animals or birds are depicted on masks, although they may have mythological or totemic significance (Zwernemann in Vogel 1981:33).

Among the Gurunsi and Ko, masks are again the physical manifestation of *Do* (Fig. 20). Each has its own specific name and dance step. There is a good chance this mask was actually carved in a nearby Ko or Gurunsi village since the Bwa often commission masks rather than carving their own. For this reason, along with basic stylistic similarities, it is often difficult to distinguish among Bwa, Nuna, Ko, and Gurunsi carvings (Roy 1979a:30). Maskers appear once every three years for a three-day festival that opens with sacrifices to ancestors or other divine powers. If masks are danced properly, these intermediaries will bestow good crops and health, as well as general prosperity. Dancers wearing zoomorphic masks mimic animal movements; plank masks are named for popular sayings or proverbs (Skougstad 1978:23). C. Roy indicates that the Ko did not have secret societies, and that if this mask is of Ko origin, it belonged to a family; the animal shown was dictated by a diviner (pc: 1984).

Masks are usually repainted before each performance, and dancers wear a costume of *da* fiber (*Hibiscus canabinus*), dyed either red, black, or white, that completely conceals their bodies. Performances are activated by drums and flutes. When used as an agent of social control or in harvest ceremonies, the mask is danced individually, but

FIGURE 20. Ko (Gurunsi) mask; Bourkina Fasso. Wood, pigments, 50.7 cm. UCLA MCH X75–46, Museum purchase.

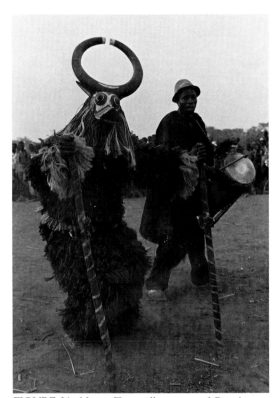

FIGURE 21. Nuna, Tisse village, central Bourkina Fasso. Photo: Christopher Roy, 1984. The bush buffalo mask appeared with twenty other masks at a funeral of a male elder to permit the spirit of the deceased to leave the village. The drummer is the head musician of the blacksmith clan in the village.

it may appear along with as many as twenty other characters at funeral ceremonies (Vogel 1981:15), like the Nuna mask in Fig. 21.

Much confusion has surrounded the peoples and cultures of the Upper Volta. Traditionally, the Voltaic peoples have mistakenly been thought of as somewhat homogeneous, partly a result of the stylistic similarities in their arts, especially masks and masking costumes. Only in recent years have the Voltaic peoples been fully recognized as a conglomeration of diverse and unique cultures. Recent studies by Roy and Le Moal have greatly contributed to our knowledge, but more research is needed if we are to appreciate and understand fully the cultural complexities of these peoples.

The "antelope" represented on the Gurunsi or Ko mask in Figure 20 is one of the most important animals in the Western Sudan and is depicted on masks of all Voltaic and Malian peoples. This is a very satisfying, well-crafted mask. It has been used in many masquerades, as is evident by its somewhat dilapidated state. There are no eyeholes through which the wearer may see, but he may have been afforded some vision by the snout while dancing. The uses and functions of Gurunsi masks are not well documented, but the dancer was probably accompanied by drums and flutes while mimicking the characteristic movements of the antelope. The costume is of the same type used by the Bwa.

Although no information elucidates the symbolism and form of this mask or why an antelope is depicted, we can postulate a possible answer by drawing on data from the neighboring Mossi. Mossi masks of the Ougadougou style area are related stylistically to Gurunsi examples—they share colors, geometric motifs, long fiber costumes, and stylized representations of wild and domestic animal heads (Roy 1979b:308). Mossi masks are both ancestral and totemic, and it is quite possible that Gurunsi ones are similar. The circular superstructure above the antelope head is also found on some Mossi masks and is believed to depict a stylized human (ancestor) head (Schweeger-Hefel in Roy 1979a:153). Of course this is speculation, and clearly more research needs to be done among the Voltaic peoples.

Bidjogo

Gail Wallace and Jeri B. Williams

The Bidjogo people, numbering approximately 15,000 (Scantamburlo 1978:8), inhabit the Bissagos Archipelago off the west coast of Guinea-Bissau. Their language is classified in the northern West Atlantic subgroup of the Niger-Congo family. The Bidjogo have no cultural subdivisions but are divided into four matrilineal clans (*djorson*). Each lineage traces its origin to one of the ancestral *djorson*.

The rich tropical environment of the islands yields an abundant food supply from both land and sea. The primary crop, rice, is produced by the slash-and-burn technique. Supplementary crops such as peanuts, fruits, manioc, yam, and beans are also grown. During the dry season the raising of domestic animals, harvesting of the oil palm, fishing, hunting, and gathering supplement faltering food supplies.

The Bidjogo live in politically and economically autonomous villages. Each is headed by either a divine king or chief chosen by both the council of local elders and the community at large. The village head is usually not a resident of the community but is a member of the village *djorson*. The village is composed of several semiautonomous extended family units, each headed by a male elder (*homen grande*) who is also a member of the elders' council. Virilocal residence and polygyny are still practiced despite the growing pressures of socioeconomic change and Christianity.

Religion is a vital part of Bidjogo life. The spiritual and physical well-being of the village depends on people maintaining a positive relationship with the spirit world. Since the gods can harm as well as protect, sacrifice plays a significant role in all religious observance as a means of keeping the deities friendly and helpful. The supreme creator god, *Nindo*, is a distant and ethereal being responsible for general welfare. However, this abstract deity is never worshiped directly, and there are no artistic representations of him. The sun, moon, wind, stars, and other natural phenomena are also included in the Bidjogo pantheon (Scantamburlo 1978:80). The spiritual guardian of a village, "The Great Spirit," *Orebok-Okoto*, serves as an intermediary between the inaccessible *Nindo* and the world of the living. Other types of spiritual energy, *iran*, also serve to mediate between the gods, ancestors, and man.[18] Although the majority of *iran* are represented in wood sculpture, there are also *iran* vegetal mixtures which can be called "power bundles." The Bidjogo have two types of priests. The female, *oquinca*, interprets the demands of *Orebok-Okoto*, while the male, *oamcandjamo*, serves as both a diviner and spiritual supervisor at male and female initiation rites. Village heads also act as religious authorities and sole custodians of the village *iran do chao*.

Utilizing motifs found within their environment, the Bidjogo make art forms charged with the wild and uncontrolled energies of the bush and sea. These powerful forces are successfully transformed into the art of masquerade, as well as into calabash and wall paintings (Gallois-Duquette 1976:26). Masks are carved by professionally

trained artists. Secret instruction is given concerning the choice of the proper wood type, carving techniques, and the ritual purification of both object and carver (Scantamburlo 1978:31). Masks are made in large quantities and are preferably stored in granaries before major festivals (Gallois-Duquette 1976:33). Traveling from village to village, masks are subject to harsh conditions and ordeals, thus many examples are worn and exhibit major structural repairs. Masqueraders primarily wear animal and marine headdresses. The one exception is a human mask sometimes used by adult males as a symbol of ridicule or derision (Gallois-Duquette n.d.:3). Bovine headdresses, collectively known in Creole as *vaca-bruto*, comprise the majority of documented examples (Figs. 22–24). *Vaca-bruto* stress the naturalistic representation of their animal models in contrast to the syncretic and composite works of the neighboring coastal Baga and Nalu peoples.

Masquerades appear at several events in the ritual calendar. Their most important outing is within the initiation cycle signaling and defining an initiate's status within his age-grade. Masks may also appear at agricultural festivals, and they have recently been incorporated into the commemoration of national holidays (Gallois-Duquette n.d.:4).

The *canhocá* age-grade is comprised of preinitiatory adolescent males twelve to seventeen years old. This stage signals the adolescent's departure from childhood and his introduction to the social responsibilities of the community. It is at this level that masking begins. The *canhocá* masquerade symbolically dramatizes the impetuous and irresponsible period preceding initiation. Boys wear nonthreatening fish or domesticated calf headdresses. Three categories of *vaca-bruto* are available to the adolescent at this stage: *gn'opara* (Fig. 22), *iaré* (Fig. 23), and *dugn'be* (Fig. 24; Gallois-Duquette 1981:57). *Gn'opara* represent female animals raised in the bush. These small wooden crests have long natural horns and leather ears. The second group, *iaré*, represent the zebu or humpbacked ox and are found only on the islands of Uno and Formosa. Made entirely from wood, these crests are characterized by long, flat wooden horns engraved and embellished with painted triangles. The last group, *dugn'be*, represent domesticated male ox (Fig. 24). These masks are also carved wood, with short natural horns and wood or leather ears. Inset eyes are made from cut bottle ends. Surfaces are painted with black, white, and red pigments and usually include a white triangle on the bull's forehead. The flexible neck is a series of circular rings attached to the mask with natural fibers. Cords extending from the mask across the upper body of the masker secure the headpiece. A cord lead is strung through the nostrils in the same manner as the domesticated oxen of the village, reinforcing the image of the preinitiate as an undisciplined being whose strength has just begun to be mastered (Gallois-Duquette 1981: 57). During the dance, *canhocá* bend forward to imitate a fish or animal's horizontal posture convincingly, momentarily concealing their own identity (Fig. 25). Maskers "swim, trot or fight, shifting from animal to human state" (Gallois-Duquette 1979:31). An adult may enter the dance both to insult and to threaten the *vaca-bruto*, allowing it to rebel. After provoking the bull, the adult proceeds to calm it and bring it under control (Gallois-Duquette n.d.:4). The dances are accompanied by songs recalling past adventures and battles (Scantamburlo 1978:73).

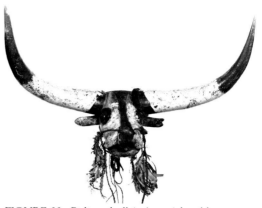

FIGURE 22. Bidjogo bull (*gn'opara*) headdress; Guinea Bissau. Wood, horns, pigment, raffia, rubber, glass, metal, vegetal fiber, 55.2 cm. UCLA MCH LX81–444.

FIGURE 23. Bidjogo bovine (*iaré*) headdress; Guinea Bissau. Wood, pigment, 75 cm. UCLA MCH LX82–153.

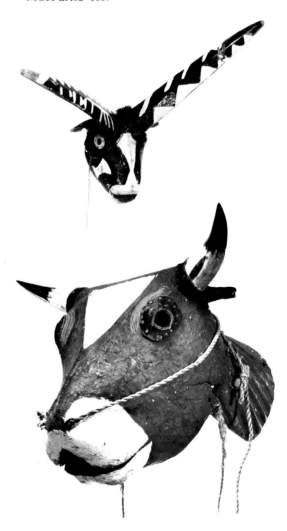

FIGURE 24. Bidjogo ox (*dugn'be*) helmet mask; Guinea Bissau. Wood, glass, hide, raffia, horn, paint, fiber, 55.3 cm. UCLA MCH LX82–162.

Headdresses, worn on top of the head, force dancers to bend forward in order to imitate the fish or animal convincingly, momentarily concealing their identity. Dancers may also wear leather waist belts, braided palm branches decorating ankles and chest, colored rings around their arms, and a pelican or other stylized bird between their shoulder blades. Sometimes they carry wooden shields and swords.

The bovine helmet mask completely covers the face unlike the headdress with which no attempt is made to conceal the identity of the dancer. A flexible ridged neck is attached with raffia rope to the mask. The dancer usually wears two engraved wooden hoops around his lower back as well as other decorative items such as wrist or arm bands, short raffia skirts, and anklets. Sometimes he will carry a sword or stick with metal rings attached.

Cabaros (*caros*), young men between eighteen and twenty-seven, form the next age-grade. Although physically mature, a *cabaro* is not considered a socially responsible adult. The heavier helmet masks worn at this stage reflect his stronger physical capacity. Dangerous creatures from both the bush and sea are represented in this masquerade. In addition to *canhocá* headdresses, the *cabaro* wears the *essenié* (*essié*), or "wild bull," helmet mask. Identified by its size and weight, the large bull mask is bound to the wearer with five cords. Dilated nostrils and in some instances a protruding red tongue are incorporated into the standard bovine repertoire. Unlike other *vacabruto* maskers, the *cabaro* does not volunteer to wear this mask but is chosen by village elders. Because of the inherent spiritual danger in wearing the "wild bull," the carrier is forced to drink a herbal concoction before his performance. While making him indifferent to pain, this mixture may cause him to lose consciousness or experience hallucinatory states. Maskers move with "uncontrolled violence, bellowing, scratching the ground and throwing themselves on spectators" (Gallois-Duquette 1979:31). In contrast to other Bidjogo masks, which are carved in public view, *essenié* are created in secret and are sacrificially consecrated (Gallois-Duquette n.d.:4). This mask is limited to the islands of Uno, Nago, and Formosa. Other masquerade varieties include the hippopotamus and pelican. Marine masks include the shark (Fig. 26), hammer-head shark, and sawfish (Fig. 27). Mask parts are further embellished with bas-reliefs of other marine creatures or the incorporation of shark's teeth. Wooden dorsal fins may also be attached to the back of the dancer (Fig. 28). It has been suggested that the dorsal fin symbolizes a boat's sail or that it refers to a sea bird (Gallois-Duquette 1976:31). Some masquerades can be erotic in nature, suggesting copulation between the creatures portrayed (Bernatzik 1950:117). After initiation, the new adult (*camabi*) abandons the festive dress of the previous age-grade and acquires the plain dress of civilized society. The adult, now officially socialized, no longer performs in masquerades and abandons his mask.

According to Bidjogo belief, if a boy dies before completing his initiation cycle, his soul is destined to wander and suffer within a dangerous liminal zone, never to reach "Anacaredo, the place of eternal beautitude" (Gallois-Duquette 1979:31). Wandering souls (*oshó*) are considered a threat to the community, especially to the deceased's mother. To preserve socioreligious equilibrium within the community, *oshó* may complete their initiation cycle ceremonially during a girl's initiation rites. The female initiate functions as an inter-

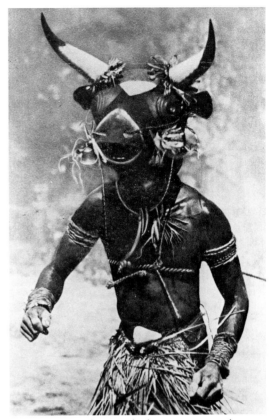

FIGURE 25. Bidjogo male dancer wearing a large bovine helmet mask (*dugn'be*). Photo: Hugo A. Bernatzik, 1930s.

FIGURE 27. Bidjogo sawfish (*kaissi*) headdress; Guinea Bissau. Wood, raffia, sawfish saw, pigment, 66.7 cm. UCLA MCH X82–1110, anonymous gift.

FIGURE 26. Bidjogo shark (*n'tempa*) headdress; Guinea Bissau. Wood, raffia, nails, paint, 43.2 cm. UCLA MCH LX82–149, anonymous promised gift.

mediary (*defunto*) between the world of the living and the dead, providing the uninitiated dead access to *camabi* status. Although less complex, the masks, costumes, and appurtenances of *defunto* masquerades incorporate the bush and sea imagery of their male counterparts. The female initiate may even play the drum, usually the exclusive right of men. Through the *defunto* the male spirit can relate his deeds as a virile warrior or skills as a fisherman or communicate to a loved one (Gallois-Duquette 1979:30).

Bidjogo masquerades transform the mysterious and unruly forces of nature into tangible and accessible creations. Land (bovine) and sea (shark) imagery is a visual testimony to the spiritual and economic concerns of the community. Spirit characters metaphorically reflect a range of oppositions present within the Bidjogo world view, for example, land/sea, village/bush, female/male, and uninitiated/initiated. Within the context of initiation, adolescent maskers embody the raw energies present within themselves and their environment. The taming of these spirit representations parallels both the imminent social change of the initiate as he becomes a productive member of society and civilization's ultimate triumph over nature.

FIGURE 28. Bidjogo dorsal fin; Guinea Bissau.
78.7 cm. UCLA MCH LX81–451, promised gift of
Mr. and Mrs. Richard Rogers.

Mende

Robbie Reid

The Mende and other nearby related peoples of Sierra Leone and Liberia (e.g., Kpelle, Temne, Gola, Sherbro, Vai) are most unusual in Africa because *women* own and dance masks. These peoples are sedentary cultivators, farming rice and producing palm oil. Together they number well over a million, while the Mende, our main focus, total about 900,000. Political organization consists of small chiefdoms with occasional larger confederacies that have formed and disbanded sporadically over the past several hundred years. The prestige and stature of Mende chiefs are enhanced by the employment of certain works of art, principally carved wooden staffs. Supporting the various leaders are powerful localized "secret societies" of virtually universal membership, with various grades controlling the initiation and socialization of youths. The men's institution, *Poro*, acts as an arbiter, employing masks and regalia in ceremonies from which females are excluded—thus following a common West African practice of separating the sexes. Women have a counterpart association called *Sande*, which in many places is equal in power to *Poro*. Women sometimes become chiefs in these Liberian societies, and the centrality of *Sande* in social and spiritual concerns is manifest in a virtually unique female concern with the art of masquerade. *Sande* officials wear wooden helmet masks called *Sowei*, and these are the only masks in Africa reserved exclusively for women.

Mende believe in a supreme god, *Ngewo*, creator and ruler of the universe, as well as in lesser, more approachable spirits, *Nga-fa*, many of which materialize in masking performances (Little 1954:114,120). These deities, along with venerated ancestral spirits which are often thought of as living under the waters (Holsoe 1980:107), are accorded responsibility for the productivity and well-being of man and the land on which he lives. They are often addressed in ritual activities of the counterbalancing male and female societies. Thus spirits populating the unseen world reveal themselves in *Poro* and *Sande* masked dances, as adjudicators in disputes involving society members, at funerals of important persons, and during other critical civic events, especially initiations. *Poro* masks are often fine and important works of art, but they are underplayed here to focus attention on the unique masquerades danced by women.

Sande

The initiation and socialization of females take place outside village boundaries in the *Sande* camp. Removed from their families (formerly for periods up to three years), the girls undergo a symbolic death. Stripped, then painted with white clay (Jedrej 1974:41), the initiates now enter a liminal or spirit state. Their schooling inculcates basic Mende feminine values, training for marriage and its attendant sexuality, domestic and family life, economic pursuits, singing and dancing. A sense of solidarity and interdependence develops between society members and initiates, and leadership qualities are recognized

and encouraged among the latter. *Sande* maskers visit initiation camps periodically, some with specific duties, and girls learn respect for these guiding and protecting spirits. Before completing their schooling process, girls undergo clitoridectomy, symbolizing removal of the male principle and thus an end to childhood androgyny (Hoffer 1975:156; Jedrej 1976:25). They emerge from the *Sande* camp, as they went in, accompanied by masked dancers, but the girls are now transformed; they are women (Jedrej 1976:141–143). Their rebirth is symbolized by new clothes, fine, elaborate hairstyling, and a new name. They emerge from *Sande* ready for marriage (Holsoe 1980:104). They have also learned the secret cherished by all masking societies whether male or female: that a flesh-and-blood human being, in this case a woman known to them, impersonates and becomes the masked spirit.

While functional and organizational parallels exist between *Sande* and *Poro* societies, legend confers the title "Mother of *Poro*" on the former and its masks are said to have been carved first (D'Avezedo 1980:15,17). This *Sande* primacy is reflected by powerful social and political authority vested in its leaders and in masked spirit characters. Although masks are owned and danced by women, the carvers are men. When a woman reaches the middle level in *Sande*, she seeks a carver and commissions her mask. Humbling herself before the artist and addressing him in a respectful language, she tells him her spirit's name. Seeking supernatural guidance through sexual abstinence and away from distraction, the carver "dreams" an appropriate form for the mask being shaped under his skillful hand (D'Azevedo 1973:282,291,306,323). His work is considered successful when the spirit and its female dancer accept the mask as a living presence. Mende artists are actually in an equivocal and mediating position. In mask carving they draw on female knowledge while being excluded from the society itself; this, along with their reliance on spiritual help, and the location of their workplace between village and bush, places them in a dangerous realm (ibid.:324).

Sande maskers wear a black pajama-like garment mostly covered by long black raffia (Fig. 29); no part of the woman's body is exposed for fear of punishment by a vengeful spirit. The dancer emits no sound (and the masks themselves have closed mouths), yet the spirit "speaks" in a virtuosic language of gesture and dance which refer to moral and social doctrines: beauty, dignity, serenity, control, order, and balance. Observers also describe nonhuman zigzag movements which inspire a sense of awe and respect (Lewis 1954:160; Little 1949:210). All these dance movements exaggerate the powers of ordinary women, as the mask dramatizes the ideals of Mende feminine beauty, along with the "non-human and mysterious quality of the spirit" embodied (Phillips 1980:114).

The mask in Figure 30, surmounted by a tortoise, with its smooth, high forehead, neck ringed in fatty folds, and hair dressed in precise and intricate patterns, refers to various aspects of Mende thought. A smooth and broad forehead signifies both wisdom and success; people say that a woman's fortune may be told by looking at her forehead. While some authors have said that the ringed necks on masks represent rolls of flesh that signify wealth, good health, and fertility (Richards 1970:94–99; Hommel 1974:n.p.), Phillips' research revealed no such meanings. Rather, neck rings depict "cut-neck" that are lines, not folds; these ". . . are considered beautiful in a person

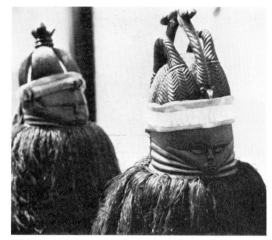

FIGURE 29. Two *Sande* maskers; Sierra Leone. Photo: Tom Seligman, 1970s.

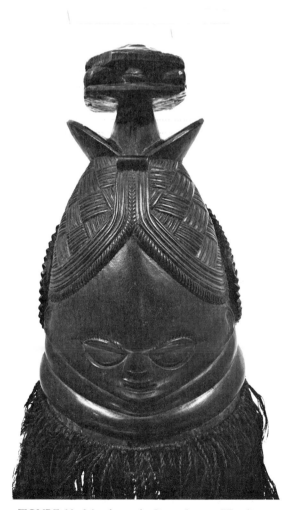

FIGURE 30. Mende mask; Sierra Leone. Wood, pigment, 38.1 cm. UCLA MCH X65-4779, gift of the Wellcome Trust.

FIGURE 31. Vai-Mende mask; Sierra Leone. Wood, pigment, 41.9 cm. UCLA MCH X65–4778, gift of the Wellcome Trust.

FIGURE 32. Mende mask; Sierra Leone. Wood, raffia, 42 cm. UCLA MCH X64–76, gift of W. Thomas Davis.

and therefore add beauty to the mask" (Phillips 1980:115). The geometric, "woven" designs of this and other mask hairstyles reflect balance and harmony found in ideal domestic households and seen in mats and textiles. They allude also to the orderly control that characterizes the demeanor of *Sande* officials. Mende women with undressed hair are considered immoral or mentally disordered. These symbolic references, taken together, become a microcosm of feminine values, those associated with domestic productivity and harmony, as well as the "cool" orderliness of village life as opposed to the danger, chaos, and "heat" of the bush.

A second mask (Fig. 31), ascribed by Hommel (1974) to the Vai, shares with the first a full smooth forehead, yet further dramatizes the folds of flesh on the neck, treated here as evenly spaced parallel tubes rising up to ear level. A string of beads circles the head in back, from ear to ear; like other parts of the mask, beads refer to beauty and wealth. The hair in this example is treated simply in a few plaits, yet this part of the head is elaborated with coiled snakes and a curving central shape probably representing four large horns with seven small horns attached. Horns are considered repositories of their animal-owners' powers (whether bushcows, sheep, goats, or antelopes). Here, as elsewhere in Africa, horns signify the protection provided by medicinal materials contained within, and thus they also refer to the horn-amulets worn by *Sande* initiates for security (Phillips 1980: 119,120). Phillips points out that such charms (prepared by native doctors) are not actually worn in the hair; their carved presence on masks thus emphasizes the invulnerability sought by the masked spirit. The size and number of protective amulets (here doubled) also allude to their cost (in this case high) and thus to the high status of the wearer/masker (ibid.:119,120). Coiled snakes on the sides of the head perhaps represent a *Sande* spirit that lives in a river, as many are believed to do (ibid.:123).

Both masks are fine examples of the genre, though quite different in conception. The first (Fig. 30) is quiet, subtle, and intricate, while the second (Fig. 31) is bold, strong, and more angular.

A third *Sande* mask (Fig. 32) shares many of the features already mentioned, yet, and in place of an elaborate coiffure, is surmounted by four small crowned heads above which projects a miniature umbrella. These features are references to chiefly authority and may indicate that the mask was dedicated to a chief or was commissioned for or by a member of his family. Like the other masks, this one has a closed mouth and downcast eyes. As the new women emerge from their *Sande* initiation, they are silent, serious, and demure, like the masks that idealize them. These features and the intense blackness of the mask and costume again also suggest the nonhuman, mysterious nature of the spirit inhabiting the mask (Holsoe 1980:103; Phillips 1980:114,115,122). The glistening black surfaces of all these masks also refer to "wetness," yet another allusion to the watery world of *Sande* spirits and the ancestral spirits that they at least indirectly represent (Phillips 1980:114).

Poro

We include two distinctly nonfeminine masks in this chapter to serve as a foil and a reminder of the great importance Mende and neighboring peoples also place on *Poro*, the male counterpart of

Sande. Regrettably we have no specific information on these masks, although both have enlarged and quite unrefined features, in one case humanoid (Fig. 33), and in the other, those of a snouted animal (Fig. 34). Possibly these masks were largely secular and belonged to households (not *Poro*) with male and female members and were danced by men primarily in entertaining displays (Siegmann and Perani 1980:25). Alternatively they may be *Gongoli* masks, which serve "as a vehicle for the ritualized reduction of social tensions through social commentary and criticism" (Siegmann and Perani 1980:32). *Gongoli* masks typically have exaggerated and often distorted features. These maskers appear at funerals mocking their solemnity and providing amusing entertainment. On other occasions *Gongoli* satirizes and ridicules chiefs and elders, his mask and anonymity giving license for commentary that normally remains unspoken (ibid.).

The fact that both masks have undyed raffia costumes, however, suggests their *Poro* origin and their association with the bush as opposed to the wet, black, watery world alluded to in *Sande* (Phillips 1980:114). Without field data or published examples for comparison, the characters represented cannot be identified, and their attribution to the Mende is only tentative. If they were *Poro* spirits, they could have had important roles in social control and in the socialization of youths during initiations.

FIGURE 33. Mende(?) mask; Sierra Leone(?). Wood, pigment, raffia, 51 cm. UCLA MCH X83–257, anonymous gift.

FIGURE 34. Mende(?) mask; Sierra Leone(?). Wood, pigment, raffia. 50.8 cm. UCLA MCH X80–696.

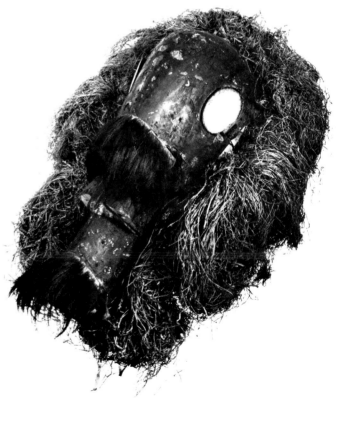

Dan and We

Jennifer Haley

The Dan are a farming people inhabiting forested regions of north-western Ivory Coast and northeastern Liberia. They are a Mande-speaking group numbering approximately 350,000. Culturally and artistically related to the linguistically distinct We (Gere)[19] farther to the south, the Dan traditionally had no strong political unity; until the beginning of this century each village was economically and politically independent. Constantly waging wars and staging slave raids against one another, the Dan and We peoples had no uniform monetary system nor steady trade between villages. Neither group had a single strong institution. The politically unifying institution of the Dan leopard society, *go*, only arose at the end of the nineteenth century (Fischer 1978:16). In this unstable situation, villages united around strong personalities, usually heads of clans, who were successful military leaders and farmers. With no royal family or unifying political institution in control, any strong leader with followers could establish a new village (ibid.).

Dan and We thus placed great emphasis upon the individual. It was vital for a leader to gain and maintain prestige within the village, to impress his peers, and to have *tin*, a concept embracing "success, reputation, being important, having a good name" (Fischer 1978:16). One could acquire such prestige by carrying out perfectly a "master role" (such as warrior, artisan, female potter, mask dancer), by extraordinary deeds (changing to an animal, creating new songs through dreams, committing atrocities), or most notably, by distributing wealth in the village by means of presents or staging lavish feasts (ibid.). The latter was, and remains, the most enviable way of acquiring prestige; only a "rich man" (*boumä*) could afford this gesture. Although no longer warring or able to found new communities at will, Dan and We men and women still compete for high status by giving expensive entertainments and staging feasts.

Dan and We arts reinforce the ideal of individual prestige. Art objects are signs of wealth and importance to be displayed before envious admirers. The "most hospitable woman," *wunkirle*, of every Dan and We village owns a large carved wooden ladle, its handle often shaped into a generalized portrait of its owner. During feasts women compete in acts of generosity, dancing through the village and showering people around them with peanuts, rice, candy, and sometimes even money (Siegmann in Vogel 1981:70). Dan wooden figures, unlike most African figural sculptures, do not represent spirits or ancestors but are *portraits* of favorite wives commissioned by rich men.[20] Again these are prestige objects; in the past the owner had to provide a feast for the whole community to celebrate completion of the carving (Fischer in Vogel 1981:70–73). The most important form of Dan/We visual art is the mask. Masks crystalize the Dan world view, representing cultural values and acting as agents of social control.

Dan and We people perceive the world as strictly divided between two realms: the *village*, which includes women, domestic animals,

and man-made objects, and the *forest* (or bush), which harbors spirits, wild animals, all raw materials, and as-yet-uncleared fields. The boys' initiation and circumcision camp is also situated in the bush. To cross between the two spheres is dangerous, as is the passage from boyhood to manhood. Powerful spirits inhabiting the forest own all of earth and nature, and a bit of bush must remain uncut near villages or else spirits will flee to the mountains; they are kept nearby because it is only through them that the descendants of village founders receive their authority (Fischer 1978:18).

These spirits originally have no corporeal form; if they are to participate in village life, a physical body must be made for them. Some spirits wish to aid, teach, and entertain humans, and so appear to people in dreams and ask for a body. These bodies may take the form of shells, fur, or horns filled with medicine, a power object ("fetish"), or if the spirit wishes to be particularly active and mobile, a mask (Fischer 1978:18). Thus a spirit may be introduced into the human sphere only by human intervention. The power object or mask is a handmade artifact and therefore legitimately belongs in the village realm. These helpful spirits demand regular sacrifices of kola nuts or blood in return for their aid.

Dan/We masks, as spirit-bodies, are believed to be alive. As Fischer points out, all masked manifestations are named *gä* in the north and *glo* or *gle* in the south, "words which approximately mean 'awesome being' " (1978:19). The same word, *gle*, is used for corpses, *gle gbe*, and ancestors, *gle gbo* (ibid.).

In general terms all Dan masks may be divided into two groups, feminine and masculine, although only men may dance masks. The feminine types (*gle mu*) have oval faces, slit eyes, and a calm, abstract beauty. They act gently and harmlessly; some sing and pantomime. These maskers may be approached by women and are associated with the boys' initiation and circumcision camps (Thompson 1974: 159–161; Fischer 1978:19). Masculine masks (*gle gon*) are carved in bolder styles, with jutting angles and protruding tubular eyes, or with eyes hidden beneath a huge overhanging brow. Male maskers are active, aggressive, and violent; they are associated with war, entertainment, and judgment (Thompson 1974:161; Fischer 1978:19). All large zoomorphic masks are considered male. Many masks fall between these "classic" male and female types, sharing elements of both.

Every Dan/We masked spirit wears a costume constructed of materials from both the forest and the village: large raffia skirts and other bush elements such as feathers and fur, as well as a woven shoulder cloth that expresses the spirit's village affiliation. Masks seldom speak the Dan language; they have followers who interpret their inhuman growls and twitterings or the foreign language they utter (Fischer 1978:19).

Fischer and Himmelheber have identified eleven major mask categories in ascending hierarchical ranks of power ranging from gentle feminine masks associated with the initiation camps to extremely weighty, judging mask spirits, *Glewa*, that control ceremonies and adjudicate matters outside modern law. *Glewa* appear rarely today; in the past they made peace between warring villages (1976: 10–11; Fischer 1978:21–23).

These hierarchical divisions of style and function, however, are not unalterable, for as a mask gains greater respect and age, it may

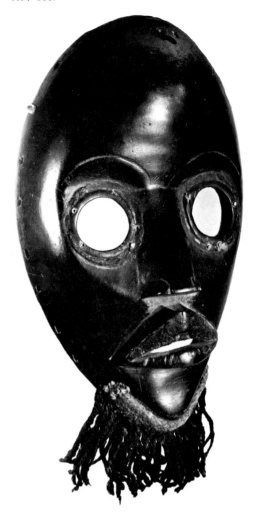

FIGURE 35. Northern Dan female mask; Liberia. Wood, cloth, yarn, brads, 23 cm. UCLA MCH X64–111.

be raised to a more powerful position. An initiation or entertainment mask, for example, may become the judge and peacemaker for its village section. The costumes and headdresses of these masks are then appropriately elaborated to fit the new character. This idea of aggrandizing individual masks in the ranks of power ultimately ties in with the high value accorded prestige (*tin*) in Dan/We culture; even relatively minor masks may gain enough respect and reverence to hold judicial, peacemaking, and controlling powers over an entire region and become *Glewa* (Fischer 1978:19–21).

Female masks recall beautiful women and are carved to represent ideals of classic feminine beauty. The mask in Figure 35 exhibits most of the elements of Dan female masks—high forehead, slender nose, and full, voluptuous lips set in a calm, slightly pointed, oval face. The planes of the face are smooth and gentle with no abrupt transitions or harsh angles evident, and the wood surface is polished to a shining finish. Above all, Dan aesthetics require that the beautiful female face and mask be strongly symmetrical (Fischer and Himmelheber 1976:31).

Unlike the prototypical Dan female mask type with slit or almond eyes, this example has large, round eyeholes that protrude slightly. Metal brad heads are placed around the rims of the eyes, a black yarn beard knotted on a fabric base is attached to the chin, a small spike projects from the top center of the forehead, and traces of red fabric may be seen around the lips. The remains of red fabric and the slightly protruding eyes may indicate that the mask was originally used by a fire-extinguishing spirit (*zakpäi gä*). These maskers protect the village against the threat of fire during the dry season by seeing that women put out cooking fires before noon (Fischer 1978:21). Although the form of fire-extinguishing masks may incorporate many female elements, the masker is intended to be male. The character is clothed in a cloth pantsuit, tall green leaves surmount the head instead of the typical female conical cap, and he wears raffia around his neck and waist (Fischer 1978:21). Behavior is aggressive—the masker usually carries a branch with which to beat women who have left fires burning.

Alternatively, this mask (Fig. 35) may represent a "house" mask-spirit (*gunyegä*). This category of mask exhibits large, round eyeholes, is usually painted black or red, and sometimes has a beard (Fischer 1978:21). The dancer wears a pantsuit covering his body and a small raffia skirt around the waist with a handkerchief over the head. The mask is worn in competitive races held every week during the winter. Masqueraders are challenged by nonmasked young men, and they race over an obstacle course through the village (Fischer 1978:21).

Like Dan examples, We male masks (Fig. 36) act in an aggressive, energetic, and sometimes violent and destructive manner. Strikingly different from the calm, abstract, and refined beauty of typical feminine masks, males obviously partake of the fearsome aspects of the bush in their strongly carved surfaces and vigorously projecting forms. Although We male masks sometimes serve as simple entertainment masks, they often have very important social and political powers (Ezra in Vogel 1981:70). Male dancers wear full raffia skirts and wigs or plumed headdresses; some Dan maskers carry hooked sticks which they swing around and use to pull people towards them in order to administer a beating (Fischer 1978:22). Some male masks are associated particularly with war. For example, the Dan "chim-

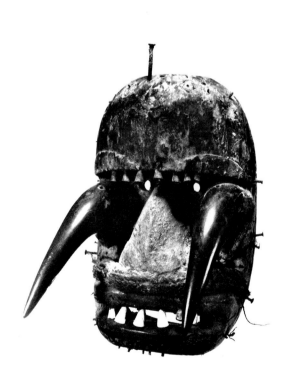

FIGURE 36. We (Gere) male mask; Liberia. Wood, horns, nails, pigment, fiber, teeth, skin, hair, 31.8 cm. UCLA MCH X78–125, anonymous gift.

51

panzee" spirits (*kaogle*) were originally intended to spur young men to war, and the Dan "gun maskers" (*bugle*) were spirits who blessed warriors and occasionally led them into battle (Fischer 1978:22) As in the Dan masking hierarchy, lower ranked We masks may move up to new roles. With greater age and respect, an entertainment mask may rise to the position of village judge or section leader, and many war masks have been promoted to judging masks (Fischer 1978: 13,94).

The aggressive bush nature of this mask (Fig. 36) is easily seen. The hemispherical forehead overshadows tiny eyeholes barely noticeable next to the large animal horns attached to the sides of the face, and a tremendous trapezoidal nose rests above a mouth that gapes across the entire width of the mask. Violent projections of many different materials are incorporated; animal horns curve downward above the mouth which has five large animal teeth inserted into open jaws. Cylindrical wooden shapes extend from beneath the forehead, and metal nails, whole and rusted away, surround the face spiking outwards. An ochre pigment is visible on the top of the forehead and nose and around the base of the horns.

Like the previous example, Figure 37 is a male We mask with strong, threatening features. The narrow jaw protrudes muzzle-like with real animal teeth inserted in upper and lower jaws. Rounded nostrils are indicated by metal appliqué. This may have had a less violent role than the previous example, but such an interpretation is impossible without field data; still, the projecting forehead is more gently rounded and is topped with a cowrie-decorated crest with dangling appendages of hide and fabric which also have attached cowries. Similar appendages are sometimes seen on Dan masks with feminine features, and a powerful rank may be indicated by a multitude of cowries, symbols of wealth. The leather and fabric ornaments may contain medicines designed to crystalize and augment the power of the spirit entering the village through the medium of the mask. Individual powers and personalities of We masks are distinguished by the addition of horns, animal teeth, and leather talismans, all objects of power that portray the unique identity and abilities of the spirit represented (Siegmann and Schmidt 1977:2).

Miniature masks are found among the Dan, We, Mano, and Bassa (Fig. 38) but serve different functions in each group. Among the Dan and Mano, they are owned by every man who controls and performs a full-sized spirit mask (Siegmann and Schmidt 1977:30). The spirit that manifests itself in the larger mask may be contacted through the miniature representing it (Fischer and Himmelheber 1976:139). Maskettes are used for substitute sacrifices honoring the spirit of the larger mask; if its owner violates a masking law, chicken blood is sprinkled on the miniature to appease the offended spirit (Tabmen in Thompson 1974:160). Small masks are also used for identification, validating the owner's right to use the larger counterpart. The owner carries the miniature in a special pouch. It is produced if he is challenged about his right to participate in meetings in the sacred grove and in decisions regarding masking activities (Tabmen in Thompson 1974:160).

Among the Dan, miniature masks may also be kept by male children of a large mask's owner and also, according to Fischer and Himmelheber, by daughters of the family protected by the helping spirit (1976:139). This link to larger masks is apparent in the Dan

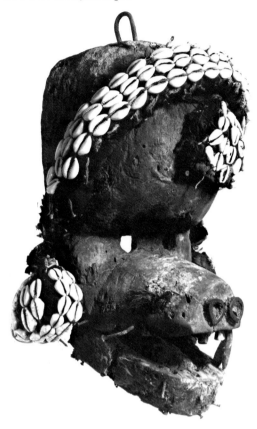

FIGURE 37. We (Gere) male mask; Liberia. Wood, shells, nails, teeth, fiber, 31.8 cm. UCLA MCH X78–109, anonymous gift.

term for miniatures: "raffia dress heads" (*maa go*), a term suggesting both the costumes of the larger masks and the forest origin of the spirits which activate them (Thompson 1974:160).

Among the Bassa (Fig. 38), two types of maskettes are used. Unlike those of the Dan, Bassa personal mask miniatures do not usually duplicate larger versions but are thought of as highly stylized portraits (Siegmann and Schmidt 1977:30). Some maskettes *are* meant as miniatures of full-sized masks, but these serve as substitutes for larger masks that have been accidentally destroyed (Siegmann and Schmidt 1977:30).

FIGURE 38. Bassa maskettes; Liberia. Left: Wood, 7.9 cm. UCLA MCH X76–1833, gift of Mrs. W. T. Davis in memory of W. Thomas Davis. Right: Wood, 9.5 cm. UCLA MCH X73–637, gift of W. T. Davis.

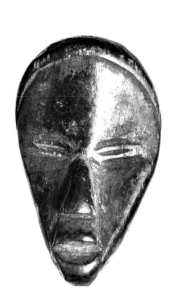
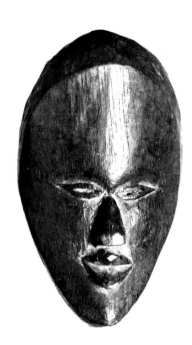

Baule

Elizabeth Evanoff

Baule peoples inhabit a part of east central Ivory Coast that marks the transition between forest and savanna. Like their environment, their world view is characterized by duality, receptivity to change, and a passage from one state of being to another. The Baule are descendants of Akan and Guro groups that settled in this region in the eighteenth century. A loose social structure, strategic marriages, and the establishment of fictitious kinship relations account for the relatively quick consolidation of Baule populations and their sharing of assimilated religious values. A basic aversion to rigid social structures results in the absence of formal political and instructional institutions common to many African cultures, such as initiation, kingship, and men's associations. Baule political systems are democratic; each village operates independently, with elders holding important decision-making roles. Dependent upon an agricultural economy (millet, cotton, and palm oil) and trade (gold and salt), the Baule population has thrived and was estimated to be over one million in 1900 (Vogel 1977:17,24,25,32).

Religious values are based upon the dualities of life—e.g., bush/village, male/female, and the invisible/visible worlds—and how the opposites conflict and interrelate with one another. The primary spirits are an intangible creator god, *Nyamien*; the earth god, *Asie*, who controls all animals and humans; and a class of personified supernatural powers, the *Amuen*. The real or human world is the opposite of the spirit or *blolo* world from which new souls arrive at birth and to which ancestral spirits return at death (Vogel 1977:42–52).

An understanding of the Baule world view is essential to an appreciation of their artistic traditions. Wood sculptures and masks are the most vital art forms, for the Baule believe they provide man the closest contact with powerful spirits (Vogel 1977:vi). Figural carvings are owned by individuals who commission them on the advice of a diviner. Figures represent either nature spirits or the spouses all people have in the spirit world (Vogel 1973). Baule artists are allowed a great deal of creative freedom, and as a result, carving styles are inventive, somewhat random, and without regional distinctions. Aside from figural carvings and masks, the Baule carve ancestor stools, staffs, flywhisks, and other prestige objects. They also cast brass goldweights similar to the better-known Akan weights from Ghana. Stools are kept in shrines and receive sacrifice in honor of ancestors. Gold jewelry and wooden gold-leafed objects are displayed by "big men" during funerals to honor the collective dead while serving as status symbols of their owners.

The Baule have three masking traditions: *Gba Gba*, *Bonu Amuen*, and *Goli*. Interpretations of these masquerades range from literal moral lessons to esoteric truths and are strongly tied to the Baule world view. All masking ceremonies make statements about the perceived dualities of life, yet at the same time show that these opposites are not necessarily mutually exclusive. While the three tradi-

tions vary greatly in terms of form and function, certain aspects remain consistent:

1. Masks are never carved to represent ancestors.
2. Mask and masquerader are viewed as an inseparable unit.
3. Maskers come out in order of ascending importance.
4. Masks are danced only by males.

Gba Gba

Gba Gba, the first tradition assimilated by the Baule, came originally from the Guro. A simplified naturalism and attention to detail in *Gba Gba* carvings are thought to be the stylistic basis for all Baule art. This masquerade is performed at women's funerals, during the harvest season, for important guests, and occasionally on days of rest. Masks appear in sequence from domestic animals (Fig. 39) to bush animals and, lastly, human characters (Fig. 40) in a set series of skits. *Gba Gba* thus represents a microcosm of the real world, and each skit presents a moral lesson to the audience. A human portrait mask, *N'doma*, is commissioned by an individual in admiration of a fellow villager, most often a female. Carvers are required to obtain the permission of their subject, however, prior to creating the likeness. When *N'doma* is danced, the subject must be present. *Gba Gba* masks are stored in the village and their raffia costumes are made from bush materials; the opposites of bush and village are thus combined. The entire village may view the flowing dances of *Gba Gba* which are accompanied by drums, wooden clappers, and iron gongs (Pl. 3). Dancers must observe sexual abstinence before performing. *Gba Gba* offers an image of a hierarchical world wherein beauty and age are honored, for masks representing these appear last in the sequence (Vogel 1977:102–103). The masks in Figures 39 and 40 are almost certainly of the *Gba Gba* category, the first a goat or sheep with large human features, the second a distinctly human character, possibly a portrait or set, recurring character such as twin, slave, foreign woman, or even the sun or moon (pc:Vogel 1984). Both have refined, delicate features, the first characteristically Baule, the second possibly Yaure. (Notably, if Figure 40 *is* Yaure, its dance context would have been very different from the Baule one, for such masks among the former are secret, sacred, and their viewing is forbidden to women; pc:Vogel 1984).

Bonu Amuen

Bonu Amuen, the second masking tradition adopted by the Baule, originated with the Wan. These masquerades serve to protect the village from external threats, to discipline women, and to commemorate the deaths of important men. *Bonu Amuen* are bush spirits that take material form in shrines and masks activated by blood sacrifice. Masks and costumes are stored in a bush sanctuary located on the outskirts of the village. Costumes consist of a raffia body covering, iron anklets, and a wooden helmet mask representing either a buffalo (Fig. 41) or antelope. These masks are characterized by a squared-off muzzle full of teeth, a form which is consistent with its function, as it is intended to project the ideal of a ferocious defender. Dancing involves wild, erratic stamping motions and is ac-

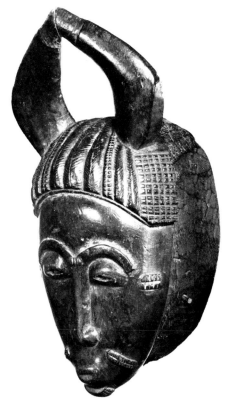

FIGURE 39. Baule face mask with horns; Ivory Coast. Wood, 32.5 cm. Anonymous loan.

FIGURE 40. Baule or Yaure face mask; Ivory Coast. Wood, 28.3 cm.

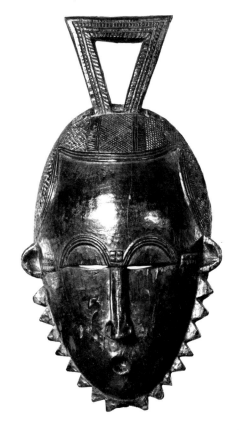

companied by a men's chorus and the playing of calabash rattles and iron gongs. Certain restrictions are strongly enforced in the ceremony: dancers must abstain from sexual intercourse, and women are forbidden to view the masks.

The *Bonu Amuen* mask in Figure 41 belongs to *Dye*, one of the oldest and most widespread of Baule masquerades. Characteristic features of this stylized buffalo mask include a nose with flared nostrils; joined horns; pink, white, and black concentric oval eyes; and an inset pink mouth with spiky teeth projecting *Dye* ideals of ferocity and aggression. The costume comprises a raffia body covering, iron anklets, and bells. His head completely enclosed by the helmet structure of the mask, the dancer is left in almost complete darkness. He views the world through an open mouth, rimmed with sharp teeth at the end of a long muzzle. In the performance, the masker takes on the spirit of the bush, which along with this altered perspective, enables him to feel the power and strength which *Bonu Amuen* represent to the Baule.

The sequence of *Dye* dances functions as a protective, disciplinary, and honorary medium for the Baule. Aside from *Dye*, there are several other bush spirit masquerades. The *Bowita* mask functions as a guardian of village morality, while his spirit wife, *Do*, is represented by the beating of a drum. Elephant and hyena helmet masks are involved in disciplining crowds at festivals. Women are allowed to participate in only one ceremony, the *Kloro*, when they sing before a performance to "warm the dance place," that is, to prepare for the main actors.

Dye performances include six masks (at times fewer), each having its own distinctive character. These appear one at a time, announced by a horn warning women of the village to retire to their homes. Women are forbidden under penalty of death to view any bush spirit masks. Baule legend attributes the discovery of masks to women who lost the secrets of masking by being foolish and weak; therefore they must now be doubly cautious. The first mask to appear is the rainbow mask which dances about, whipping the crowd and performing the magic feat of making itself tall, like a rainbow. The three masks that follow have unclear significance and order of appearance. *Kouassi Fli* enters, menacing the crowd by throwing hunting lances at them. This mask has the power to kill domestic animals and exact fines from the audience. Mister Tomorrow (*Misie*) brings a moment of comic relief, not by dancing but by talking to and mocking the crowd. Though beautiful, *Dyoha*, the senior male mask, is well known for his ferocious potential. *Akplowa Ngoie* is the last of the series. This dancer carries branches of leaves which signify honor and beauty. The name translates to "the discussion of this contestation is over" (Vogel 1977:82), indicating the mask's seniority over all other *Bonu Amuen*. The entire *Dye* performance is dramatized by wild dancing, magical feats, and a testing of wills between audience, which is continually provoked, and masked dancers.

Although form and color are variable, the squared-off, toothed muzzle is a traditionally consistent feature of *Dye* masks (Fig. 41). A hierarchy of sizes exists, and there is a correlation between the ferocity of the mask and the number of horns it has. Masks carved more recently tend to be smaller in size and are characterized by fussy details and attached elements. Older masks, like our example, which is of particularly fine quality, exhibit a bolder structure with fewer

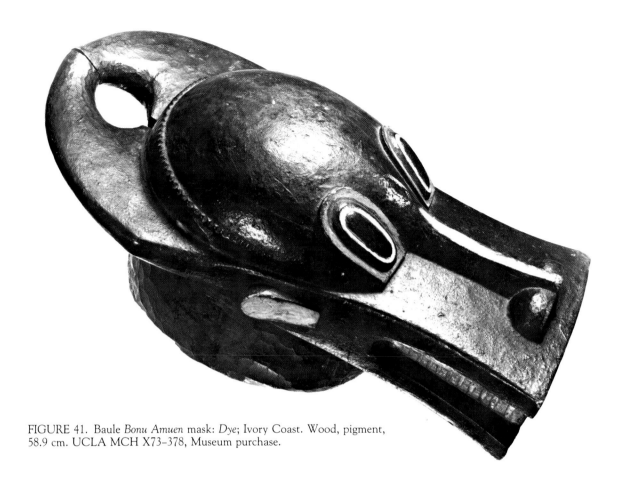

FIGURE 41. Baule *Bonu Amuen* mask: *Dye*; Ivory Coast. Wood, pigment, 58.9 cm. UCLA MCH X73–378, Museum purchase.

FIGURE 42. Wan *Goli* mask (similar in form to the Baule junior male mask, *Kple Kple*); Ivory Coast. Wood, 101.6 cm. UCLA MCH X67–2021, gift of George G. Frelinghuysen.

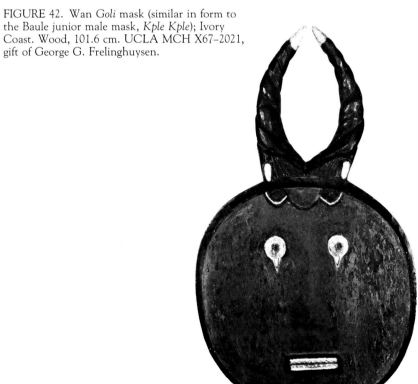

details and are carved from a single piece of wood.

Dye provides Baule men with an escape from the routines of daily life. In addition, the appropriation of fines serves to redistribute wealth in the community. Masked spirits of the bush penetrate the boundaries of the village and violate the separation of bush from village and male from female, demonstrating that nothing is completely good or evil, wild or civilized. *Dye*'s contrasting counterpart is the female spirit ceremony from which men are completely excluded. *Dye* dramatizes the male/female dichotomy and helps to preserve and uphold the important cosmological ideal of duality (Vogel 1977:71–101).

Goli

Like *Bonu Amuen*, the *Goli* ceremony was adopted from the Wan, but not until about 1900. *Goli* festivals occur on the same occasions as the *Gba Gba* yet serve purely as entertainment. Assimilated by the Baule at a period of social stress, *Goli* provided a sense of peace and cohesiveness for Baule villages. *Goli* is a festival which the Baule describe as being sweet, beautiful, and joyous. It is a day-long event in which the entire village participates with song, dance, and palm wine. Masks are danced in four sets of pairs beginning with *Kple Kple*, a horned, disc-faced mask representing junior males (Fig. 42).[21] Next appears *Goli Gulin*, an animal helmet mask symbolizing senior men. Horned junior female masks with human faces, *Kpan Pre*, follow. The last and most honored mask type is the senior female pair, *Kpan*, characterized by a detailed crested hairstyle (Fig. 43). Costumes are made from various bush materials such as raffia and animal hides, yet include scarves and other cloths from the village realm. Dances range from wild stomping to graceful flowing movements and are accompanied by calabash rattles and, in the case of *Goli Gulin*, side-blown antelope horns. The entire village may witness this popular spectacle.

Kple Kple is the first of four pairs to appear and is considered the least beautiful and prestigious. *Kple Kple* is characterized by its simple form, a flat disc face with curving horns, features in low relief, and projecting eyes (Fig. 42). Its dance consists of rapid and erratic stamping motions. *Kpan* is the last of the series to appear and is considered the most beautiful and prestigious masquerade, with a slow and rhythmic dance. In Baule relief, the last place is the place of honor, and it reiterates the importance of females and their supremacy in the spirit world. Like other *Kpan* masks, this (Fig. 43) has a typical crested hairdo and bulging eyes, but since it is smaller than most *Kpan*, it may have had a different function. It is also a good example of a characteristic Baule convention, a heart-shaped face enclosed within a continuation of the eyebrows.

Junior male masks alternate when dancing, the red mask performing first, followed by the black. Each dancer wears an animal hide on his back which he strikes with a long bent stick at the end of his turn. The entrance and exit of the senior female pair are highly dramatic. Certain taboos are associated with *Kpan* such as not being exposed to water and not appearing until dusk. *Kpan* dancers hold flywhisks associated with elderhood and wisdom. Leopard skins on the dancers' backs are symbols of high rank and honor. The senior female masks are painted red because it is considered the most beautiful and masculine color and therefore serves to counterbalance

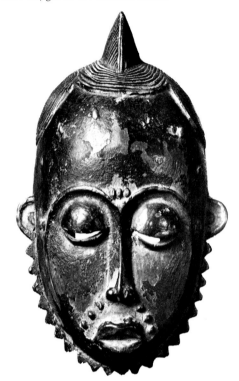

FIGURE 43. Baule *Goli* mask: Senior female, *Kpan*(?); Ivory Coast. Wood, 18 cm. UCLA MCH X64–85, gift of W. Thomas Davis.

the otherwise overwhelmingly feminine quality of *Kpan*. Instead of dancing in alternate turns, like other *Goli* mask pairs, both *Kpan* may dance simultaneously. All *Goli* masks are accompanied by attendants who keep them from falling; this could be fatal to the masker unless certain sacrifices are made. Several hours preparation are required for each performance; repairs must be made to the costumes, and shea butter is applied to the masks to freshen their colors. Such preparations take place in seclusion. It is thought that if women were to see the dance accoutrements out of context or to touch the masks at any time, they would become sterile.

Goli masks lack holes along the edge typically used by the Baule to attach the costume and support the mask. Instead, a raffia cape is attached to the mask by winding a raffia cord around a special flange or collar behind the face. Often these masks also have a bite-piece which helps the masker steady the weight of the costume.

As mentioned above, *Goli* was adopted from the Wan, a people known for powerful medicines and fetishes. All songs are sung in the Wan language, though it is unintelligible to the Baule. The Wan *Goli* festival is an extended funeral rite lasting several days. Among the Baule, it has been transformed into a one-day affair, which more often than not has nothing to do with commemorating the dead. The Baule also abandoned the religious and clan associations of the masks as they have no indigenous institutions of this kind. The most radical and Bauleizing alteration was the doubling of single personae into male and female pairs. The relationship of the pair is described as that of a married couple. Beyond this, there is a blurred sexual distinction, with elements of both sexes in each mask, implying a kind of bisexuality.

On the simplest level, *Goli* is a hierarchical model of nature and human society. The structure of the dance also alludes to the hierarchical structure that quickly developed around colonial rule which was being established at the time *Goli* was assimilated by the Baule. The dances then served to demystify something new and threatening to these peoples. Not being of Baule origin, *Goli* crosses categories and permits men and women to participate in an event that strict adherence to the Baule system would not permit. *Goli* nevertheless reiterates and embellishes Baule world view (Vogel 1977:124–151).

Baule world view reflects their origins, environment, and individualism. Masking traditions, in their turn, strongly reiterate Baule cosmological idealogies. Paradoxically the Baule, known for flexibility and the adaptation of "foreign" traditions (e.g., *Goli*), display undaunted consistency in preserving their values and expressing them artistically.

Yoruba

Debbie Randolph

Located in southwestern Nigeria and neighboring the Edo (or Bini) to the east, the 12,000,000 Yoruba comprise one of the largest language groups in Africa and are the most prolific art producers on the continent (Bascom 1973:85). The Yoruba are divided into about twenty subgroups loosely united by a common language, history, and culture.

The Yoruba depend on a root-crop economy (yam and cassava) and are unique in their preference for and extent of urbanization. This patrilineal people created city-states perhaps as early as the eleventh century (Nelson 1982:5), and the ancient city of Ife remains their spiritual capital. City-states are governed by divine kings, *oba*, whose power is balanced by that of a cult/council of selected leaders called *Ogboni* or *Oshugbo*. As a divine monarch, an *oba*, with various cult priests, acts as mediator between men and gods, *orisha* (Fagg and Pemberton 1982:19).

Yoruba art embraces many media: wood, terracotta, cloth, bronze-brass, beadwork, clay, and iron. Most forms are sacred and bound by conventions established by tradition and cult practices (Fagg and Pemberton 1982:13). Men produce most art with the exception of pottery, dyed cloth, and some weaving, yet women play cooperative and often important roles with respect to art.

Art permeates Yoruba life—from the king down to the ordinary domestic household. The royal arts form bonds between various subgroups while symbolizing the relationship between the divine king and the gods. Most common is beaded regalia, including crowns, staffs, scepters, and slippers (Thompson 1971:8/11). Palaces have finely carved doors and verandah posts often depicting equestrian and mother-and-child images. The arts associated with *Ogboni* are elaborately decorated wooden drums, carved posts, and paired bronze figures, *edan ogboni* (Berns 1979:14).

Visual arts at the domestic level include carved wooden stools, doors, and panels found in the houses of the wealthy. Important family-related art objects are twin or *ibeji* figures, which are universal throughout Yorubaland. Twin births are very common; when a twin dies a figure is carved to honor him/her and to receive his/her vital spirit (Berns 1979:14).

On a different level are cult arts of the approachable deities, *orisha*, which include a variety of forms: masks, staffs, bowls, and statues. Four widely distributed Yoruba cults are those of *Ifa* (divination), *Eshu/Elegba* (trickster), *Ogun* (iron and war), and *Shango* (lightning and thunder).

The major purposes of Yoruba art are to provide for the welfare of the people through ritual, show respect for history, and honor the large pantheon of gods. Ritual performance is the means to display power as is well illustrated in the three major Yoruba masking traditions: *Egungun*, *Efe/Gelede*, and *Epa/Elefon*.

Egungun

The most complex and diverse Yoruba masquerade is *Egungun*; its ritual and theater exist primarily to honor the ancestors. *Egungun* festivals are celebrated by all Yoruba subgroups, but in keeping with local autonomy, each performs it differently. Masqueraders are usually completely covered by costume, thus the manipulation of cloth is key in the unfolding of an *Egungun* dance. Themes are satirical as well as symbolic and honor ancestors by continuing their traditions and maintaining the reputation of the masquerader's lineage (Drewal 1978:18).

The series of performances at an *Egungun* festival begins with an entrance song and invocation. Acrobatic displays and dances alluding to the gods follow and introduce the dance theater which includes satirical sketches and scenes from myths of gods and ancestors. The finale and recessional follow (Drewal 1975:51).

Panels of cloth enclose the masquerader and the ancestral force, and some *Egungun* are comprised entirely of rich, layered cloths, both locally woven and imported, and often with varied geometric appliqué panels (Figs. 44,45). This costume, probably from Oyo, is the *Paka* type and more than likely had associations with royalty (cf. Houlberg 1978:fig. 2). Cloth is manipulated through the dance to portray the glory of a lineage. Masks, wooden headdresses, and other media are often combined with cloth to refer to the power of the entire assemblage (Drewal 1980:48,77).

One group of characters in the *Egungun* ceremony is the *idan*. *Idan* are references to animals, spirits and gods, worshipers, and social stereotypes. Stereotypes include Yoruba undesirables (e.g., prostitutes and drunks) and non-Yoruba peoples. Using *alujo* dance rhythms as the foundation of the dance, *idan* masqueraders perform in accordance with their individual characters. Animal *idan* come alive through movable parts on the costume. Representations of the gods and spirits float and undulate, creating a sense of the otherworld. Satirical *idan*, of which Figure 46 is an example, establish their character by mocking the familiar (Drewal and Drewal 1978:34). This mask, Oyo-related and from northern Yorubaland, represents a "stranger,"a non-Yoruba, possibly a Bariba or Nupe person. The two boils under the eyes and the gouging teeth, however, may refer to a Dahomean warrior. This popular character (*Egun Idahomi*) was a development from nineteenth-century warfare with the Dahomey kingdom (pc:H. Drewal 1983).

All masks and other visual forms associated with this cult contain imagery evocative of male supremacy (Drewal 1974:10), and the elder *Egungun* characters were responsible for killing witches. *Egungun layewu*, masks of the hunters (Fig. 47), form a subgroup of elder *Egungun*. They appear at festivals for *Ogun*, also the deity of hunters, and on other occasions. The masquerade is celebrated by a chief of hunters, his family, and those allied with him in the hunt (Fagg and Pemberton 1982:104).

To protect and strengthen the hunter, medicines are inserted into the skin, marked on headdresses by a large tuft of hair hanging to the left covering the incisions (Drewal 1980:77). The tuft distinguishes hunter headdresses from other types and symbolizes the power concealed within it. It recalls the proverb: "Stout tuft, child with

FIGURE 44. Yoruba *Egungun* costume; Nigeria. Cloth, 165.6 cm. UCLA MCH X76–1731, gift of Mrs. W.T. Davis in memory of W. Thomas Davis.

FIGURE 45. Yoruba *Egungun* masqueraders; Oyo area, Nigeria. Photo: William Bascom, 1950s(?).

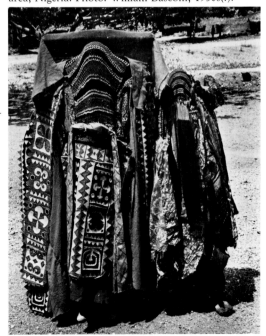

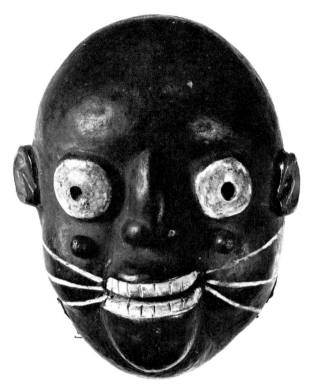

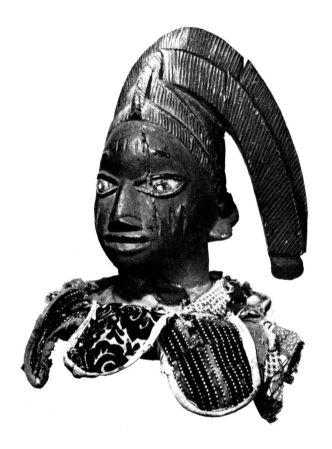

FIGURE 46. Yoruba *Egungun* mask, *idan*; Nigeria.
Wood, pigments, 26.8 cm. UCLA MCH X77–1527,
gift of J. Philip Keeve, M.D.

FIGURE 47. Yoruba *Egungun layewu* mask; Nigeria.
Wood, pigment, 38.2 cm. UCLA MCH X77–1354,
gift of Dr. and Mrs. Leonard Zivitz.

FIGURE 48. Yoruba *Gelede* mask; Nigeria. Wood,
pigment, 40.6 cm. UCLA MCH X78–1730, gift of
Lee and Dona Bronson.

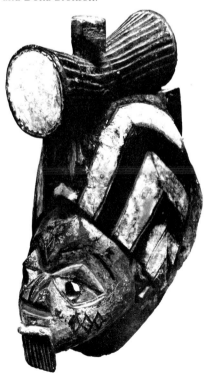

medicine on the head, whose head will be spared" (Drewal 1980:77). Scarification, a typical feature of the hunter headdress, appears here on the forehead and cheeks.

The *Egungun* headdress tops the cloth panels of the costume. Bascom suggests that those *Egungun* types without wooden headdresses or masks are the most powerful (1973:89). It would seem, however, that since the *Egungun layewu* is only danced on certain occasions that this headdress also holds a special place in the *Egungun* repertory.

Gelede

Gelede pays tribute to "the mothers," *aje*, who are believed to possess spiritual life force, *ase*, and who use this power to either benefit individuals and communities or bring them havoc (Drewal 1974:8). Appeasing "the mothers" who control fertility and the life and death of offspring is accomplished through dance, mask, costume, and poetry. Without such appeasement, "man sleeps in danger" as the witches may drain "his blood and vital essences" (Thompson 1974:200).

Gelede imagery documents social roles deemed valuable, while unworthy actions and attitudes are satirized through "anti-aesthetic" statements. The Yoruba cosmos is reinforced by hierarchical sets of masks, and the past is recalled through the commemoration of specific events and by the continuation of the masking tradition itself (Drewal 1974:18).

Speak of *aje* in a whisper lest the mothers/witches hear and not be pleased. *Aje*, "the one who has water in the house yet washes her face with blood," transforms into a bird to fly at night and sucks the blood of those that offend her. *Aje*, the witches, control the flow of semen and menstrual blood, can neutralize the effect of medicines, and prevent or terminate pregnancy (Lawal 1978:65). *Aje* are jealous of those who are too happy, too prosperous, or too beautiful. *Aje* possess an equal or greater spiritual life force, *ase*, than the gods (*orisha*) and can use this power to bring troubles or blessings to a community (Drewal 1974:13).

A positive/negative duality is apparent in these beings. In the negative, they are witches, in the positive, "the mothers." "The mothers" are regarded as calm, creative, and protective. Renown for their knowledge of herbal medicines, "the mothers" assure equality of wealth, prestige, and power (Drewal 1974:13). *Efe/Gelede* masquerades are performed out of fear of the witches and, simultaneously, respect for "the mothers."

Although a woman, *Yewejabe*, first danced *Gelede*, only men may do so today. When men follow her example and dance *Gelede*, "the mothers" are pleased, as illustrated in a second myth. *Orunmila*, visiting the haven of the *aje*, disguised himself with a mask, waist cloth, and metal anklets and thus identified himself with *Yewejabe*. He was not harmed (Lawal 1978:67).

The season of *Efe/Gelede* is roughly March to May, in anticipation of the rains. Funerals and times of civic calamity or celebration also merit the dances. The *Efe* festival takes place the night before *Gelede*, with characters reprimanding certain members of society through verse. *Gelede* begins the following afternoon in the main market. Elders, especially women, have the choice seats. The order of performances is determined by seniority; small children, older

children, and teenagers precede master dancers (Drewal and Drewal 1975:40). Dances are dictated by drum phrases mimicking tonal Yoruba speech patterns, and it is through the dancer's skillful interpretation of the drums that proverbial messages are relayed to the audience (Thompson 1974:203). *Gelede* is danced in pairs, and "the two literally become one as they exactly match the drumming" (Drewal and Drewal 1975:41).

Masquerade costumes are bulky to honor the *aje* with ideal corpulence. Female costumes emphasize buttocks and breasts, for the dances of fat women are considered more graceful. The male costume consists of a long-sleeved shirt, long gloves, stockings, and leg pads. Both incorporate metal anklets (Lawal 1978:67). Masks are worn slanting over the top of the head. The identity of the dancer is not secret—he can unmask in public and speaks in a natural voice (Lawal 1978:69).

Drewal categorizes *Gelede* masks into four groups: 1) those for role recognition 2) hierarchy 3) commemoration and 4) satire (1978:14). The first group represents those in the society who are respected, such as hunters, warriors, drummers, marketwomen, and priests. Hierarchical masks show the order of the world and, therefore, often have multiple figural compositions or motifs of animals devouring. Commemorative masks portray mythical events or personages. Satirical masks (such as the one illustrated in Figure 48) express the anti-aesthetic. This mask is from the Pobe area, and the beard is possibly a reference to a Muslim (pc:H. Drewal 1983). In a similar example, a masquerader representing a Muslim was accompanied by a parody of Islamic prayers, the drummers creating rhythmic nonsense (Lawal 1978:41). The pressure drum atop the mask head may honor a drummer's clan (pc:H. Drewal 1983).

Epa

Epa or *Elefon*[22] masquerades in northeastern Yorubaland promote the fertility and well-being of communities and are held every two years in March (Fagg and Pemberton 1982:20). These festivals incorporate processions and large Janus-helmet masks, *Epa*, supporting superstructures. Similar masks appear at *Elefon* festivals further south to celebrate the return of warriors, mark the appearance of new crops, and honor *Ogun*, the god of iron and war. The festivals suggest the attainment of higher powers of existence and the strengthening of the body through the ordeal of supporting the physical weight of the heavy mask (Thompson 1974:192).

Emerging from the forests for the festival, the *Epa* masquerader captivates the audience with his athletic agility and manipulation of a mask more than one and a half meters high and often weighing fifty pounds (Pl. 4). Spectators are immediately awed by the elaborate carving: one piece of wood, a Janus-faced head topped by a superstructure of one or several figures (Fagg and Pemberton 1982:20).

The masks are ceremonially washed and repainted in preparation for the festival commemorating certain events and personages and promoting the fertility and health of the community. Palm fronds are tied to the mask's lower edges and the masker's waist; raffia and cloth make up the bulk of the costume.

Several mask types appear during *Epa* festivals which last between three and seven days, depending on the region. The large helmet/superstructure masks, as in Plate 4, are of the greatest ritual impor-

tance. At most festivals masqueraders jump off a mound, the result of which is an omen for the coming year. Thus the masker attempts to keep his balance and not fall, which would bring misfortune to the community (Thompson 1974:191).

The entirety of an Epa mask suggests a balance between the real and other worlds. The Janus-helmet with its two grotesque faces is all-seeing, supernatural. Superstructures usually appear in several forms: equestrian/warrior figures; motifs based on *Osanyin*, the god of medicine; and mother-and-child figures. Our mask represents a mounted personage of high stature, perhaps the legendary warrior, *Jagunjagun*, but more probably a hunter/warrior, judging from the long tail of his cap. Similar tailed headdresses, however, are associated with the trickster god *Eshu*. Indeed there are several *Eshu* suggestions on this superstructure, including a small half-red, half-black asymmetrically posed "imp" who may be *Eshu* himself, plus a flute-player seen on many *Eshu* carvings (Thompson 1971:9/5). Whoever the personage is, his image radiates superiority and power. Grasping an authoritative weapon and supported by the many figures at his feet—not to mention the commanding presence of his horse—this leader, whether real or legendary, will be well-remembered whenever this mask dances.

Northern Edo

Richard Blades

Northern Edo peoples (earlier known by the pejorative term Kukuruku) live in the northern parts of Bendel state, Nigeria. Their neighbors to the west are the Yoruba, to the south, the Ishan and other Edo-speaking peoples, to the east, Igala and Igbo. Benin, to which most of these groups trace their origins, is south of Ishan territory. The Northern Edo live in villages or clusters of them and speak related but mutually unintelligible languages; our emphasis here is on the Okpella people studied extensively by Jean Borgatti (1976,1979), on whose data we rely.[23] Normally Northern Edo political authority is vested in councils of elders, and ritual authority and kinship provide further cohesion. Religious belief begins with a remote creator of all things but focuses more attention on ancestor spirits and the shrines of tutelary deities centered around natural forces (Borgatti 1979:3,4). Masquerade societies are concerned with social control, the spiritual control of witchcraft, and honoring ancestors and local deities.

Three festivals provide the major masking institutions in Okpella: *Aminague*, *Okakagbe*, and *Olimi*. The most ancient, associated with the secret *Aminague* society, features snake imagery. To Okpella people, the python symbolizes legitimate authority and the forces of the night and forest. *Aminague* is rare, and the associated society is vanishing because its powers are felt to be increasingly uncontrollable (Borgatti 1976:26). The festival was usually an annual rite designed to foster good relations with ancestral spirits. *Aminague* maskers are expected at important funerals and may be called upon by individuals or the community to confront the effects of witchcraft and disease. Each cult member has the right to own and activate an *Aminague* masked spirit. The masker appears in a woven raffia headdress with long fringe, cloth appliqué apron, and ankle rattles. He carries a switch and is accompanied by a custodian playing a flute. His polychromed mask is usually festooned with an aluminum strip (snake) with a protruding ribbon "tongue."

Okakagbe is primarily a social masking institution, not associated with cults, and is designed to provide entertainment. Its outing is a lively, joyful occasion centered on the presentation of a masking ensemble of five or six "persons," covered head-to-toe in vibrantly patterned, colorful appliqué, along with *Idu*, the mythical bush monster (Fig. 49). *Idu* has buffalo and antelope horns, peccary tusks, and a horribly expressive face modeled in gum over a basketry or wooden core. His body is of split seedpods (like scales) with a ruff of porcupine quills, all materials from the bush. *Idu* is the herald of *Okakagbe* who remains to police the crowd during the performance. Maskers of the *Okakagbe* troupe, representing other specific bush spirits (Ancient Mother, Respected One), appear in an orderly procession and engage in synchronized and solo dancing in their beautiful masks and costumes.

The origin of this masquerade dates to about 1920, when Okeleke, a visitor from east of the Niger River, made a set of costumes and

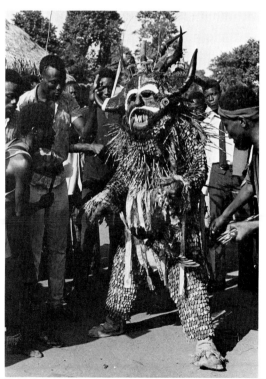

FIGURE 49. *Idu*, the mythical bush monster. Ekperi, Ugbekepe (N. Edo); Nigeria. Photo: Jean Borgatti, 1972.

taught a Northern Edo village, Weppa-Wano, the dances. They spread to other communities in the region. Okeleke's popularity and artistic expertise spread rapidly and provided the basis for a greatly revitalized social masking institution. Okeleke returned to the east in 1966. Lawrence Ajanaku continues the costume making tradition in the Etsako region, and he created the *Okakagbe* costumes for the UCLA Museum of Cultural History (Figs. 50,51), commissioned by Dr. Jean Borgatti in the early 1970s.

Okakagbe is performed whenever colorful entertainment is required—at funerals, the visits of dignitaries, or year-end ceremonies, for example. The dancing troupe is hired by a host to add luster, dignity, and visual/musical/dance embellishment to any valued social occasion. The masked dances are lively and complicated, with virtuosic solo performances and well-choreographed ensembles. Dancers enter the arena single file, led by "Respected One." The last to appear is "Ancient Mother," *Odogo* (Fig. 50), wearing a headdress on which are attached several small cloth appliqué, stuffed figures. "She" wears long flat breasts indicating that she has suckled many children (Borgatti 1979:6). A dancing child called "Little One" (Fig. 51) accompanies the senior lady, and other characters include "Too Fine," "Answerer of Questions," and "Owner of the House." "The dancers remain in line, executing a complex pattern of stamps, leaps, and twirls, their movements synchronized," and solo dances are interspersed with group sets. The name, *Okakagbe*, suggests "something difficult, skillfully executed" (Borgatti 1976:27).

Olimi is an annual, year-end festival which originated around 1900 in Okpella, having been borrowed from neighboring peoples. *Olimi* grew and spread due to rivalries among villages competing to enhance their spectacles by adding new masks over the years (Borgatti 1976:30). It is produced by several ritual night societies acting in concert. Each day during the preceding three months, the festival heralds, *Inogiri* maskers (s: *Anogiri*), bring spiritual power into the village to enable the people to sustain life and prepare to honor the reappearance of ancestral spirits during *Olimi*. *Anogiri* is a messenger of the Dead Fathers and a servant of the night society (ibid.; Pl. 5). He appears in a cloth hood or a wooden helmet mask decorated with seeds, shells, and paint. In contrast to the delicate features of *Okakagbe*, these masks are abstracted brutalizations with exaggerated and distorted forms. On *Olimi* eve, the various maskers of the secret societies ritually purify the village. *Olimi* day, the spirits return as masqueraders to establish the continuity of life in death. Among the maskers is the elders' masker, *Efofe*, called "Knockout," a curious composite with bush monster face, completely encased in the costume of an Ancient Mother from *Okakagbe*. *Efofe*, seeming at first contradictory, appears to symbolize the triumph of culture (*Okakagbe*) over the unknown, dangerous forest night (*Idu*). Other maskers include characters commemorating men and titled women; these represent the collective dead who thus assemble to prepare the human community for another year (Borgatti 1976:32–33).

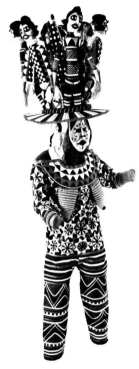

FIGURE 50. Okpella (N. Edo); Nigeria. Ancient Mother, *Odogo*. Mask: 51 cm, UCLA MCH X76–1711; costume: 105.5 cm, UCLA MCH X76–1716. Gifts of Mrs. W.T. Davis in memory of W. Thomas Davis, made by Lawrence Ajanaku of Ogiriga Okpella.

FIGURE 51. Okeplla (N. Edo); Nigeria. "Little One." Mask: 49.5 cm, UCLA MCH X76–1712; costume: 74.5 cm, UCLA MCH X76–1717. Gifts of Mrs. W. T. Davis in memory of W. Thomas Davis, made by Lawrence Ajanaku of Ogiriga Okpella.

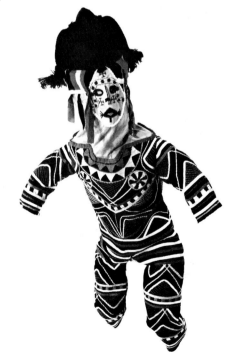

Cameroon Grasslands

Judith Hunn

The central and western part of Cameroon is a lush and hilly plateau region referred to as the Grasslands (or Grassfields). It is a dense and culturally rich area with many small kingdoms nestled throughout fertile valleys, gallery forests, and steep hills. The area has a cool, healthful climate and an abundant water supply from streams and rivers which also facilitate communication and trade. The societies depend upon an agricultural economy; plantains, yams, maize, and guinea corn are staples supplemented by millet, beans, and peanuts, among other vegetables and fruits. Livestock include goats, fowl, and short-horned cattle. Coffee is a cash crop. Raffia, palm oil, bananas, and kola nuts are used and traded. Crafts also flourish in the Grasslands, one of Africa's richest art areas.

The region is commonly divided into three cultural groups that trace their origins to common ancestors. This is supported by linguistic data (most people speak Bantoid languages) and by similar social structures in all areas. A unity of artistic form and style prevails too, despite regional differences. The Bamileke region in the southwest is the most densely populated area with 700,000 inhabitants. Bamileke comprises many autonomous chiefdoms, and the art tends to be expressionistic. The Bamenda-Tikar area in the north includes about 450,000 people living in independent chiefdoms, whose art shares a cubistic style. The third subdivision, Bamum, is the northwest border of Bamileke, with a population of 80,000. The art of this area has generally rounded forms (Wittmer 1977:7; Gebauer 1979:32–35).

The Grasslands are organized into villages or chiefdoms that uniquely combine two forms of sociopolitical authority—kingship and secret societies. Each chiefdom is organized around the secular and priestly authority of an hereditary divine king or chief. He is the living representative of a line of royal ancestors who own the land, control fertility, and provide for the well-being of the people. The king is believed to possess supernatural abilities such as being able to change himself into a powerful animal, usually an elephant, leopard, or buffalo. Other associated animals are a toucan, whose feathers are used in the selection of a king; spider, a symbol of wisdom and used in divination; toad, a fertility symbol; and chameleon, whose presence announces death (Northern 1979:n.p.; Wittmer 1977:4–5).

The king tops an elaborate hierarchy of titled nobility and secret societies whose functions are to protect and counsel the king, select and crown a successor, administer, police, judge, and provide economic and social control. Among these secret societies is one governing body that both enforces royal prerogatives and acts to check and balance the king, who is thus not an absolute ruler. This regulatory society, called *Kwifon* in the eastern parts, is found in all Grasslands chiefdoms. Princes' societies, called *Nggiri*, serve as advisors and have some influence on the king. Independent military organizations (e.g., *Manjong*) are a third type of society. They are licensed by *Kwifon* and

were responsible in the past for warfare and hunting; today they oversee community work and perform shooting demonstrations at annual dances. Like other societies, they participate in death celebrations (Wittmer 1977:5; Northern 1979; Koloss 1977).

Cameroon art promotes equilibrium and harmony by reinforcing the social order both in the royal sphere and among the regulatory societies. Most Grasslands art is ceremonial, an elaborate, symbolic expression of social status. The widest range of object types is found in the king's treasury and includes sculptures, masks, headdresses, and personal regalia in a dazzling array of forms, materials, and colors. Only royalty may use or adorn objects with ivory, brass, cowrie shells, beads, and rare feathers. Leopard pelts and elephant tusks especially are reserved for palaces, as these animals symbolize the divine attributes of aggression, cunning, survival, and strength (Northern 1979). Art is thus a constant and impressive visual reinforcement of the social hierarchy. The artist in Grasslands society often ascends to the highest ranks of nobility, and chiefs have gained stature by their ability to carve (Gebauer 1979:113).

Masks outnumber other types of Grasslands sculpture; they belong to the palace, secret societies, and certain lineage groups. Palace masks and those of *Nggiri* are distinguished by the application of beads, sheet brass, and cowrie shells. They are usually single masks, the heads human males, buffalo, and elephant.

Masquerades also play an important role in *Kwifon* policing activities. *Kwifon* masks are believed to have been created by ancestors and are ritually consecrated. One of the major traits of such masks is their magic power derived from medicine.[24] They destroy witches and devils and are often treated with medicines such as sacrificial blood, hair, horns, bones, shrubs, or bushes. Masqueraders usually wear magic or "power" objects such as cones, teeth, and small calabashes holding medicines (Koloss 1977). *Kwifon* has several single masks that command great respect and through which *Kwifon* demonstrates its power and strength of sociopolitical control. Among these is *Mabu*, a wooden human face mask that is *Kwifon*'s "running mask"; he wears a feather garment and carries a spear.[25] *Nkok*, the most dangerous of all *Kwifon* masks, is a huge, frightening human head worn over a heavy, black, woven garment.[26] Other *Kwifon* messengers, escorts, and supervisors wear only face nets and garments and carry sticks, switches, and clubs (Koloss 1977; Northern 1979).

Manjong, the military society, only occasionally owns masks; among these is the extremely dangerous *Samba*, which appears only at death celebrations. *Manjong* attain their striking power primarily from their medicines and special musical instruments, principally a much feared bull-roarer (Northern 1979; Koloss 1977).

In addition to single examples, masks in groups from seven to thirty are the property of important extended families or lineage groups. Permission to own these masks is granted by *Kwifon*. Costumes, dance styles, and sequences vary among different lineages and chiefdoms, but processions usually begin with a male leader mask, *Kam*, followed by *Ngon*, his first wife. The sequence continues with alternating human male and animal masks depicting bachelors, warriors, old men, buffalos, elephants, sheep, goats, monkeys, dogs, bats, ducks, and various birds of prey. The masquerade concludes with a second leader mask in animal or human form, but most often a large buffalo or elephant mask (Northern 1979; Koloss 1977).

Masks attained their importance in warfare and as a medium of social control and suppression of women. They also perform at death celebrations, the number of masks indicating social status. These ceremonies are among the more important religious events, and apart from them masks are not active in religious life (Northern 1979; Koloss 1977).

Establishing the provenance and particular context of the mask in Figure 52 (or any Cameroon mask) is difficult without reliable field data. Most chiefdoms employ the same types of masks: buffalo, ram, elephant, bird, and male face masks like this one with openwork superstructures. Masks may, however, be distinguished to some degree on the basis of style. The most frequently cited attributions for examples of this type are Kom and Babanki.[27] Both are characterized by a symmetrical facial configuration formed by a prominent nose, ears at eye level, and neatly outlined eyebrows high on a bulging browridge. A crescentic mouth displays even rows of teeth. Both styles have full, rounded cheeks and an overall wide-eyed, smiling, expectant expression. While the two styles are often indistinguishable, nuances for the Babanki are an indentation at the center of an X-shaped meeting of facial planes and a sharper nose ridge. Kom examples have thicker noses with broader bases (Northern 1979; Wittmer 1977:9–13). This mask conforms most closely to the Kom style and is similar to one illustrated by Wittmer, which she describes as "the purest manifestation of the Kom style" (1977:9–13).[28]

Although the attribution of masks to specific Cameroon masking societies also is difficult, most human and animal masks in Western collections were owned by extended families. It seems that single masks, dangerous by their very nature, were rarely released for sale (Northern 1979; Koloss 1977). Figure 53 indeed conforms to a type used in extended family mask groups. These were either male or female faces with superstructures displaying motifs of human heads, insects, or animals.[29] The four heads above this mask are joined above and below by rings; the small heads may represent royal ancestors or the skulls of enemies (Gebauer 1971:28). The fact that this form resembles royal stools is not surprising in that mask headpieces are called "chairs" in the eastern Grasslands. In Bamenda-Tikar they are considered "baskets" which, in a symbolic sense, carry fruit or game (Koloss 1977).

Among lineages such masks are used with varied costumes and dance styles. In a masquerade from the Bamenda-Tikar area documented by Koloss (1977), maskers dance barefoot in shirtlike garments with arms and legs exposed. Rattles with wooden, beanlike fruit-pods strung together are tied around the ankles and beat a rhythm during the dance. This helmet mask is worn on top of the head, which is covered by a netlike fiber or cloth through which the dancer can see. During the masquerade hundreds, sometimes thousands, of people assemble and judge masks, drummers, and dancers, as the latter conspicuously try to gain the attention of the audience.

Available literature seems to indicate that animal masks of the type seen in Figure 54 are owned by extended families[30] and danced in sequence with human and other animal masks. While the leader's mask, *Kam*, is designated as the family chief and is followed by various wives and family members, interpretations of animal masks are not certain. Occasionally informants have suggested that they represent gifted men who can mystically transform themselves into

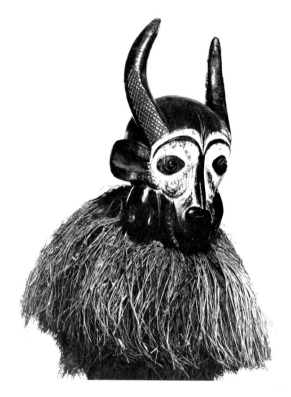

FIGURE 52. Cameroon Grasslands mask; exact provenance unknown. Wood, pigment, fiber, 81 cm. UCLA MCH X66–65. Museum purchase.

FIGURE 53. Bamum human face mask with superstructure; Cameroon. Wood, pigment, 43.5 cm. UCLA MCH X78–126, anonymous gift.

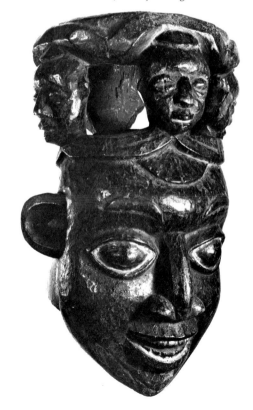

animals, some of which have specific attributes. The elephant and buffalo represent strength, for example, and the spider is a symbol of wisdom. But the meaning of monkey, bird, and bat masks in these masquerades is unexplained. In fact, informants were sometimes uncertain as to whether a particular mask represented a hippopotamus, elephant, monkey, or even sea cow. Even the gender of human masks is often in question and is apparently unimportant to Grasslands peoples (Koloss 1977).

Like human masks, animal examples are worn on top of the head, which is covered by a netlike fiber. Animal masks such as this one (Fig. 54), which probably depicts a bush buffalo, are worn horizontally. According to Lecoq (1953), animal masks were only found in Bagam (in northern Bamileke), Bamenda, and Bali (in Bamenda-Tikar). While a northern orientation is apparent in all masks except birds and elephants, Wittmer (1977) claims that distribution is actually much wider. Lecoq (1953) also says that animal masks are used in hunting rites; Northern (1979), however, states that they are never so used. Animal masks of all kinds, on the other hand, are worn by warrior societies whose activities support kings throughout the Grasslands. Wittmer thus suggests that the definition of hunting may also extend to include warfare (1977:26). Regarding animal masks of the Bamenda-Tikar region, Koloss (1977) states that there are no religious or totemic meanings ascribed to them, and indeed, he found no indication of totemic relationships between animals and humans in the Grasslands.

FIGURE 54. Bamileke bush buffalo mask; Cameroon. Wood, pigment, 68.6 cm. UCLA MCH X77–935, anonymous gift.

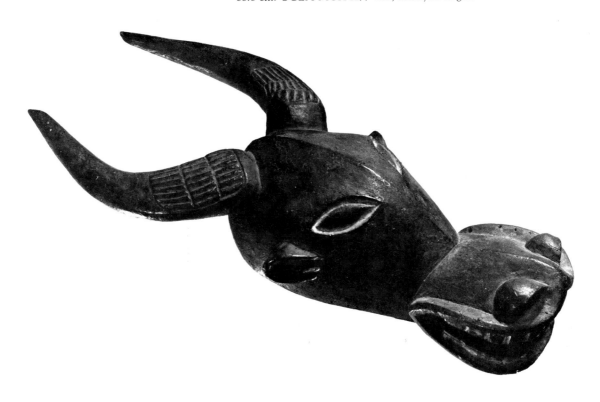

Elephant masks

Elephants are the world's most commanding land creatures, unsurpassed in grandeur and power. Thus elephant masks such as those in Figures 55–57, while rare in Africa, are fully appropriate symbols of important leaders or, at least, their respected deputies or messengers. Elephant societies that use these masks in fact act as agents of chiefs' control and as formal royal emissaries. Elephant societies that originated in Bamileke and spread elsewhere in the Grasslands consist of three graded ranks attained by wealth. In the past, payment of a slave to the chief who owns the society was necessary for entrance to the highest rank. The glass beads used on earlier masks were nineteenth-century trade beads of Venetian or Czechoslovakian manufacture, used as well in exchange for slaves. Elephant mask costumes were thus called "things of money" since their beads were both objects and symbols of wealth (Brain and Pollock 1971:100; Northern 1975:17–21).

Elephant masks comprise cloth panels and hoods woven from plantain fiber over raffia. On this background multicolored beads are stitched in geometric patterns.[31] The basic form depicts salient features of the elephant—a long trunk and large ears. The hood fits tightly over the masker's head, and two hanging panels, one behind and one in front, partially conceal the body. The front panel is the elephant trunk, and the two large, stiff circles hinged to either side of the head are its ears, which flap as the masker dances. While the mask symbolizes an elephant, the face is human. Eyeholes provide visibility, and a nose and mouth with teeth are normally present.

Such masks are worn with robes of dark woven fiber covered with small fiber knobs (Fig. 57) or indigo and white tie-dyed "royal" cloth. The robes contrast greatly with the maskers' bright red legs, dyed with camwood. Costumes also include beaded vests with broad belts and leopard pelts attached at the back. The larger of these examples has a large, conical beaded hat with two small beaded leopard sculptures on top (Fig. 56). Since a chief owns or controls the masking society, both leopards and elephants are apt metaphors for symbolic impersonation.[32]

Maskers dance barefoot in these colorful costumes to a drum and gong, moving slowly as they wave poles with blue and white beaded tips trimmed with horsehair (Fig. 58). They whistle "mysteriously and

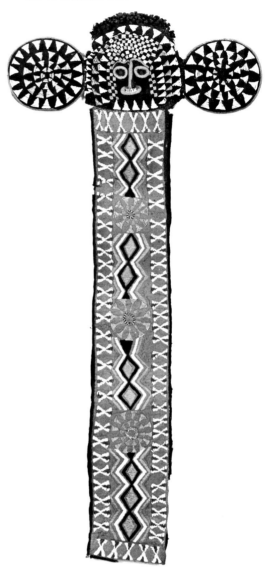

FIGURE 55. Bamileke elephant mask; Cameroon. Raffia, plantain fiber, hemp, glass beads, 118.1 cm. UCLA MCH X82-569.

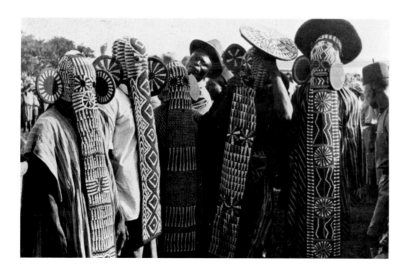

FIGURE 58. Cameroon elephant maskers in the Bamenda highlands (Nsaw group). Photo: Paul Gebauer, 1930s.

tunelessly," brandishing spears and horsetails. Maskers are later joined by chiefs and princesses, parading by an elaborate tent in which high-ranking men sit to observe. A masker hurls his horsetail to the chief, the crowd cheers, and the celebration continues with various feats performed primarily by younger maskers. When the festivities end, the favorites are rewarded with kola nuts and wine (Brain and Pollock 1971:100–104; Northern 1975:17).

The beauty of these masks is largely in their colorful beaded patterns. Dark blue or red backgrounds provide foundations for basic geometric designs laid out in white, creating a striking contrast. As Northern indicates, the masks show varied degrees of order and complexity (1975:116).[33] The mask in Figure 55 has a high degree of order but little complexity, while that in Plate 6, with several geometric and schematic designs, is less orderly and far more complex. Masks may be sparsely or densely beaded. Decoration and background are well-balanced in both masks, yet Plate 6 is the finer and more interesting example. The quality of its beaded designs is superior. Asymmetrical patterns on ears are common, and their subtlety in this case is notable. It is probably an older example since masks with longer panels and proportionately smaller ears are known to have been made more recently (Northern 1975:41).

FIGURE 56. Cameroon elephant mask headdress. Cloth, beads, 47.5 cm. UCLA MCH X64–86, gift of W. Thomas Davis.

FIGURE 57. Cameroon elephant mask and costume. Cloth, fiber, beads, 118.1 cm. UCLA MCH X73–529.

Chokwe

Bonnie E. Weston

The Chokwe people dominate the northeastern quarter of Angola and have substantial settlements along the borders of southern Zaïre and northwestern Zambia. Tributaries of the Zaïre River fragment the region which is largely savanna with scattered forests in the south. Founded in Angola at the end of the sixteenth century by a disinherited son of a Lunda sovereign, the Chokwe nation remained under Lunda domination until the end of the nineteenth century, when the Chokwe spread northward, taking over Lunda territories and moving into Zambia and Zaïre.

Numbering over 600,000, the matrilineal Chokwe are organized into a series of small, decentralized chiefdoms. Despite the great number and autonomy of these polities and the wide dispersal of populations, Chokwe political, social, and artistic institutions are largely homogeneous. A chief is the descendant and representative of the chiefdom's founding ancestors; his authority is hereditary, passed down from uncle to sororal nephew. His considerable powers are held in check by a democratic council of distinguished individuals —priests, diviners, judges, artists, and skilled hunters—who represent the different villages' lineages (Lima 1971:71–74; Bastin 1961:47–48).

Chokwe men's hunting expertise is widely admired among the neighboring Lunda, Pende, and Lwena peoples. A professional hunting association, requiring initiation for membership, promotes Chokwe hunting skills and reputation. A great number of spirits and charms aid and protect hunters, emphasizing the profession's signal importance in Chokwe society. Sculptors are commissioned to carve powerful images venerating legendary chiefs and heroes, showing them garbed as hunters, armed with bows or rifles.

Although the Chokwe recognize a supreme deity to whom they address occasional prayers, he is not worshiped through organized cults or venerated in masks and statues as are the numerous *hamba*, ancestral and nature spirits. These closer supernaturals are continually involved in the lives of the Chokwe and act as intermediaries between mankind and the creator. Shrines dedicated to such spirits are housed in the domestic compounds of devotees, while the chief maintains shrines dedicated to the collective ancestors. Cult statues placed in these shrines are modeled in clay or carved by cult leaders, not professional sculptors (Bastin 1961:34,36).

The Chokwe attribute all misfortune to supernatural forces; illness, sterility, crop failure, and poor hunting may result from neglect of a shrine, abandonment of a mask, or manipulation by a sorcerer of negative, occult forces called *wanga*. The diviner is expected to identify the nature and cause of such problems and prescribe a remedy. Usually a person of high standing, often the head of a village, a diviner receives exhaustive training and must pass an arduous initiation before he is allowed to practice his art (Bastin 1961:38,40–41).

Chokwe masks may be divided into three groups; all have a spiritual basis and are generically called *mukishi* after the abstract class of spirits they incarnate. *Cikunga* is most powerful of all masks, a

74

sacred, highly charged mask that represents the chief's ancestors and is feared by men and women alike. Constructed of bark cloth stretched over a frame, *Cikunga* has an anthropomorphic face and an elaborate winged headdress similar to those worn by chiefs and featured on the statues of ancestral heroes. *Cikunga* appears at a chief's investiture and is worn by the chief to perform sacrifices in emergencies (Bastin 1961:201–204,370;1968:63).

Mukanda is the all-important male rite of initiation which marks the passage of Chokwe boys from puberty to young manhood. Boys live in a bush camp, separated from their families for one to two years. The boys are first circumcised and then given a lengthy education. Besides being taught the history and traditions of the village and the secrets of masking, the boys learn how to make and perform masks and what is expected of them as adult males in Chokwe society (Bastin 1961:48–55).

Various masked spirits guide and protect initiates during *mukanda*. Most important is *Cikunza* (Figs. 59,60), who is manifested in a great, conical bark cloth mask. A host of lesser bark cloth masks, modeled after the aristocratic *Cikunga*, fetch food and provisions from the village and assist in various *mukanda* rites. *Mukanda* masks are made exclusively of bark cloth, may only be handled and worn by devotees of the spirits they represent, and may be viewed only by men (Bastin 1961:48–53,201–204,370–375).

Cikunza is the powerful, beneficent guardian of fertility, hunting, and male initiation. Praised alternately as "father of masks" and "father of initiation," the ancestral spirit (*hamba*) is manifested in a ritual bark cloth mask of the same name and protects *mukanda* initiates and directs their passage from puberty to adulthood (Fig. 59). In a cast of over fourteen *mukanda* masks, *Cikunza* is by far the strongest, one of only two that *must* participate in order for the critical rite of passage to be valid. Of all Chokwe masks, *Cikunza* is second only to *Cikunga*, the aristocratic mask worn exclusively by the chief and his heirs.[34]

Mukanda opens with the initiates' abduction by masked spirits who lead them to the secret camp. Each masquerade assumes the personality of the particular spirit it represents—*Cikunza* ambles slowly toward the village, issuing long, ululating cries to alert prospective initiates and warn women to hide. Carrying a rifle or sword in one hand and a branch in the other, he wears a close-fitting net costume with loose fiber ruffs encircling his waist and neck. *Cikunza* directs the initiation, assisted by other spirit-maskers. The youths' instruction includes the making and performing of masks, although the important ritual masks, such as *Cikunza*, are made only by specialists. At the conclusion of *mukanda*, the masks are discarded in the bush, and the camp is burned.

Cikunza represents, in part, the grasshopper after which it is named. The tall conical "coiffure," however, recalls an antelope horn with its painted and raised rings. Almost always male, *Cikunza* is understood in terms of the mask itself; this mask image depicts the spirit in other art forms. Its face, extended conical projection, and long nose are reproduced in figural statues of *Cikunza* and on hunting whistles, divining instruments, chiefs' ceremonial chairs, and the painted walls of domestic compounds. The *mukanda* circumcision knife is forged in its image. Small charms, carved to resemble *Cikunza*, are carried by hunters on rifles and bows for good luck and

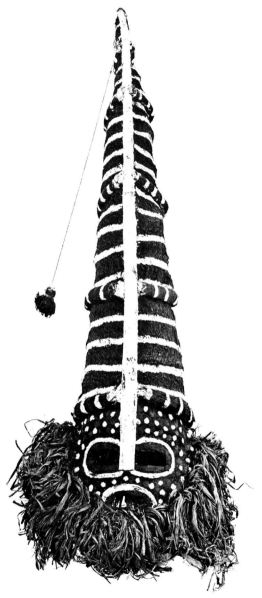

FIGURE 59. Chokwe *Cikunza* mask. Bark cloth, fiber, pigment, 142.2 cm. UCLA MCH X67–2125, gift of George G. Frelinghuysen.

protection, and on the belts of sterile women hoping to tap *Cikunza's* powers of fertility.

With so few extant *Cikunza* masks, it is difficult to compare Figure 59 with others of its type, although our example is taller and more dramatic than one photographed in the field in 1960 (Fig. 60). Certainly the mask's greatest hallmarks, the tall conical coiffure and nose which runs to the mask's top, are found on all examples. Constructed of bark cloth stretched over a rigid rattan or fiber frame, the mask is painted with natural pigments, in this case white, rust, and brown. While the painted and raised rings appear to be typical, some examples are more elaborately decorated with geometric and natural motifs familiar on other Chokwe art forms. Facial features vary from mask to mask but are always roughly anthropomorphic.

Wooden dance masks also perform in ritual contexts but have become increasingly secularized, appearing openly before women and uncircumcised males. Masks are danced by itinerant actors who travel from village to village living on gifts received at performances. Some dance masks are made of fragile, resin-coated bark cloth, but most are more practically carved in wood. *Cihongo*, who represents the spirit of wealth, is a well-known male mask. Formerly it was worn by a chief or one of his sons who would travel through the chiefdom exacting tribute from villages in exchange for the protection of the mask spirit. Still highly respected, *Cihongo* performs today with *Pwo* (Fig. 61), his female counterpart. There are six or seven dance masks in all, representing a broad range of character types (Bastin 1961:63,201–204,380–390).

Pwo (Fig. 62) is said to reincarnate the feminine ancestor of the Chokwe and to encourage fertility. Along with its male counterpart, *Cihongo*, a stern old chief, *Pwo* is the best known and most numerous of Chokwe dance masks. More recently it has become known as *Mwana Pwo*, "Young Woman," symbolic of maidens who have undergone initiation and are ready for marriage. The transition from *Pwo* to *Mwana Pwo* suggests a change in Chokwe ideals, reflecting a modern preference for youthful women over mature ones who have already borne many children. *Pwo* maskers imitate women's graceful dance motions and wear close-fitting net costumes with cotton wrappers and false breasts. Mask, costume, rattle, flywhisks, and other dance accessories are all integrated into this image of ideal Chokwe femininity.

FIGURE 60. Chokwe man holding *Cikunza* mask (right) and *Ngoyo*. Photo: Frank O. Biedka, 1960.

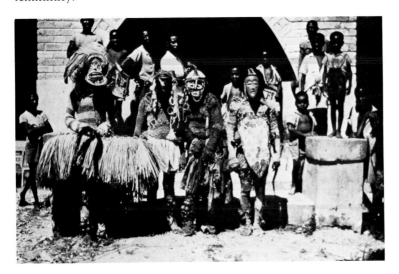

FIGURE 61. Chokwe *Cihongo* masker (left) with others in the dancing troupe including *Katoyo* (center) and *Pwo* (right); Zaïre or Angola. Photo: Frank O. Biedka, 1960.

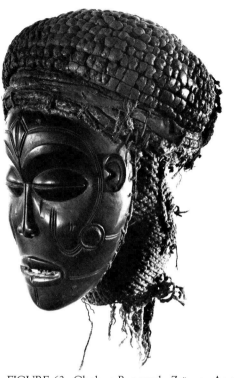

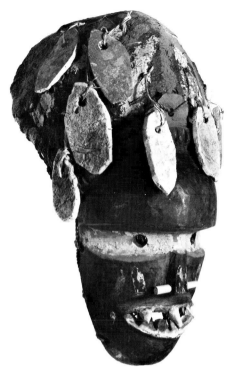

FIGURE 62. Chokwe *Pwo* mask; Zaïre or Angola. Wood, fiber, cloth, 39 cm. Lent by Professor and Mrs. Daniel Crowley.

FIGURE 63. Chokwe *Katoyo* mask; Zaïre or Angola. Wood, burlap, gourd, pigment, fiber, 29 cm. UCLA MCH 399–40, Museum purchase.

The fabrication of a dance mask is a ritual process hidden from women and uncircumcised males. A sculptor respectful of traditional canons uses a beautiful woman as his model, reproducing her facial markings and hairstyle. Mask markings are generally ancient patterns and may reflect the status of the woman represented, as they do on living women. Common markings on the mask in Figure 62 include the line along the nose called *kangango*, after a mouse with a stripe on its back, and the vertical incisions under each eye, said to be tears. Among the Chokwe, filed teeth are a sign of beauty, a feature reproduced on this example and many others. The hairstyle here is a wig, modeled by a woman, that reproduces one of the traditional female plaited hairstyles caked with clay.

Figure 63 shows *Katoyo*, a comic dance mask representing a white man who performs as a buffoon. Like *Pwo*, it is worn by professional itinerant maskers. Its costume is close-fitting netted fiber with a wooden penis covered with the same fabric. Operating hidden strings, the lewd buffoon periodically exposes himself to the greatly amused audience. While all Chokwe masks have a spiritual basis, *Katoyo* is a professional clown seen by women and children and, as such, is only a weak spirit.

Most *Katoyo* masks are carved in wood, although some are made of resin-coated bark cloth used in *mukanda* and other more powerful masks. According to Bastin, the projection over the eyes is an abstract rendering of the visor of a cap.[35] This example has a nose plug similar to those on some *Pwo* masks. Its hairstyle is a rigid armature covered with burlap sacking and pigmented clay. Oblong pieces of gourd are attached with fiber string. A light buff pigment highlights the eyes and filed teeth; dark brown stains cover the surface of the face and brow.

Yaka

Richard Blades

The Yaka of southwestern Zaïre are an ancient and cohesive people. Numbering about 300,000, they and their close neighbors, the Teke and Suku, inhabit the savanna grasslands of the Zaïre River basin. Yaka villages are located along the Kwango River and adjacent valleys. Hunting is the prestigious male occupation, and women's farming by shifting cultivation of manioc, sorghum, corn, peanuts, and sweet potatoes provides sustenance.

Yaka sociopolitical organization is predictably complex given its tumultuous history. The Yaka are probably descendants of Jaga warriors who invaded the Kongo kingdom in the sixteenth century. Continuing immigration and the mixing of groups from Angola and elsewhere provided the bulk of the population (and accounts for similarities with Suku culture). By the early twentieth century traditional leadership existed as a system of coexisting overlays. The most ancient stratum is matrilineal, organized around headmen, who oversee ritual and control hunting on ancient lands. Next is a patrilineal structure resulting from the Lunda conquest in the early eighteenth century. The Lunda imposed a system of hierarchical dominance: from local village headmen, through regional chiefs, to a paramount chief of Lunda derivation. Existing on yet another plane are ritual authorities, diviners and priests, whose specialties are fortune-telling, making medicine, and other rites associated with well-being. These men and women are highly respected among the Yaka (Bourgeois 1984:30,37,38,97) and, with chiefs on various levels, are in part responsible for the fertility of mankind and nature.

Because of proximity and historical interactions in the area, the peoples of the Zaïre basin and associated river valleys to the east share certain cultural conventions. Regional object-types held in common include wooden images (power figures) with cavities for the placement of magical materials and varied regalia used by leaders as symbols of rank and prestige. There are masks with a wealth of connotations (small and personal or larger and worn in ceremonies), carved figures, slit drums, costumes, talismans, containers, ancestor images, divination objects, pipes, headrests, combs, and a host of other artistic objects. In these pieces we perceive power, humor (often satiric), dignity, humanity, respect for nature, a prevailing design consciousness, and frequently virtuoso craftsmanship—all indicating how compelling and pervasive is the creative artistry of these peoples.

The Yaka believe that in the distant past the supreme being gave the secret of mask-making and usage to the oppressed. In one Yaka legend—which may have evolved during the time of Lunda domination—a gazelle is dominated by a leopard. The supreme being appears to the gazelle, explaining how to make a mask from calabash and how to use it to triumph over the stronger leopard (Planquaert 1930). Today, authority is still assailed vigorously in masquerades.

Nkanda, which is the primary educational and initiating institution for young boys and the major masking institution in Yaka culture, is also found among the related Suku, the Chokwe to the

south, and the Pende to the east; even the Kuba, further to the northeast, have a variant form. *Nkanda* is opened when enough candidates between ten and fifteen years old are available and when the village elders so decide. The rites last from one to three years, and their conclusion depends on the progress of the initiates as well as on the generation of sufficient revenues and gifts (Planquaert 1930; Bourgeois 1984:119–121). Young candidates are removed to a protected camp in the forest where they undergo a sequence of ceremonial procedures including circumcision, physical testing, deprivation, and isolation from women, all as preparations for manhood. Initiates are incorporated into their fathers' groups and acquire manly characteristics by instruction and practice. Nakedness prevails and implies infancy or liminality during the circumcision period, prior to final coming-out ceremonies. Exit from the camp is accomplished as an initiate crawls through the legs of the camp leader. Thus a symbolic birthing process is enacted, anticipating the boy's climactic reentrance into society as a man. Periodic sorties into nearby villages are made by the group to elicit gifts and money. At coming-out ceremonies, degrading, lewd, and amusing comments are recited in masquerade songs about mothers and sisters and their genitals and are directed toward women in general in a final statement of male sexual dominance and the separation of the the sexes (Bourgeois 1983b:1,6).

As a kind of charm, masks protect initiates from harm during transition to manhood, insure future fertility, and maintain fear and respect for the *nkanda* institution. Masks are posted at the gates to ward off witches, and some are danced during the coming-out ceremony. Interestingly, many of the dance masks associated with *nkanda* incorporate both male and female features: the accented nose, ears, and eyes are male, while the tear streaks, necklace, and headband are female. Bourgeois feels that this androgyny occurs as a mediating influence for societal reentry (1983b). Even masks clearly designated male (e.g., *kakungu*) exhibit female attributes as well, seeming to symbolize both the importance of male dominance and the paramount necessity of the sexual unity required for procreation. Yaka color symbolism further develops androgynous characteristics in masks; red and white are both variously associated with male and female vital attributes (Bourgeois 1983b:4-5).

Another interesting feature of *nkanda* dance masks is the headgear surmounting them. Varied direct and symbolic references are made to sexuality, to marriage, and to the coiffures known for more than a century as distinctive Yaka traits (see Planquaert 1930).

Typically, the wooden face of a *nkanda* mask (Fig. 64,Pl. 7) is carved with a distinctive nose and deep eye sockets, is surmounted by an elaborate headpiece, and is encased in a bushy raffia shoulder covering. The upturned nose seen on Plate 7 is quite common on northern Yaka masks and carved figures collected prior to 1930. The headpiece is cloth constructed on a frame of palm stems, impregnated with resin, and painted. A mother and child are attached to the crown, and packets of magical material may have been tied to cloth strips at the tips of the cones. The post carved below the wooden face is the handle by which the mask is held before the dancer's face. All *nkanda* dance masks are so constructed yet vary tremendously in the elaboration of the headpiece. The topknot will have attached human figures often in explicit sexual poses, animal figures (symbolically sexual), houses (implying marriage), or a variety of structures recalling

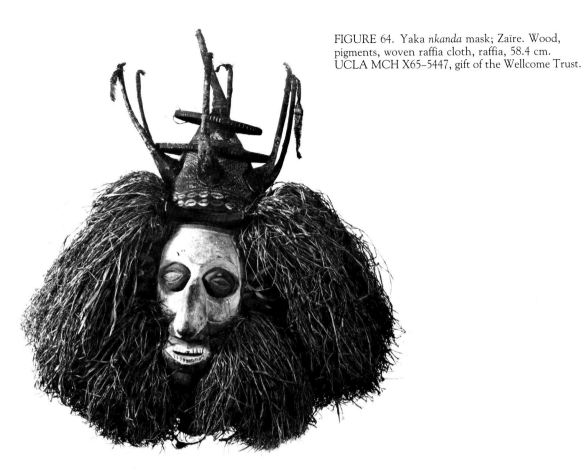

FIGURE 64. Yaka *nkanda* mask; Zaïre. Wood, pigments, woven raffia cloth, raffia, 58.4 cm. UCLA MCH X65–5447, gift of the Wellcome Trust.

coiffures once common to the Yaka. The face is painted white with decorative elaboration in red-orange and black (plus blue in this case). The most enjoyed masks are those with explicit sexual references worn by camp leaders. They are danced in conjunction with sung and recited prose designed to insult (and express dominance over) women, chastise political leaders, and exalt the new life of the young men.

Although it is unusual in Africa for a masquerader to show his face, the *nkanda* dancer sometimes appears carrying his mask off shoulder by the short wooden post, and he advances, thrusting the mask, dancing, and intermittently holding the mask to his face (Fig. 65). He may recite lewd verse to the pleasure of the crowd and "prove" himself by inducing an erection which is exhibited by removing his masking cape at the crucial moment. Normally conservative with respect to nudity, the Yaka greatly enjoy this escapade, and it suggests a direct pride in evidence of procreative potential.

Women are excluded from *nkanda*; they are quite knowledgeable about it, however, and desire their sons and husbands to be members of great *nkanda* brotherhoods. Although much effort is expended toward expressing male dominance, the primary function of society is the continuance and growth of the family. This duality creates a tension which is symbolically indicated by masks of this type.

As noted above, the mask in Figure 64 exhibits the androgynous symbolism characteristic of *nkanda* masks. The enlarged ears, nose, and eyes are male features as is the straight hairline. Feminine features include the visor piece, headband, tear streaks painted on the cheeks, and the coiffure as a whole. However, the coiffure is said to have male parts in the stretched conical projections (relating to palm

80

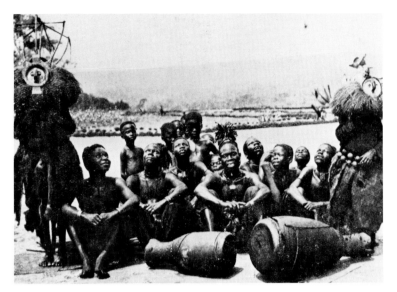

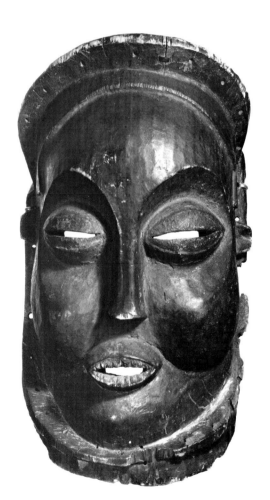

FIGURE 66. Yaka or Suku *Kakungu* mask; Zaïre. Wood, pigment, 82.6 cm. UCLA MCH X78–1814, gift of Bob Bronson.

trees, regarded as male), while the discs are female (related to food-carrying baskets and the moon, the "disc in the night sky"). The central cone projecting through the female discs is therefore probably an integrated symbolic sexual reference. The primary painted colors are white (the color of semen and of milk) and red (the color of "blood of vengeance" and of maternal blood), androgynous choices in Yaka art. The beard piece is both male and female (equated with the wisdom of age), while the broad raffia covering is evocative of the house of a husband and wife. It is hard to imagine a more tightly integrated design of polarized symbolic characteristics than is evident in these masks (Bourgeois 1982a:47–50).

Kakungu (Fig. 66) is the oldest and most powerful mask-charm among the Yaka and Suku. Because of a widespread move in the mid-1950s to eliminate traditional charms, *Kakungu* has ceased to exist except in legend and memory. Although its use was integral to *nkanda*, this male mask also functioned in a broader social context to confront or instigate curses (the *Kakungu* sickness), provide protection against witches, and promote human pregnancy (Bourgeois 1980:42–46).

The mask is always carved from a large block of soft wood, and averaging some 85 cm in height, it is among the larger of African masks. Further characteristics include inflated cheeks, massive features, prominent chin, and red and/or white paint. It is worn with a full fringe of palm leaf strips, large animal skins, and attached seed-pod rattles. This fine example, apparently well used, is well modeled, showing elegant modulations from the cheeks around through the forehead and continuing down the decisive nose. The eyes and mouth provide a rich counterpoint to the harmonious undulation of curved masses and distinct edges. Ears are subdued to give full impact to the facial structure. This mask thus fulfills an important criterion of acceptance: it must be distinctly carved. In addition it must instill instant fear when viewed from any distance. Once accepted, the mask is assigned ownership to a selected charm specialist, thereby becoming a lineage charm (*nkisi*; ibid.).

Unlike dance masks, *Kakungu* is never used in dances of social debut in *nkanda* ceremonies. The specialist who wears it does, however, appear at certain crucial points of *nkanda* to promote well-being among initiates. In some northern Suku villages, it appears

dramatically at the shouted summons of an assistant, whereupon it advances on the leading candidate and grabs him until his father pays ransom. His arrival is fearful, and he makes the sounds, "Iiiiiih! Iiiiiih! Iiiiiih! Hum, hum, waka, waka, waka." *Kakungu* will appear again on circumcision day, the day of departure, and at other significant points of *nkanda*, especially in times of crisis. His presence demands respect for elders and threatens anyone who has evil intent toward the initiates. To this latter end he stays nearby in a special shelter to prevent witches from entering the camp (Bourgeois 1980:42).

Outside *nkanda*, *Kakungu* is called forth to remedy the *Kakungu* sickness (attributed to a curse laid down by *Kakungu*), especially sterility. The sick man or woman is sequestered in a hut with *Kakungu* for several days. However, *Kakungu*'s appearance is thought to be harmful to fertile or pregnant women with the exception that *Kakungu* is the first to recognize that a woman is pregnant. Grabbing her by the foot and ordering the child to "go out," *Kakungu* must then be paid shell money and the woman treated with healing kaolin else the child be born malformed. *Kakungu* appears at new moon among the southern Suku to cure the ill. Great feats of physical magic are ascribed to *Kakungu*. He is believed to leap from village to forest over tall palm trees and can move from village to village in an instant. He can even control the weather and has been called upon to confront violent storms. With his unique powers, *Kakungu* has apparently been most susceptible to banishment by a society in "emergence" to the twentieth century (ibid.:43).

Pende

Kairn Klieman

The Pende peoples of Zaïre number more than 250,000 and are divided into many territorial groups. The two most significant are the western or Kwilu Pende and the eastern Kasai Pende. There is no centralized government but, rather, more than sixty chiefdoms of varying size and influence presided over by elders and chiefs. Pende society is matrilineal; clan affiliation is determined by mothers' brothers. Although succession and inheritance are matrilineal, trading skills and artistic techniques are passed from father to son. In this way artistic traditions have remained localized in villages and clans. This has often led to regional and clan specialization as in the case of the Kisenzele clan of the Katundu tribe who are known for their beautifully carved miniature ivory pendant masks, *ikhoko*.[36]

The basis of Pende religion is ancestor worship. Ancestors are honored in village shrines and are made visible in *Minganji* masquerades. Most village shrines are found in chiefs' compounds or in small huts on the edge of the forest. Often these square-shaped buildings, surrounded by fences and with broad overhanging roofs, become art complexes. A statue of the chief's wife holding the axe carried at the chief's investiture stands on the crown of the roof. This statue symbolizes fertility and emphasizes the importance of women in Pende society. Doors, houseposts, and fence posts of these huts are often carved in high relief with representations of the masks and ancestor figures housed inside. The Pende have great reverence for these shrines; they are very sacred and, indeed, considered the source of all life.

Although most of their artwork consists of carved figures and masks, the Pende also produce a variety of utilitarian, prestige, and ritual objects such as chairs, stools, orators' staffs, miniature ivory and bone masks, flutes, horns, and drums. The carver, *mbembo*, is also the blacksmith in most villages. Carver/smiths are highly respected and many chiefs come from this group. Although metalwork may be practiced in public view, carving must be done outside of the village, usually in a designated hut at the forest's edge. This seclusion is necessary since among the Pende the production of masks is a male prerogative and a highly sacred process. Women and children may only view the mask in performance. Artists follow stringent rules of celibacy while producing both metalwork and carvings.

The Pende are best known for their great variety of masks which fall into two categories: *Minganji* (power masks) representing ancestors, and *Mbuya* (village masks) representing various real human types such as chief, diviner, executioner, fool, widow, and flirt. These too are considered ancestors in a loose sense. Although there are as many as twenty *Mbuya* characters and seven *Minganji*, only a few appear at any ceremony. Both mask types are believed to have magical powers, although the *Minganji* are more powerful. All masks are hidden when not in use since it is believed that their being seen by a woman or child would result in grave illness. Both types appear at important community events such as the millet dance—a village

renewal ceremony following planting—the consecration of an ancestor shrine, the inauguration of a chief, and most important, during and after the circumcision and initiation ceremony, *mukanda*, of twelve- and thirteen-year-old boys.

The distinction between *Mbuya* and *Minganji* masks is defined by both function and form. *Mbuya* represent village characters in a theatrical manner, designed to amuse and entertain (Fig. 67), and therefore they are rendered in a more realistic and expressionistic manner than the abstract *Minganji*. *Mbuya* serve as stabilizing forces by displaying the culture, behavior, and values of the Pende, and they function as socializing agents by satirizing deviations from those ideals. *Mbuya* costumes are made of raffia cloth, European fabrics, or foliage.

In contrast, *Minganji* ancestor masks are intended to evoke fear and respect from villagers. Large and awkward to dance, they are constructed entirely of raffia which extends down to cover the whole body. The only indication of a face are two tubular eyes protruding from the front. This obscurity of form and lack of clear features add to the awesome quality they project.

During *mukanda* circumcision ceremonies, *Mbuya* characters appear in the afternoon at the concluding rites. They emerge from the bush one at a time, accompanied by musicians comprised of drummers and singers. Masqueraders dance and whirl about the village square while two assistants collect gratuities from the spectators. These dances continue until dusk when the *Minganji* appear in the distance. The latter never come directly into the village, but dash among the tall grasses surrounding it, allowing themselves to be glimpsed but never completely seen.

At the end of the *mukanda* ceremony, the newly circumcised boys are taken back to their camp in the bush; the masqueraders then appear before them, taking off their masks and costumes. The initiates are now considered men and masqueraders are revealed to them as equals—men rather than ancestors. From this moment on, the youths are allowed to see and touch the masks which are now stripped of their mystery and danger.

Mbuya

Due to a lack of field data, it is impossible to identify the specific village character represented by the *Mbuya* mask shown in Figure 68. This determination can only be made at the time of the dance by reference to coiffures, movement, and objects held in the hands of the dancer. Prior to European contact, each *Mbuya* was carved with a specific character in mind. Each had an individual expression, and they were easily identified ouside the ceremonial context. Today masks are rendered in a more stylized and uniform manner and are apparently able to fulfill various roles. The mask is well carved, characteristic of *Mbuya*, and has obviously seen a great deal of use. The face is painted yellow; eyebrows, cheek marks, and mouth are black. The "drooping" slit eyes and upturned nose are distinguishing traits of the Katundu carving style, although the mask lacks the usual unbroken eyebrow line extending across the forehead.

Nor is the *Mbuya* character of Figure 69 identifiable. It is a small, wooden face mask with an attached string net in back that covers the whole head. The elaborate black headdress has three large woven raffia protrusions covered with string and fiber "hair." A fiber beard

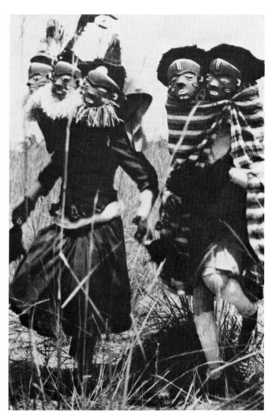

FIGURE 67. Two multi-headed *Mbuya* masqueraders; Zaïre. Photo: C. Dessart, Leopoldville.

is attached to the chin. The face has been rubbed with red-orange camwood pigment; eyes, ears, mouth, and eyebrows are highlighted by black and white paint. A flat metal strip is nailed across the top of the head from ear to ear. Figure 69 is a beautiful and serene example and probably represents a woman. Although many female characters are found in the *Mbuya* category, they are danced only by men. This could be the representation of the village flirt (*gabuku*) or the prostitute (*ngobo*). Often these two characters are fused to become the beautiful young girl placed at the disposal of newly circumcised boys (*thambi*).

A mask of the *Mbuya* category, Figure 70 represents the village diviner, *nganga-ngombo*. It is one of the few masks recognizable by its characteristic form rather than by its costume, accessories, or manner of dance. It has a calm, serene face and a vertical mark on the forehead painted red or white. The carved wooden face is surmounted by a four-lobed raffia headdress. The face is painted red, eyebrows black, and ears, cheeks, mark on the forehead, eyes, and mouth are highlighted with white paint.

Among the Pende, as in most African societies, diviners play a vital role in community life; they are intermediaries between the mundane and spirit worlds. Diviners are regularly consulted by villagers to determine the causes and remedies of illness, sterility, death, theft, poor harvests, or failure in love. The great respect accorded this position is indicated on this mask by the four-lobed headdress, a symbol of status and prestige. This headdress style is found only on the masks of chiefs, executioners, and diviners—the three highest ranking individuals in Pende society.

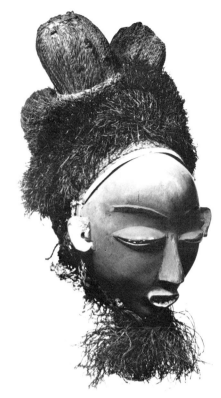

FIGURE 69. Pende *Mbuya* mask; Zaïre. Wood, raffia, string, metal, nails, raffia cloth, 45 cm. UCLA MCH 413–16, Museum purchase.

FIGURE 68. Pende *Mbuya* mask; Zaïre. Wood, pigment, 21.5 cm. UCLA MCH X78–1811, gift of Bob Bronson.

FIGURE 70. Pende *Nganga-ngombo* mask; Zaïre. 50.8 cm. UCLA MCH X81–226.

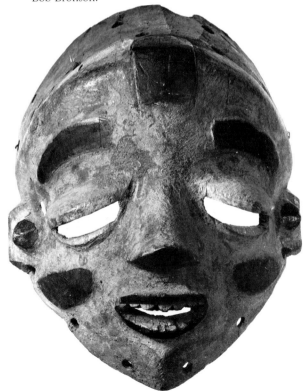

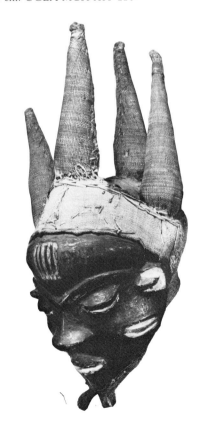

Nganga-ngombo is danced only among the Pende of the Katundu region where masquerades are of a very theatrical nature. Among the Kasai Pende, the positions of chief and diviner are never danced in public exhibition, except during times of difficulty or strife. In contrast to the village characters who dance and jump in a lively manner, the chief and diviner dance slowly, in a serious, calculated manner with deliberately heavy steps. This serves to emphasize their power and influence while showing respect for the spirits upon whom life depends.

Giphogo

The wooden *Giphogo* helmet mask of Figure 71 represents the village chief. When worn, it covers the shoulders of the masquerader. Unusual features of this mask type are the large horizontal "beard" extending laterally from the chin, ornamented with geometric patterns; a prominent nose projecting at a right angle to the face; slit eyes; curved black eyebrows; and ears projecting from the sides of the head. Red camwood pigment on the face and nose serves to emphazise the force and power of the mask. The dance costume is made of cloth with pieces tied and bundled at the waist. *Giphogo* wears a monkey skin attached to the top of his head with a wooden pin, recalling an ancient Pende coiffure. He carries a flywhisk in each hand, symbol of chiefly prestige and power. The name *Giphogo* derives from the word *phogo*, meaning "executioner's knife," a Pende symbol of power, aggression, and influence. This type of helmet mask, once produced only among the eastern Kasai tribes, forms a third category in addition to the *Mbuya* and *Minganji* types. In many villages, replicas of these powerful *Giphogo* masks are carved on fence posts or door lintels of chiefs' houses. These indicate the presence of *Giphogo*, the spirit whose magical power strongly influences the life of the village.

Giphogo is linked to the ancestors; it is kept in the ancestor shrine with other sacred and ritual objects comprising the chief's treasure, *kifumu*. *Giphogo*, as spirit, is believed to have great influence over the health and well-being of the community, and the Pende believe that its absence will result in disaster. *Giphogo* appears during times of strife, sickness, or disorder. Because of his association with ancestors, he is thought to have magical healing and fertility-inducing powers. He can cure the ill by dancing and jumping over them during a special public ceremony. This is done with the help of *phota*, a masked *Mbuya* character who serves as assistant. *Giphogo* also appears at the end of *mukanda* circumcision rites when "the young initiates eat the last bite of symbolic food off its nose and afterward vow to keep the sacred teaching of *mukanda* secret" (Mudiji-Selnge in Vogel 1981:229).

Ikhoko

Miniature ivory pendant heads called *ikhoko* (Fig. 72) are attached to necklaces work by the Pende as protective amulets. They are miniature versions of *Mbuya* village masks whose meaning and power they represent. The three *ikhoko* shown in Figure 72 present a perfect synthesis of the characteristic traits of Pende mask carving. The eyes and mouth are triangular, the nose is slightly flared, allowing the nostrils to be seen, and the forehead is separated by a continuous line in relief that curves into a point above the nose. This rather

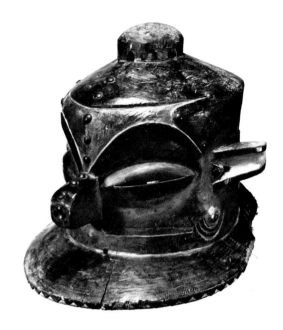

FIGURE 71. Pende *Giphogo*, Kasai region; Zaïre. Wood, paint, brass, 26.7 cm. Lent by Lee Bronson.

naturalistic style originated in the Katundu chiefdom of the Kilembie region and is thus often referred to as the Katundu style.

The three-pointed headdress indicates that these pendants are reproductions of the *Mbuya* masks called *fumu* or *phumbu*, believed to have great healing and fertility-giving powers. Generally *ikhoko* are carved in this form, though there are other styles carved with long beards to represent the *kiwoyo* mask, and some without beards or headdresses represent another character called *phota*. Among the eastern Kasai Pende, a miniature *Giphogo* helmet mask is also carved.

Ikhoko are carved in a great variety of materials including ivory, hippopotamus tusk, wood, and the *muhafo* seed, an extremely hard and durable material. Replicas are also made in metal, especially lead, but ivory examples are the most numerous and best known.

Only Pende men are allowed to wear ivory *ikhoko*, for they are symbols of status and prestige. Miniature masks are given to boys at initiation and are worn until death when they are given to another family member. An *ikhoko* serves as a "diploma" or verification of having successfully completed the circumcision rites. Men often wear an ivory whistle with the pendants. These whistles sometimes serve as *ikhoko* also when they incorporate the face of an important *Mbuya* mask. Also found are small full-figure pendants carved in ivory, although these are quite rare.

Women and children may wear *ikhoko* carved of wood or seed. These are generally of lesser quality and smaller than men's ivory pendants. Women and children wear them for protective and amuletic purposes only. Along with such pendants they wear miniature carved versions of their close relatives' tools of trade, for tools are considered to be spiritual agents.

Ikhoko are also used during healing rituals. After a mask has finished its curing performance, a miniature representation is placed around the neck of the patient to assure and prolong the mask's curative influence.

FIGURE 72. Pende miniature pendant masks (*ikhoko*); Zaïre. Ivory, 5.3 cm, 5.3 cm, 5.8 cm. UCLA MCH X65-6196, –6165, –6174, gifts of the Wellcome Trust.

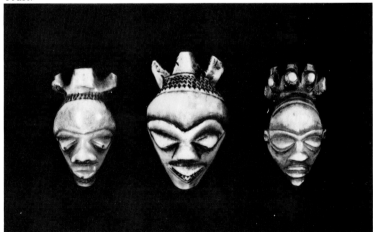

Lega

Judith Hunn

The Lega are a culturally and linguistically homogeneous people of the eastern Congo numbering about 250,000. While the Lega share a common origin and culture, they are politically noncentralized; they live in scattered, autonomous groups, organized into localized patriclans comprised of numerous lineages. The environment in Legaland ranges from dense tropical rain forest in the northwest to savanna and woodlands in the southeast. Agriculture, food gathering, hunting, and trapping are the basic means of sustenance. The area harbors a rich variety of lush vegetation and exotic fauna important in both diet and symbolic value. Animals include many species of monkey, turtle, antelope, rodent, and elephant, as well as buffalo, leopard, aardvark, pangolin, warthog, hornbill, and giant snail. Game meat is served at feasts and exchanged during ceremonies. Animal parts are used as adornments, initiation objects, and prestige symbols.

Central to Lega life, society, art, and religion is the graded *bwami* association. It represents the search for moral excellence, prestige, wealth, and authority. Advancement in *bwami* is the goal of Lega life, and the association consists of five grades for men and three for women. Membership in *bwami* transcends kinship and territorial subdivisions, thereby providing solidarity among the Lega. By means of song, dance, pantomime, and drama, initiatory rituals promote the virtues of beauty, wisdom, peace, and strength.[37]

All Lega art is made exclusively for the *bwami* association by members of respective grades.[38] Art objects, along with natural objects and manufactured goods,[39] are integral to initiatory rituals. Single pieces of special importance are kept by individuals in bags, while most are placed with other initiatory objects in collectively held baskets. Each piece acquires meaning and significance only from consecration. Through the manipulation and display of these items and through sung aphorisms, these meanings are revealed. *Bwami* art and initiatory objects thus become vehicles for vast numbers of proverbial teachings. Outsiders must not assume equivalences of form or meaning for often none exists. This multidimensional symbolic system is known only to the Lega and has retained much of its secrecy.

The Lega make no evaluation of quality in their art. All objects associated with *bwami* are considered good and beautiful and, therefore, are not compared on aesthetic grounds.[40] Mediocre carvings and natural objects are displayed with artworks of superb quality. Moreover, when a piece is lost or broken, its replacement need not even be another art object; rather, as Biebuyck has stated, it must be "something that is functional and is the semantic equivalent of the original article" (1973:177–178).

Ownership and transfer of objects occur completely within kinship groups. The transfer of an object, upon the death or ascendance of its owner or trustee, provides a communicating "essence" between initiates. Art thus becomes part of a vital symbolic chain linking the

living with the dead and representing the permanence of *bwami* (Biebuyck 1973:158;1972:19).[41]

Masks and maskettes constitute one of several categories of *bwami* art objects. Masks are made of wood, elephant ivory and bone, and occasionally elephant leather. Some have fiber beards, and wooden masks may be painted either red or white. Like most Lega art forms, masks are used extensively in the highest *bwami* grades, *yananio* and *kindi*, and to a lesser extent in lower grade rituals. Masks are owned by initiated men, either individually or collectively. However, wives of initiated men may use them in their own *bwami* rites.[42] During *bwami* ceremonies dancers, whether masked or not, wear no elaborate costumes; they are dressed in their regular dance paraphernalia or occasionally in white bark cloth or animal skins. Masks are worn on the face, skull, temples, back of the head, shoulders, or knees (Fig. 73). They are rubbed, touched, turned, swung, dragged by the beard, and shot with arrows; they are displayed alone or in groups with other objects in piles, circles, and rows or may be fastened to fences or poles (Fig. 74; Biebuyck 1973:149,210–211). These varied viewing contexts, rarely involving concealed masqueraders, stand in marked contrast with most African masking practices.

Five categories of masks are determined according to size, material, and form. *Lukwakongo* are wooden maskettes with beards, individually owned by members of the *yananio* grade. They are the most numerous of all mask types. *Kukungu* are small ivory, bone, or well-polished wooden masks used in *kindi* initiations. Large wooden or ivory masks held in individual trusteeship by *kindi* members are called *idimu*; these are quite rare. Large wooden horned masks, painted white, are called *kayamba* and are kept in collectively held baskets. These four types represent grade emblems and change hands within their respective grade upon the death or elevation of a member. Only rare wooden *muminia* masks are kept by individuals throughout their membership in different *bwami* grades, and they are passed on within kinship groups only at the death of their owners. *Muminia* masks are thus primarily possessions of kinship groups and are only secondarily *bwami* initiatory objects (Biebuyck 1954:109;1973:164,183).

In general masks bring to the Lega mind death and sorcery for they are associated with skulls. Nevertheless, masks may symbolize varied ideas depending upon their use in a given ritual context. Like all Lega art, masks derive their value and meaning from a complex social and philosophical system. Lega art is highly functional and dramatically underlines the ethics and ideals of the *bwami* association. Art and other initiatory objects are thus a storehouse of concrete symbols that help to translate intricate, abstract notions into metaphorical language (Biebuyck 1973:170,185,212–213).

Lukwakongo

The wooden masks in Figures 75 and 76 illustrate the formal conventions of the *lukwakongo* type. Nearly all wooden Lega masks have raffia beards (Biebuyck 1954:110), as these do. Figure 76 exemplifies the typical heart-shaped face set off by white pigment, while Figure 75 has concave eye sockets rather than a full heart-shaped face, and the pigment (now missing) appears to have been rust-colored.

Lukwakongo, the largest of the five Lega mask categories, are individually owned by members of the *lutumbo lwa yananio*, the second

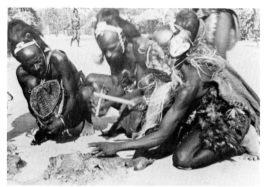

FIGURE 73. Preceptor wearing a *muminia* mask in the *nkunda* rite of *lutumbo lwa kindi*; the rite illustrates the activities of a tutor who searches for candidates whom he can help through initiations; Zaïre. Photo: Daniel Biebuyck, 1950s.

FIGURE 74. Masks in ivory or bone attached to a fence, together with a large *muminia* mask, during a *lutumbo lwa kindi* rite; Zaïre. Photo: Daniel Biebuyck, 1950s.

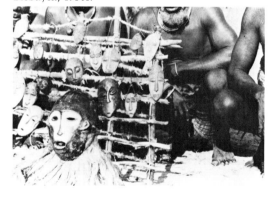

and highest level of the *yananio* grade of *bwami*.[43] *Lukwakongo*, which literally means "death gathers in," are occasionally called *tulimu*, a term connoting spirits and ancestors (Biebuyck 1973:164). In songs a group of *lukwakongo* is sometimes referred to as *malumba*, meaning "graves." When a *bwami* dies, his mask remains a memento after his true grave is no longer visible. A Lega aphorism associated with this notion is "Bring together the graves, that I may know the skull (mask) of my father" (Biebuyck 1973:174,211–212).

Lukwakongo and *tulimu* also refer to initiation rites of *lutumbo lwa yananio*. This ceremony lasts two to three days and consists of thirteen rites during which masked initiates represent proverbial beings that embody ideas. For example, initiates wearing masks with beards may incarnate the Bearded-Folk, referring to a group in which senior and junior members cannot be distinguished and thus all have equal say. Or they may represent the Great-Old-Organizers who "agitate the beards because they have eaten nothing," referring to old men who are due respect and should not be ridiculed or rejected when they beg for food. Maskers also clown and mock improper behavior (Biebuyck 1973:212). During the *lukwakongo* rite, all participating *yananio* members must produce and dance their masks while eleven songs and chanted proverbs interpret their actions. In the *tulimu* rite, initiates hold wooden masks with long beards and dance, reciting nine proverbs (Biebuyck 1973:77–79,168). During the *nkunda* rite, seventy-two proverbs are used in a reenactment of a poison ordeal in which leaders are partially disguised by small face masks and costumes of genet hides, feathers, and snake skins. Still another rite involving sixty-nine proverbs uses masks in conjunction with objects including chimpanzee skulls, giant snail shells, porcupine quills, small knives, parrot feathers, and various leaves.

During the *lutumbo lwa yananio* ceremony, *lukwakongo* masks may be carried, tied to the knees, the forehead, the back of the head, or the temples, or they may be held under the chin. Each mask acquires a new meaning during different phases of the initiation. For example, picking up a mask from the ground with one's teeth is a symbol of strength and of one who achieves *bwami* by his own power without the aid of a father or senior brother. A mask hanging by its beard represents a *mulima* bat that is angry with the sun and refers to a person who prefers stupidity to *bwami* and its wisdom. Attaching a mask to the knee illustrates the aphorism, "The long well-shaped nose becomes a licker of honey," which stigmatizes interference in other people's business. Holding a mask by the forehead and swinging its beard in the air refers to the idea that all come to the initiations, kinsmen and nonkinsmen, and is associated with the aphorism, "I have arrived at the place where the elephants slept; every leaf has a stain of soil." A mask tied to the back of the head is meant to recall the battle of Tubala where the Lega were defeated and carried their shields on their backs (Biebuyck 1973:213).

Yananio initiates thus perform a succession of symbolic dramas, each employing masks in a different context. Words, music, dance, mask, and the masker's activity are interdependent, equally essential components meaningful only in unison.

The mask in Figure 77 probably belongs to the *lukwakongo* ceremony, being small and of carved wood.[44] Unusual, however, is the abundant adornment of feathers and monkey fur bordering the face. Curiously, *lukwakongo* masks are used by preceptors to personify

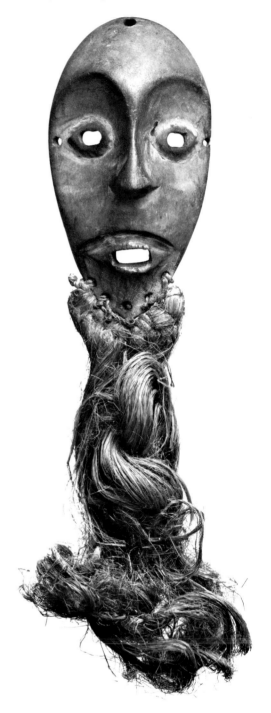

FIGURE 75. Lega *lukwakongo* mask; Zaïre. Wood, red and white pigment, 25.5 cm. UCLA MCH 378–145, Museum purchase.

90

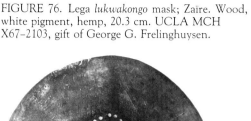

FIGURE 76. Lega *lukwakongo* mask; Zaïre. Wood, white pigment, hemp, 20.3 cm. UCLA MCH X67–2103, gift of George G. Frelinghuysen.

FIGURE 77. Lega *lukwakongo* mask; Zaïre. Wood, white pigment, monkey fur, feathers, 27.9 cm. UCLA MCH 378–119, Museum purchase.

creatures like pangolins, turtles, queen bees, old chimpanzees, and monkeys (Biebuyck 1973:212). Perhaps the mask was intended to represent the latter.[45] Among the other characters enacted by *lukwakongo* are the diviner, tracker, harvester, guardian, old beggar, and proverbially, beings such as: Glutton; Mr. Well-Shaped-Nose; Who-Looks-For-Trouble; Who-Is-Always-Sick; and Mr. Pride (Biebuyck 1973:212). This mask is an especially fine example with well-defined and proportioned features and a beautifully shaped ovoid head with a heart-shaped face painted white. The head is black, bordered by an array of black and white fur and feathers in striking contrast of both color and texture.

Lukwakongo masks are sometimes hung on a fence or laid out in configurations on the ground and referred to as the skulls of a legendary group defeated by its enemies. In this context they are reminders of war and destruction (Biebuyck 1973:212). According to Biebuyck, the Lega rubbed white clay around the eyes and ashes on the eyebrows when at war (1954:110). Similar patterns on the masks may be a carry-over of such practices. Figure 78 shows a red mask that has white clay (*mpemba*) around the eyes and nose. Application of white clay around only the eyes and nose is rare on Lega masks; either wooden masks are painted white on the entire face or heart-shaped area, or they have no paint at all. Such designs sometimes occur on *muminia* masks (Biebuyck 1954:110).

Size and material suggest *lukwakongo*, not *muminia*, as the category for this mask. It is a beautiful and unusual example, with great depth and a striking reddish-brown color. The limited area of white pigment is not arbitrarily painted but follows a concave, carved facial surface. The features are particularly rounded, especially in the line of the nose ridge, which joins the brow with the small round mouth. The impression of a skull is strongly suggested.

Lukungu

The two *lukungu* masks in Figures 79 and 80 are carved ivory, and they have the characteristic slightly convex, oval head with a heart-shaped concave face. The nose ridge is in low relief, and the mouth and eyes protrude slightly with indentations. Such masks vary in size not exceeding 18 cm (Biebuyck 1954:111). These examples have the common Lega circle and dot motif, above the eyes of the smaller mask and over the brow of the larger. Such decorations probably refer "to the transience of youth and physical beauty" (Biebuyck 1973:213). The smaller mask has a fiber beard and a fiber harness on the back; the larger has holes above the temples for the attachment of such a harness.

The concept of a spirit of oneness and solidarity guiding the masks is reinforced by the standard facial type of Lega masks and the fact that masked initiates are referred to as "insects that all look alike." Masked initiates may symbolize the gatherings of all, including clever and intelligent beings as well as persons of evil wit and purpose (Biebuyck 1973:92).

Lukungu masks are owned by individual members of the highest level of *kindi, lutumbo lwa kindi*.[46] They are more limited in usage and meaning than *lukwakongo* masks and are never worn on the face or elsewhere on the body. During the initiation rites to this level, which

FIGURE 78. Lega *lukwakongo* mask; Zaïre. Wood, white clay or pigment, reddish pigment, 13.9 cm. UCLA MCH 378-123, Museum purchase.

FIGURE 79. Lega *lukungu* mask; Zaïre. Ivory, 17.3 cm. UCLA MCH X73-584.

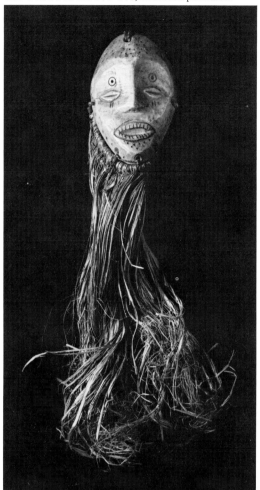

FIGURE 80. Lega *lukungu* mask; Zaïre. Ivory, 21.6 cm. UCLA MCH 378-144, Museum purchase.

last four to seven days, each *kindi* hangs his *lukungu* mask on a fence (Fig. 74). Often they are fastened around a larger, single wooden *muminia* mask. Initiates dance around the fence, pointing to the masks and to figurines hanging beside them. The dancers enact proverbial dramas while aphorisms are sung as part of the teachings of the initiation. *Lukungu* means skull, and the masks are a reminder of the skulls of those who died in war or because of fighting in the village. Such a confrontation also recalls the death of *kindi* members and suggests the universality of death. Among the aphorisms associated with this rite is "Death is the rising moon; every clan has seen it" (Biebuyck 1973:213).

Upon the death of a *lutumbo lwa kindi* member, his *lukungu* mask is displayed with other insignia on his grave. Afterward it passes to a nephew or a close kinsman initiated into *lutumbo lwa kindi*. This transfer of ownership adds a mystic dimension to the mask, which serves as a symbolic medium linking the new owner to the previous ones. An associated proverb is "I know my father because of his skull (mask) although I do not know where/when he died" (Biebuyck 1954:111; 1973:173–174,211). Proverbs such as this suggest that masks, as well as other artworks, "are equated with the vital and permanent bony parts of the human (skull, limb) and animal (ivory tusk) body" and that they are either a semblance of the dead or an idea about them (Biebuyck 1973:174). In general a mask may be called *kansusania ka muntu*, meaning "a semblance of a man."

Lukungu masks are also carried in the hand and placed on the ground in patterns with figurines and natural materials (Biebuyck 1973:plate 56). Despite the seriousness of these initiations, the dramatic contexts are characterized by entertainment, play,and surprise, and Lega masks are used to teach but never to inspire fear or terror (Biebuyck 1973:176–177).

Makonde

Gail Wallace

The approximately 500,000 Bantu-speaking Makonde live on high plateaus flanking the Rovuma River in southeast Tanzania and northeast Mozambique (Fouquer 1971:4).[47] They are principally agriculturalists, relying on slash-and-burn techniques in arid, nutrient-poor soil. They also raise domestic animals, hunt wild ones, and gather fruits and plants in the forest. Although their agricultural efforts are successful, men sometimes leave villages to work in industries or on plantations (Dias 1964:59).

The Makonde are comprised of separate clans, each embracing several autonomous villages (Dias 1964:30). Important community decisions are made by a chief under the guidance of a council. Clan members congregate normally only for special festivals, mainly for ancestor worship and to celebrate initiations (Dias 1964:44–45).

Succession and inheritance are matrilineal and marriage is matrilocal among the Makonde. The high status of women is also reflected in mythology, religion, and art. According to a Makonde myth, shortly after the first ancestor of man, or perhaps man himself, crawled out of the bush, he carved a female figure from a piece of wood and the fell asleep. He awoke later to find the statue transformed overnight into a woman. She bore him many children and, after her death, was deified as the original ancestress of the people. This legend, as Dias points out, seems to explain not only the cult of female ancestor worship, but also the profusion of carved female figures that were kept in huts or sometimes taken on trips for protection (1864:33). In any case, the Makonde believe in a spirit world consisting primarily of ancestors, some of whom are deified and worshiped, and mischievous spirits, all of them supposedly appearing and dancing at the conclusion of initiation rites.[48]

Initiation ceremonies, *unyago*, are held for both males and females to mark their entry into adulthood. Male initation consists of a long period of seclusion in the bush where the boys, during and after circumcision, undergo schooling and trials in discipline, endurance, strength, and various male skills. The girls are secluded for about six months and are principally taught their new roles as women, including sex education. Both sexes sometimes choose to be tattooed at this time (Schneider 1975:28). The Makonde regard these designs not only as decoration but as a form of tribal identity as well, and many elaborate tattoo designs for which these people are well known are faithfully reproduced on their masks (Figs. 81–83).

Initiation rites end with several days of feasting and dancing, including dances by masked men who have already been initiated and whose bodies are completely covered to conceal their identity. When the traditional initiatory activities have been completed, the chief hands the initiates back to their parents in the central village square. The masqueraders and their sponsors, who play drums and sing, follow the new adults and dance in front of each of their homes. This ceremony is repeated during the next two days. Relatives of new initiates give gifts of food or money to the dancers who share it with

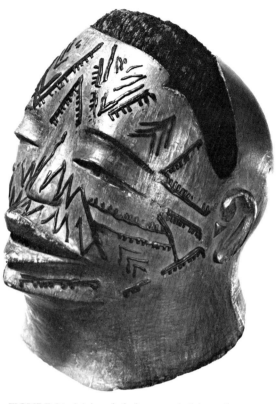

FIGURE 81. Makonde helmet mask; Mozambique.
Wood, wax, hair, 23.5 cm. UCLA MCH X83–269,
gift of Arthur H. Stromberg.

FIGURE 82. Makonde helmet mask; Mozambique.
Wood, wax, 27 cm. Anonymous loan.

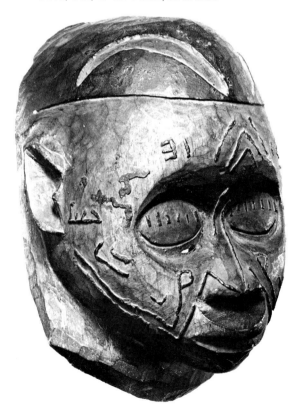

their numerous sponsors (Wembah–Rashid 1971:43–44).

Masks represent either ancestral spirits or animals; many of the former are recognizable as famous or infamous personages—"devils." Ancestors return, masked, to express their joy that initiations are taking place. Their presence of course demonstrates the close link between the living and the dead in Makonde thought. Many of the masks are painted a dull red. This coloration is probably tied to the initiation rite itself, as initiates are marked several times with a powerful red ochre medicine (Lang 1960:32–33). Furthermore, red is symbolic of menstruation, just as black indicates sexual impurity and white, sexual purity (Harries 1944:42).

Several types of masked dances are performed for three days at the termination of initiation ceremonies. Usually two pairs of male and female dancers—females easily recognizable by wooden breastplates and the lip-plugs on their masks—dance together by standing across from one another, sometimes moving their pelvises in simulated sexual intercourse. The maskers, of course, are exclusively male. Other masqueraders represent animals or evil spirits, as well as particular individuals or types of people. Stilt dancers dramatize different aspects of community life (Wembah–Rashid 1971:42). All masquerading involves drum music and often singing too.

All these exclusively male masked dances were originally intended to terrify women and thus strike a blow against their power, although these days it is said that women no longer fear the masks.

Figure 81 is a good example of a helmet mask carved in a fleshy, naturalistic mode. Helmet masks are exclusive to the Mozambique Makonde and are worn at the culmination of initiation rites. They are worn on top of the dancer's head with a cloth wrapped around the base of its neck, disguising the face of the masquerader. Since, according to Wembah–Rashid, the mask is worn for half a day's dance, ventilation is a consideration (1971:41). Tightly fitting costumes cover the entire body, and as Figure 83 indicates, are often hung with rattling seedpods activated by the dancers' motions. Costumes and hand-held objects vary according to the character portrayed. Several specific animals and people may appear, Old Man, Glutton, Doctor, Young Girl, among many others, and the plays dramatize varied aspects of Makonde life: "The hazards of honey collection, hunting, clearing a new farm, the cunningness of doctoring, courting a girl, witchcraft and cowardice, the impudence of the unfaithful wife and husband, etc." (Wembah–Rashid 1971:42).

The elaborate geometric beeswax designs, reproducing tattoo, completely cover the smooth wooden face (Fig. 81). These symbols and their placement on the face and body are ruled by tradition and were thought at one time to have had a magical as well as decorative function. Professional tattoo artists who have inherited the knowledge make the incisions which are then rubbed with charcoal dust. This procedure is repeated over a period of months until the desired pattern is complete (Schneider 1975:27,28). The dark, crescentlike shape above the brow represents a shaved hair design. Many Makonde masks, like this one, have real human hair glued on to create these patterns.

The very fine mask in Figure 82 is an older, well-worn example very sensitively carved in a somewhat less naturalistic style than the mask in Figure 81, although its facial planes are gently rounded and the features smoothly integrated. The flat plane over the upper lip prob-

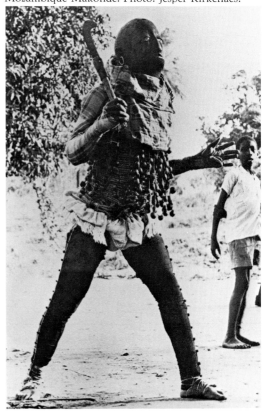

FIGURE 83. Helmet-masked dancer among the Mozambique Makonde. Photo: Jesper Kirkenaes.

ably represents a lip labret or plug. It too has beeswax tattoo patterns in relief. The nearly closed eyes on this example give it—to us—a solemn, meditative expression although we cannot be sure this was the artist's specific intention.

The lip-plug (*ndona*) is a decorative feature peculiar to Makonde women in recent times, although on occasion an older male can still be found wearing one. It is also a mark of tribal identity. Insertion of a plug occurs when the girl is still a child. Her upper lip is pierced, a small object such as a twig or a blade of grass is placed into the wound. The hole is gradually widened, and a larger plug of ebony or bleached white wood is eventually worn as a mark of status and prestige. The small face mask in Figure 84 dramatizes such a projecting labret. According to Wembah-Rashid, most face masks come from Tanzania and, like the helmet masks, are worn at initiation ceremonies (1971:42). Furthermore, while helmet masks are detailed and almost grotesquely naturalistic, face masks are simplified and highly conventionalized, as is this example with its thin, bladelike nose extending downward from a pronounced browridge. The simple, tablike concave ears project boldly and help to create the impression of alertness conveyed by this mask.

FIGURE 84. Makonde mask; Tanzania. Wood, 21.6 cm. UCLA MCH X65–5858, gift of the Wellcome Trust.

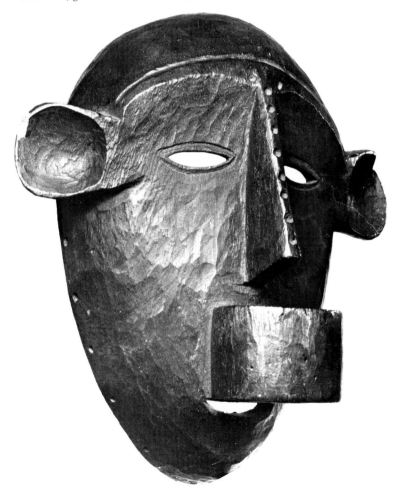

A Mumuye Mask

Arnold G. Rubin

The Mumuye are a collection of peoples speaking several related languages. They live in the arid and rocky hills south of the Benue River in northeast Nigeria and had no centralized political organization until the advent of colonial rule. Chiefs and religious specialists, in conjunction with elders, however, held authority at local levels. The Mumuye were often invaded by other peoples—the Chamba and Fulani, for example—but, for the most part successfully resisted these attacks and held to their own traditions and beliefs. Their religion stresses rainmaking, and the Mumuye are especially well-known as yam farmers. Some diviners and doctors own figural sculptures—dynamic abstractions and distortions of the human body—which oversee their professional functions, while other images symbolize generalized tutelary spirits and reinforce the role and stature of important elders who are their custodians.

Masquerades,[49] in contrast, focus the collective identities of age-sets, groups of males who are initiated together, usually at seven-year intervals. These organized and disciplined groups are important in a culture without a centralized political system, and they formerly served as defensive militia. Today they foster male solidarity and unity. The men of one age-set hunt and farm together and often marry in the same year; as young initiates one of their first collaborative acts was to pool their resources to commission a mask which symbolizes their social cohesion. This mask and age-set share the same name.

The typical form of a Mumuye mask is that of a honored animal—bush cow or cape buffalo—generically called *Va* or *Vabon*. The masks are worn diagonally, with thick mantles of white, combed-out hibiscus fiber (Figs. 85,86). In some places initiates are called "sons of *Va*," indicating their close relationship with *Va*, a guiding tutelary spirit. Masks also have specific personal names: "Troublesome," "Leopard," "Crazy," "Fire," "The Wind Can Blow in Any Direction," for example. The mask in Figure 85 was identified by its owners as "Horse," *Va Gbanta*. These names stress the association of powerful creatures of the bush, unpredictable spirits, other forces (i.e., "fire") and even ideas ("crazy") with the age-grade. Some of these animal masks are also owned by kindreds, and these, along with age-set masquerades, discharge a variety of social control functions.

Vabon dance at initiations, funeral celebrations, agricultural rituals (planting, harvest), and other public events important to community life. Initiation "graduation" rites feature masked dances of the new initiates as well as older groups, each with its own mask, and these performances are strictly closed to women and children. Other maskers exercise regulatory authority such as peacemaking and punishing social deviants; masks could even ward off epidemics. Some of these masks attained considerable spiritual power; they were kept in shrines administered by hereditary priests, and in some places masks were used to inspire young warriors preparing for battle. The Mumuye are a heterogeneous group of people, and it is not surprising

that their masks serve many and varied purposes.

If their resources are sufficient, some age-sets commission a second mask, usually conceived of as female, called "Wife of *Va*," "Grandmother," or "Old Woman." Some of these masks provide comic relief and are distinctly secondary to the male spirits, while others are paramount religious images in their communities.

One striking masquerade occurs each year (in some places, every two years) when the souls of those who have died during that period are ritually released to the world beyond. After his death, each prominent man's family erects a domestic altar for him; on it is placed (among other things) a large ceramic pot with a bush cow finial. The pot is made by the deceased man's sister. On the day appointed for the memorial, four to six maskers troop through the community with their attendants who blow long calabash trumpets, visiting each deceased man's compound (Fig. 86). His ritual pot is removed from the shrine, its finial broken off, and the pot, with others, is carried to a sacred site. While the bush cow maskers encircle the area to the sounds of trumpets, the designated leader fans a handful of straw into flame, whereupon the pot-bearers smash their vessels on the heap of shards accumulated from previous observances. Before the pots are smashed, the maskers will have removed their masks to their shoulders, as if to keep their own souls from being drawn into the world of spirits. This dramatic event, a kind of "all souls festival," effects a final separation of deceased men from the living community. Women are barred from this rite, yet earlier in the day have conducted an analagous ritual, using a different sort of ceramic vessel, for the female dead.

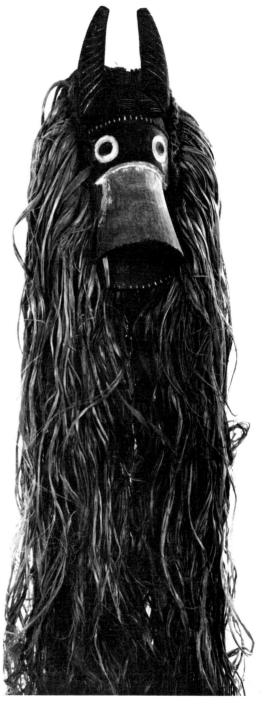

FIGURE 85. Mumuye *Va Gbanta* mask (horse); carved by Sowa of Pantisawa village, Nigeria, ca. 1963. Wood, fiber, 51.1 cm. UCLA MCH LX83–12, collected by Arnold Rubin in 1970.

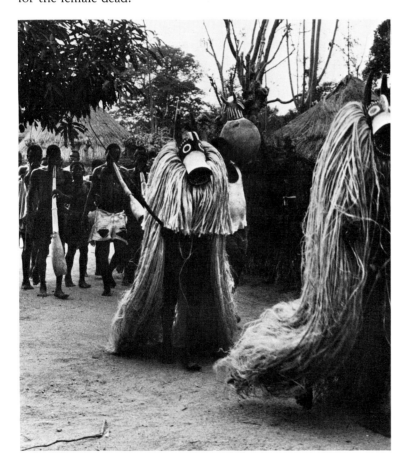

FIGURE 86. Two *Vabon* maskers with trumpeters and an attendant carrying a memorial ceramic pot; Pantisawa, Nigeria. Photo: Arnold Rubin, 1969.

A Salampasu Mask

Herbert M. Cole

The Salampasu are a warlike people who live east of the Kasai River in Zaïre. Their neighbors are the Chokwe and Lunda to the west and south, the Lwalwa and Kete to the north and east. In contrast to the Lunda, whose attempted domination they largely resisted, Salampasu peoples are loosely organized politically (Walker 1966:46). Some chiefs, however, exercised considerable power and organized armies strong enough to repulse Lunda and Chokwe expansionist campaigns. Warfare and hunting were esteemed occupations.

Salampasu arts are not well elucidated in the literature although their masks are well-known and distinctive in style. They are often multimedia constructions of fiber, feathers, wood, and other materials, some being covered over with sheet copper strips. Style features include a projecting domical forehead beneath which springs a pyramidal nose, wide at the base. Masks, as well as monumental figural sculptures in wood, are known to have figured in male initiations and "during propitiatory ceremonies which assure or reestablish the well-being and equilibrium of the group" (Walker 1966:46). Apart from these generalizations—which apply to most African masks—we have some unique data from the man who collected the mask in Figure 87 in the early 1940s.

In a letter dated May 10, 1944, from the mask's collector, a missionary named Joe Henderson, to its then-owner Ralph Altman (who subsequently gave it to the Museum of Cultural History), we learn rather more about the power-contexts of at least some Salampasu masks. And we understand more about the awe in which Salampasu people were held. Mr. Henderson's letter, which we quote at some length, also reveals something about the beliefs and behaviors of both the Salampasu and the missionaries who labored in their fields.

> The name of the Costume is "Ackish" but when it is being worn by a man it is called, "Mukish." Mu- which means "in," denotes that the man is in the "Ackish," so that when a native says "Mukish" they know that the costume is being worn. Then all the women and children will run from the village when they hear the word spoken. But when they hear "Ackish" they know that the costume is in the house that is built purposely for it to be stored in.
>
> I was working in the village of Kandembu (a chief) building a church. I had 30 men working on a grass roof. I was sitting beside the chief on the roof when suddenly they cried "Mukish"! Everyone slid to the ground, but when the chief started to slide I caught him and asked him where the men were going, why they were quitting work. He told me that a powerful "Mukish" from another village was passing through the country and would kill all the women who might see him so they were trying to protect the women of the village. I thought that a man being that powerful I wanted to see him to (sic) so jumped on my bycycle (sic) and arrived at the path entering the forest before the rest. Three boys about 15 years of age were standing there and showed me where he had entered. These boys led the way and I

overtook the "Mukish" and five or six of his attendants about a half mile in the forest. But the men of the village that were building the church never caught up with me. I wondered where they had gone to as I was alone with only the three small boys.

After I had stopped the Mukish with his personal body-guard and tried to get him to talk I saw all of my workmen (some one hundred of them) had traveled through the forest and had circled around us as we were standing in the path. Then I knew that I was safe to demand him to remove his mask. My men would have killed the entire group if I had of given them the word. He refused to remove the mask so I took his mask and cut it from him. Upon seeing his face I knew that it was one of the men that had helped me build a church in his own village some weeks previous.

After I removed his mask all of my workmen gathered in closely around us. I removed all of the costume from him and gave him some leaves of the trees to wear for clothing. I could not get one man to touch the costume because of the fear that they have for it. When I reached the path at the edge of the forest my arm became tired from holding the skins up from dragging the ground so I dropped them in the path behind me. The chief was walking backwards in front of me pleading for me not to take it into the village as it would kill all of the women. I stopped and explained to me (sic) that I would be responsible for every woman that died, and when I looked behind me no one would walk in the

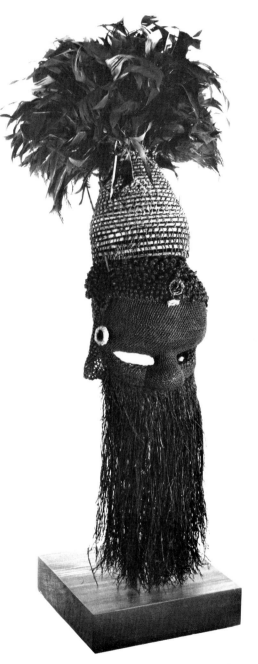

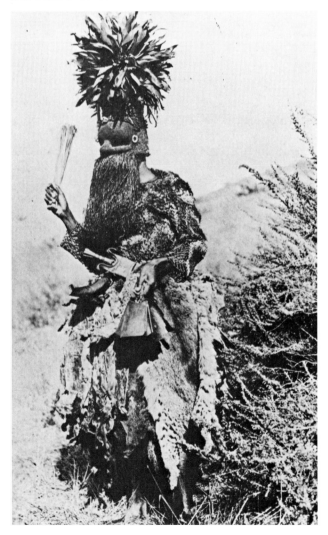

FIGURE 87. Salampasu mask; Zaïre. Fibers, feathers, 91.4 cm. UCLA MCH X63–592, gift of Mr. and Mrs. Ralph Altman.

FIGURE 88. The mask shown in Figure 87, in context with its animal skin costume. Photo: Joe Henderson, 1940s.

path behind me because the spirits were falling in the path where the skins were touching the ground. I then held them high in the air and shook them and told them that the spirits had all fallen off.

When I arrived at my camp I put the costume on my bed and made ready for dinner as it was late in the evening. But to my surprise found that my christian cook would not come to the house from the kitchen with my food, as he knew that every native who would enter the house where the costume was would die. He knew that the man that owned the "ackish" would be the one who killed him.

The man who wore the costume was sitting in the path in front of my camp and begged for at least one hair. I inquired of my cook why he wanted that one hair and learned that it would be a part of the original and when rubbed upon another skin the spirits would all join him again, and he would possess as much power as before. I then called the man that wore the costume and explained to him that I was going to keep it forever and take it with me to America, and that if one person man or woman ever became ill because of this ackish that I would report him to the Government and have him placed in prison. I knew that he or his attendants would be the ones that would poison the people that became sick. He promised me that no man or woman would ever be sick, and then my cook brought my dinner to me.

After I arrived in the United States I was compelled to destroy the skins because of the moths.

I disposed of the rest of my costume among my friends before leaving for the field.

If you are a collector of costumes and masks or native art of any kind whatsoever, I will no doubt be able to send you quite a collection after my arrival upon the field.

I have tried to explain how I acquired the Mukish in detail and trust that it is to your satisfaction. I did forget to tell you that I tried to trace it to its origin and found that it had been owned by a number of men that had possessed it for approximately 200 years. As time went on when parts of the costume would wear out they would add new parts to it.

We are fortunate to have Mr. Henderson's photograph (Fig. 88) of our mask, its feathers somewhat fuller than they are today. It would appear that *ackish* and *mukish* are generic names for masks and spirits, respectively, rather than being specific to this example.

A Kuba Mask

Bonnie E. Weston

The Kuba live in the Lower Kasai region of central Zaïre in a rich environment of dense forest and savanna. Organized into a federation of chiefdoms, the almost 200,000 Kuba are a diverse group of over eighteen different peoples unified under the Bushong king. They share a single economy and, to varying degrees, common cultural and historical traditions. Agriculture is the main occupation, supplemented by hunting, fishing, and trading. The name "Kuba" comes from the Luba people to the southeast. The Kuba call themselves "the children of Woot"—after their founding ancestor (Vansina 1964:6;1078:4).

Praised as "God on Earth," the king, *nyim*, is a divine ruler who controls fertility and communicates with the creator, *Mboom*. The royal court at Nsheng is a hierarchical complex of councils and titled officials who advise the king and balance his power. Outlying Kuba chiefdoms are largely autonomous, organized on models analogous to those of the capital but on a lesser scale (Vansina 1964:98–99; 1978:216). Kuba society parallels governmental organization in that it is stratified. Yet the Kuba people prize hard work and achievement, and while position of birth may secure advantage, it is not binding (Vansina 1964:188;1968:13,15).

Kuba religion, however, is not highly organized. The creator, *Mboom*, is recognized but is not formally worshiped. More consideration is given to Woot, who led the Kuba migration "up river" and established matrilineal descent, male initiation, and kingship. Local nature spirits, tended by priests and priestesses, are actively involved in people's lives, notably in matters of fertility, health, and hunting. The Kuba have no ancestor cult but do believe in reincarnation (Vansina 1964:9–10).

Kuba arts primarily address status, prestige, and the court; they are manifestations of social and political hierarchy. Rank and wealth are expressed in extensive displays of regalia: jewelry, rich garments of embroidered raffia cloth, ceremonial knives, swords, drums, and elaborated utilitarian items. Valuable imported cowrie shells and beads emblellish garments, furniture, baskets, and masks.

The outstanding Kuba style diagnostic is geometric patterning used to embellish the surfaces of many objects. These designs are woven into raffia textiles and mats, plaited in walls, executed in shell and bead decoration, and incised on bowls, cups, boxes, pipes, staffs, and other forms including masks. All art forms and designs are laden with symbolic and iconographic meaning, and the same is true of the rich Kuba masquerades.

Masking was first introduced by a woman who carved a face on a calabash, the original model for initiation masks. The invention was taken over by men, incorporated into initiation, and remains a male privilege. Once Bushong boys move into the *nkan* initiation shelter, they can wear masks and make excursions into the village frightening women and small children. More powerful masks are

103

worn by initiation officials. The masked Kuba dancer is, in every instance, a spirit manifestation (Torday 1910:250; Vansina 1955:140).

Three royal mask types exist:[50] the tailored *Mwaash aMbooy*, representing Woot and the king; the wooden face mask, *Ngady Mwaash aMbooy*, the incestuous sister-wife of Woot; and the wooden helmet mask, *Bwoom* (Pl. 8), the commoner. These characters appear in a variety of contexts including public ceremonies, rites involving the king, and initiations. Although their dances are generally solo, together the three royal masks reenact Kuba myths of origin (Cornet 1982:254,256; Roy 1979:170).

Bwoom is a wooden helmet mask elucidated by varied oral traditions. The Kuba feel that one " 'understands' the why of something if one knows how it 'began'; something is known if it is explained" (Vansina 1978:15). Thus *Bwoom* is the spirit first seen by *nkan* initiates; he is a hydrocephalic prince, a commoner, a pygmy, or one who opposes the king's authority. Two traditions trace Bwoom's origin to the reign of King Miko mi-Mbul, who had gone mad after killing the children of his precedessor. Although he finally became sane, Miko would lapse into madness each time he wore *Mwaash aMbooy*, the most important royal mask and until then the only one worn by the king himself. A pygmy offered the king *Bwoom* as an alternative. Suffering no ill effects with the new mask, Miko accepted it. A less dramatic version is that Miko, known as a great dancer, was simply seduced by the pygmy's creation and adopted it despite its humble character. In both cases the King is credited with improvements to the mask that justify its inclusion in the royal repertoire (Cornet 1982:269).

As inconsistent as they may seem, each account expresses an aspect of the mask or its character. The identification of *Bwoom* as a pygmy or a hydrocephalic man is often cited to explain the mask's enlarged forehead and broad nose. *Bwoom* appears in initiation and is always considered a spirit. The lowly origin of the character is reflected in its description: "a person of low standing scarcely worthy of being embodied by the king" (Cornet 1975:89) and conversely in its defiant performance opposite the regal *Mwaash aMbooy*. The two may act out a competition for the affections of the one female in the royal mask trio, *Ngady mwaash aMbooy* (Cornet 1982:255). *Mwaash aMbooy*'s dance is calm and stately, while *Bwoom* acts with pride and aggression (Cornet 1982:255). The masks are easily differentiated by material, for *Bwoom* is carved from a single piece of wood and *Mwaash aMbooy* is made from cloth and raffia textiles.

Bwoom appears on the *nkan* "initiation fence" of the Bushong (Vansina 1955:150–151) and in other initiation contexts. Little is known of this mask (or indeed most Kuba arts) outside of the royal Nsheng tradition.

A royal mask, *Bwoom* is sometimes worn by the king. Yet unlike *Mwaash aMbooy*, *Bwoom* does not appear at funerals, and it is never interred with the king or other dignitaries (Cornet 1982:270). The costume is similar to that of *Mwaash aMbooy*: heavy with profuse layers of raffia-cloth, bead and cowrie decoration, leopard skins, anklets, armlets, and fresh leaves. Eagle feathers or other prestigious media are added to the crown of the head when the mask is danced.

Despite regional variations, the *Bwoom* mask conforms to a distinct type. All styles feature strongly rendered proportions dominated by an enlarged brow, broad nose, and usually naturalistic ears. Typical

features include the metal work on the forehead, cheeks, and mouth, bands of beads that embellish the face, and an expanse of beadwork at the temples and back of the head. Plate 8 has these plus patterned raffia-cloth covering the top of the head, with a fringe of hair. The blue beads set into the white band at the temples imitate ethnic tattoo patterns (Cornet 1982:266), and the design at the back of the head is one associated with royalty.

Notes

1. In most cases the peoples of these cultures speak a language (e.g., Bamana, Bidjogo) by which they are known. This is not true of the Voltaic, Northern Edo, and Cameroon Grasslands sections, however, which embrace several peoples (and languages) that tend to be quite closely related. Furthermore, some chapters (i.e., Mende, Dan, Baule) include masks from other contiguous peoples.

2. This essay expands upon some ideas first expressed by me in *African Arts of Transformation* (1970), an exhibition and catalogue. The latter has long been out of print, and for some years I have been revising and expanding parts of it for publication.

3. Without quantified data available, it appears that masking is no more prevalent along matrilineal peoples than those practicing patriliny. What is very clear, on the other hand, is that settled agriculturalists very often embrace masquerades, while they are rarely found among pastoralists and nomads. We may therefore suppose that the agricultural revolution fostered the development of masking along with its male orientation..

4. Why some African cultures rely on masking as an important dimension of their religious and social life while others do not is one of the many unsolved mysteries in the history of African arts. Normally, pastoralists, nomads, and hunting/gathering peoples have few masks, or none, probably beacuse their movable property is often minimal and light. Some kingdoms (e.g., the Akan, Fon, Buganda) apparently eschew masking because of its potential threat to their divine kings. Yet other kindgoms (Yoruba, Cameroon, and to a lesser degree, Benin) do employ masks, so the question remains open.

5. A cross-cultural examination of the uses, roles, and meanings of masks in African initiations has not yet been undertaken to our knowledge. This would be a most revealing study into the essence of masking as a liminal, mediating, and socializing institution, not to mention one which exploits universal notions of play and illusion.

6. Data and translations in personal communications (1969) from Leon Siroto (BaKwele), Daniel Biebuyck (Lega), and Arnold Rubin (Jukun).

7. For many Westerners who have spent months or years in Africa the power of masked spirits is very real. To be initiated into a masking cult or to be severely beaten by a masker (as the author has been, on both counts) is a strong inducement to alter preconceived notions.

8. Among the Igbo of Nigeria, unmasking a spirit masker is aptly spoken of as "breaking its head." In precolonial times when maskers held critical executive or judicial roles, the violator was not infrequently sentenced to be executed, the executioner itself being another spirit (a masker).

9. Although largely unexplored in literature, Bamana women's initiation societies serve equally important functions in the community (McNaughton 1979:6,10).

10. *Jow* are viewed differently by Bamana scholars. Zahan believes the *jow* were originally entered successively until final enlightenment was reached for each man as a member of *Koré*. Imperato supports this hierarchical view, although both note that, with modernization and Islamization, by the 1940s the traditional sequence was no longer maintained. Other authors (Paques, Dieterlen, Tauxier, Monteil) feel that after joining, *Komo* men are free to participate or not in the other *jow* as they so wish and can afford. (*Komo* is generally considered the most powerful *jo* except by Zahan and his school.) This more flexible view is supported by the fact that historically most villages did not have all of the six major initiation societies, and that many *jow* are interchangeable in roles and activities. See McNaughton (1979:3–9) for a concise summation of the various interpretations.

11. According to Imperato, circumcision used to take place when boys were around sixteen years of age but is now done at eight or even younger (1970:19).

12. Zahan sees the *Koré jo* as the final step in a Bamana man's search for self-knowledge; in his view *Koré* offers a mystical assimilation with God; by being ritually "killed" and "reborn," initiates are able to overcome death and achieve endless reincarnation (1974:20–23).

13. The data in this section are drawn from Patrick McNaughton's extensive 1979 study of the *Komo* society and its art, based on his fieldwork among the Bamana and apprenticeship to sculptor-smiths.

14. Because of the secret and personal nature of the *daliuw*, the mask carver usually also dances the mask. Another person could not know all of the power elements embodied in the mask and, therefore, would have great difficulty in controlling it.

15. See *Mossi Masks and Crests* (1979) by Christopher Roy.

16. Roy's description of this funeral dance is used as a generic one that might have applied to the specific contexts in which our mask appeared.

17. Information and research on the Bobo, Bwa, and Gurunsi are very limited and sometimes contradictory, although a recent publication by Guy Le Moal, *Les Bobo*, 1980, is an exhaustive and informative study. Main Gurunsi groups are the Bwa, Nuna, Ko, Sisala, and Kassena. The word *Gurunsi* means "bark eaters" and is obviously pejorative (pc: Roy 1984).

18. It is important to note that *iran* are not incarnations of ancestors as previously reported in the literature (Gallois–Duquette 1978:95). Each *iran* is named according to the function it serves. The village *iran* (*iran do chao*) is always consulted during times of crisis (e.g., illness or death) and conflict.

19. Both the Dan and We are sometimes referred to in the literature as *gä*, which means "bush people" and is actually a term which implies cultural inferiority. *Gä le* or *gere* (Guere) means "*land* of the bush people" and thus is not an accurate name for people (Fischer 1978:16). Following Fischer and Himmelheber (1984), we include We masks in this discussion, which like theirs, focuses on the Dan, in the assumption that culture patterns and mask contexts are similar in the two groups.

20. Wooden figures and ladle handles are not truly imitative, realistic portraits as understood in Western art but are "portraits by designation"—works which are locally understood to represent an individual. The sculptures may incorporate certain distinctive characteristics such as scarifications, but they are carved within the conventions of local style.

21. The Museum of Cultural History collection does not include a fine example of Baule *Kple Kple*, and since this essay was written under the mistaken belief that Figure 42 was indeed Baule, we have retained this section, illustrating a Wan mask, which may have had a rather different function and meaning. The work of Philip Ravenhill among the Wan was not available at the time of writing. (Editor's note.)

22. Vander Heyden suggests that the terms *Epa* and *Elefon* be used with caution. Many mask names, festivals, and mask types are associated with these words (1977:21). Thompson notes that choreography marks the difference between *Epa* and *Elefon* (1974:191).

23. Our treatment of Northern Edo masquerades is comparatively brief because Borgatti's studies of them are readily available. Her 1979 publication, indeed, is in the Museum of Cultural History's monograph series.

24. A special medicine society, *Ngang* (in the Tikar region), administers the medicine; however, every new concoction must be demonstrated and presented to *Kwifon* for permission to use (Koloss 1977).

25. *Mabu* represents *Kwifon*'s voice and announces itself with a flute, publicly stating *Kwifon*'s decrees in the market. As a "running mask," *Mabu* precedes other *Kwifon* masks, coercing people to proper behavior and driving away women, children, and all those to whom the other masks are forbidden (Koloss 1977; Northern 1979).

26. *Nkok* is given medicines that make him "lose his senses" and act wildly. He is held with ropes by several medicine men until the spell is broken by sprinklings from a magic calabash (Koloss 1977).

27. A Kom-Tikar style was first postulated by Tamara Northern, the Babanki style by William Fagg. Both styles are from the Bamenda-Tikar region and are designations of a style only and not necessarily of a chiefdom. For example, Kom clearly did not produce all the stylistically similar masks currently being attributed to it; some were made in neighboring chiefdoms (Wittmer 1977:9; Northern 1979).

28. Other masks formally similar to this one are Gebauer 1979, cat. nos. M6,P10,P15,P16, all from Tikar/Bekom.

29. Koloss' (1977) illustrations of such extended family masks with superstructures closely resemble this mask.

30. In Koloss (1977) the only descriptions of animal masks in the Bamenda-Tikar region are those used among the extended families. Wittmer does, however, mention that animal masks were used by warrior societies in Bamum and elsewhere in the Grasslands (1977:26). Nevertheless, it seems most likely that this mask is from a lineage group, as Koloss (1977) and Northern (1979) both state that these are the most frequently found types in collections.

31. The basic design unit is an isosceles triangle and variations thereof. Patterns are neither fluid nor curvilinear, and individual bead strings are short, creating compact rhythmic designs.

32. Elephants and leopards are now extinct in the Cameroons; however, they are memorialized in legends and tales (Northern 1975:21) and, of course, in the arts.

33. Order is the repetition of one design unit; complexity is multiple and varied pattern configurations.

34. The information for this chapter is taken from Bastin's extensive publications, particularly 1961, Vols. 1 and 2, unless otherwise noted.

35. Chokwe boys wear an elaborate visored headdress at the end of *mukanda* initiation. There is no known connection between the visor of the *Katoyo* mask and initiation headdresses.

36. This and all other information came from *L'Art Pende* by L. de Sousberghe, published in 1958 after two excursions and extensive fieldwork among the Pende, the first from 1951–1953 and the second from 1955–1957.

37. Unless otherwise stated, all information regarding the Lega is from the publications of Daniel Biebuyck, notably *Lega Culture: Art, Initiation, and Moral Philosophy among a Central African People*, 1973.

38. While all Lega men may carve, only those of recognized talent are commissioned to carve masks and figurines (Altman 1963:n.p.).

39. Natural objects include items of vegetal, animal, and mineral sources. Manufactured goods refer to pottery, basketry, and objects made from rope, wood, bark, iron, copper, leather, bone, ivory, resin, stone, and fiber (Biebuyck 1973:143,147).

40. The Lega do, however, have an implicit aesthetic code, characteristics of which are smoothness of surface, lightness, and smallness of objects and overall simplicity of form with no excessive ornamentation (Biebuyck 1973:180).

41. While the Lega have no elaborate myths or cosmology, ancestors are worshiped as mediating powers in the conflict between good and evil. Because they are a symbolic link, artworks serve as vehicles for this worship. The Lega also believe in a power or life force that is unspecified yet omnipresent and that is contained in works of art (Biebuyck 1973:53; Altman:n.p.).

42. Although in these contexts they are not employed as face-coverings.

43. The lower *yananio* level does not have masks.

44. The distinction between *lukungu* and *lukwakongo* masks is somewhat unclear. According to Biebuyck, both *lukungu* and *lukwakongo* are small and both may be made of wood. *Lukungu*, however, are made of "well-polished wood" and are delicately finished to resemble the *lukungu* ivory masks. These sorts of aesthetic criteria are sometimes difficult to access for a particular mask. Moreover, Biebuyck is contradictory on this point. He states (1954:111) that *lukwakongo* are "never of 'masquette' manufacture," but in 1973:164 he calls them wooden maskettes.

45. Biebuyck, however, says that "all wooden *lukwakongo* masks are supposed to be the same and to have identical usages and meanings" (1973:211).

46. The two lower levels of *kindi*, *kyogo kya kindi* and *musagi wa kindi*, do not have masks. Therefore, when a *yananio* member of *lutumbo lwa yananio* enters *kindi*, his *lukwakongo* mask is passed on, and he will not have a mask again until he enters the *lutumbo lwa kindi* level. In a few instances *kindi* members of *lutumbo lwa kindi* do not have a mask. These include some who collectively hold ivory statues and very old men who have assisted in many initiations and are no longer subject to taboos (Biebuyck 1954:111).

47. Dr. Lyndon Harries claims that the Tanzanian and Mozambique Makonde are separate peoples who just happen to share the Makonde plateau (1970:3). Dias states, however, that older Mozambique Makonde consider the Tanzanian Makonde to be distant relatives (1964:30).

48. In the past the Makonde were also noted for their carvings of human and animal heads on lids of small containers (Shore–Bos 1969:48). Today the Mozambique Makonde are particularly noted for their hardwood sculptures which have become commercial successes.

49. This discussion of masks is a compressed version of a section of my forthcoming book on the art of the Benue River Valley.

50. A full chapter dealing with the three royal masks and a forth related type, all in the Museum's collection, was written by Bonnie E. Weston during the seminar. The decision to deal with only one Kuba mask here was made because the Museum of Cultural History is now planning a larger publication on Kuba masks and other arts. (Editor's note.)

Altman, Ralph
1963 *Balega and Other Tribal Arts from the Congo.* Los Angeles.

Bascom, W.R.
1973 *African Art in Cultural Perspective: An Introduction.* New York.

Bastin, Marie-Louise
1961 *Art Decoratif Tshokwe,* 2 vol. Lisbon.
1968 "Arts of the Angolan Peoples." *African Arts/Arts d'Afrique* 2(1):40–46,60–64.
1976 *Statuettes Tshokwe du civilisateur "tshibinda ilunga."* Arts d'Afrique Noire, supplement 19. France

Bernatzik, Hugo Adolph
1933 *Anthiopen des Westens: Forschungsreisen in Portugiesisch-Guinea.* 2 vols. Vienna.
1950 *Im Reich der Bidjogo: Geheimnisvolle Inseln in Westafrika.* Vienna.

Berns, Marla
1979 *Àgbáyé: Yoruba Art in Context.* Los Angeles.

Biebuyck, Daniel
1954 "Function of a Lega Mask." *International Archiv f. Ethnologie* 47(1):108–120.
1972 "The Kindi Aristocrats and Their Art among the Lega." In *African Art and Leadership.* Douglas F. Fraser and Herbert M. Cole (eds.). Madison.
1973 *Lega Culture: Art, Initiation, and Moral Philosophy among a Central African People.* Berkeley and Los Angeles.

Borgatti, Jean
1976 "Okpella Masking Traditions." *African Arts* 9(4):24–33,90,91.
1979 *From the Hands of Lawrence Ajanaku.* Los Angeles.

Bourgeois, Arthur P.
1980 "Kakungu among the Yaka and Suku." *African Arts* 14(1):42–46,88.
1982a "Yaka Masks and Sexual Imagery." *African Arts* 15(2):47–50,87.
1982b "Yaka and Suku Leadership Headgear." *African Arts* 15(3):30–35,92.
1983a "Mukoku Ngoombu: Yaka Divination Paraphernalia." *African Arts* 16(3):56—59,80.
1983b "Male and Female in Yaka-Suku Masquerades." Unpublished paper read at The Fifth Triennial Symposium of African Art, Norman, Oklahoma.
1984 *Art of the Yaka and Suku.* Meadon, France.

Brain, Robert and Adam Pollock
1971 *Bangwa Funerary Sculpture.* Toronto

Campbell, Joseph
1959 *The Masks of God: Primitive Mythology.* New York.

Cole, Herbert M. et al.
1970 *African Arts of Transformation.* Santa Barbara.

Cole, Herbert M. and Chike C. Aniakor
1984 *Igbo Arts: Community and Cosmos.* Los Angeles.

Cornet, Joseph
1975 *Art from Zaire: 100 Masterworks from the National Collection.* New York.
1971 *Art of Africa: Treasures from the Congo.* New York.
1978 *A Survey of Zairian Art: The Bronson Collection.* Raleigh, North Carolina.
1982 *Art Royal Kuba.* Milano.

D'Azevedo, Warren L.
1973 "Sources of Gola Artistry." In *The Traditional Artist in African Society.* Warren L. D'Azevedo (ed.). Bloomington.
1980 "Gola Poro and Sande: Primal Tasks in Social Custodianship." In *Ethnologische Zeitschrift Zürich,*1. Monni Adams (ed.).

de Sousberghe, L.
1958 *L'Art Pende.* Louvain.

Dias, A. Jorge
1964 *Portuguese Contribution to Cultural Anthropology.*

Dieterlen, Germaine
1951 *Essai sur la Religion Bambara.* Paris.

Drewal, Henry John
1974 "Gelede Masquerade: Imagery and Motif." *African Arts* 7(4):8–19,62–63.
1975 "African Masked Theatre." *MIME Journal* 2:36–53.
1977 *Traditional Art of the Nigerian Peoples: The Milton D. Ratner Family Collection.* Washington, D.C.
1978 "The Arts of Egungun Among the Yoruba Peoples." *African Arts* 11(3):18–19,97–98.
1980 *African Artistry: Technique and Aesthetics in Yoruba Sculpture.* Atlanta, Georgia.

Drewal, Margaret T. and Henry J. Drewal
1975 "Gelede Dance of the Western Yoruba." *African Arts* 8(2):36–45,78–79.
1978 "More Powerful than Each Other: An Egbado Classification of Egungun." *African Arts* 11(3):28–29,98–99.
1983 *Gelede: Art and Female Power among the Yoruba.* Bloomington.

Fagg, William and John Pemberton III
1982 *Yoruba: Sculpture of West Africa.* New York.

Fischer, Eberhard
1978 "Dan Forest Spirits: Masks in Dan Villages." *African Arts* 11(2):16–23.

Fischer, Eberhard and Hans Himmelheber
1976 *Die Kunst der Dan.* Zürich.
1984 *Art of the Dan.* Zürich.

Fouquer, Roger
1971 *Sculpture Moderne des Makondés.*

Franz, Marie
1969 "Traditional Masks and Figures of the Makonde." *African Arts/Arts d'Afrique Noire* 3(1):42–45.

Fraser, Douglas (ed.)
1974 *African Art as Philosophy.* New York.

Fry, Jacqueline (ed.)
1978 *Twenty-Five African Sculptures.* Ottawa.

Gallois-Duquette, Danielle
1976 "Informations sur Les Arts Plastiques des Bidjogo." *Arts d'Afrique Noire* 18:26–43.
1978 "Seated 'Iran' Figure." In *Twenty-Five African Sculptures.* Jacqueline Fry (ed.). Ottawa.
1979 "Woman Power and Initiation in the Bissagos Islands." *African Arts* 12(3):31–33.
1981 "Ox Mask (Dugn'be)." In *For Spirits and Kings: African Art from the Paul and Ruth Tishman Collection.* Susan M. Vogel (ed.). New York.
n.d. "Les Masques Bovins des Iles Bissagos (Guinee-Bissau)." *Connaissance des Arts Tribaux. Bulletin.* no. 12:n.p.

Gebauer, Paul
1971 "Art of Cameroon." *African Arts* 4(2):2–3,80.
1979 *Art of Cameroon*. New York.

Goldwater, Robert
1960 *Bambara Sculpture from the Western Sudan*. New York.

Hammond, Peter B.
1966 *Yatenga, Technology in the Culture of a Western African Kingdom*. New York.

Harries, Lyndon
1944 "Initiation Rites of the Makonde Tribe." *Communications From the Rhodes-Livingstone Institute*, No. 3.
1970 "à propos." *African Arts* 3(3):3,7,68.

Henderson, Richard N.
1972 *The King in Every Man*. New Haven and London.

Hoffer, Carol P.
1975 "Bundu: Political Implications of Female Solidarity in a Secret Society." In *Being Female*. D. Raphael (ed.). Chicago.

Holsoe, Svend E.
1980 "Notes on the Vai Sande Society in Liberia." In *Ethnologische Zeitschrift Zürich*,1. Monni Adams (ed.).

Holy, Ladislav
1967 *Masks and Figures from Eastern and Southern Africa*.

Hommel, William L.
1974 *Art of the Mende*. Baltimore.

Horton, W.R.G.
1960 *The Gods as Guests: An Aspect of Kalabari Religious Life*. Lagos.
1965 *Kalabari Sculpture*. Lagos.

Houlberg, Marilyn Hammersley
1978 "Notes on Egungun Masquerades among the Oyo Yoruba." *African Arts* 11(3):56–61.

Imperato, Pascal James
1970 "The Dance of the Tyi Wara." *African Arts* 4(1):8–13,71–81.

Jedrej, M.C.
1974 "An Analytical Note on the Land and Spirits of the Sewa Mende." *Africa* 44:38–45.
1976 "Medicine, Fetish and Secret Societies in a West African Culture." *Africa* 46:247–257.

Koloss, Hans-Joachim
1977 *Kamerun Konige Masken Feste* (The Masks of the Tikar). Stuttgart.

Lajoux, Jean-Dominique
1963 *The Rock Paintings of Tassili*. Cleveland and New York.

Lang, Werner
1960 "Makondemasken in der völkerkundlichen Sammlung der Universität Göttingen." *Zeitschrift Für Ethnologie* 85(1):28–36.

Laude, Jean
1967 "Sudanese Cultures." *Encyclopedia of World Art*, vol. 13:cols 685–698. New York.

Lawal, Babatunde
1978 "New Light on Gelede." *African Arts* 11(2):65–70,94.

Lecoq, Raymond
1953 *Les Bamileke*. Paris.

Lem, F.H.
1949 *Sudanese Sculpture*. Paris.

Lewis, Roy
1954 *Sierra Leone*. London.

Lima, A. Mesquitela
1971 *Fonctions sociologiques des figurines de culte "hamba" dans la societé et dans la culture tshokwé (Angola)*. Luanda.

Little, Kenneth L.
1949 "The Role of the Secret Society in Cultural Specialization." *American Anthropologist*, n.s. 51, no. 2:199–212.
1954 "The Mende of Sierra Leone." *Worlds*. Daryll Forde (ed.). London.

McNaughton, Patrick R.
1979 *Secret Sculptures of Komo: Art and Power in Bamana (Bambara) Initiation Societies*. Philadelphia.

Nelson, H. (ed.)
1982 *Nigeria: A Country Study*. Washington, D.C.

Northern, Tamara
1975 *The Sign of the Leopard: Beaded Art of Cameroon*. Storrs, Connecticut.
1979 *Art of the Cameroon Grasslands*. New York.

Ojo, J.R.O.
1978 "The Symbolism and Significance of Epa-Type Masquerade Headpieces." *MAN* 13(3):455–470.

Ottenberg, S.
1975 *Masks Rituals of Afikpo: The Context of an African Art*. Seattle.
1983 "Igbo and Yoruba Art Contrasted." *African Arts* 16(2):48–55.

Phillips, Ruth B.
1980 "The Iconography of the Mende Sowei Mask." In *Ethnologische Zeitschrift Zürich*,1. Monni Adams (ed.).

Planquaert, M.
1930 *Les societes secretes chez les Bayaka*. Louvain, Kyul-Otto (Biblioteque Congo 31).

Richards, J.V.O.
1970 "Factors of Limitation in the Art Forms of the Bundu society of the Mende of Sierra Leone." Ph.D. dissertation, Northwestern University, University Microfilms.

Roy, Christopher D.
1979a *African Sculpture: The Stanley Collection*. Iowa City, Iowa.
1979b *Mossi Masks and Crests*. University Microfilms, Ann Arbor.
n.d. *African Art from Private Iowa Collections*.

Scantamburlo, Luigi
1978 *The Ethnography of the Bijogos People of the Island of Bubaque, Guiné-Bissau*. Master's thesis, Wayne State University.

Schneider, Betty
1973 "Body Decoration in Mozambique." *African Arts* 6(2):26–31.

Shore-Bos, Megchelina
1969 "Modern Makonde: A Discovery in East Africa." *African Arts* 3(1):46–51.

Sieber, Roy
1962 "Masks as Agents of Social Control." *African Studies Bulletin* 5(2):8–13.

Siegmann, William and Judith Perani
1980 "Men's Masquerades of Sierra Leone and Liberia." In *Ethnologische Zeitschrift Zürich*,1. Monni Adams (ed.).

Siegmann, W. and C. Schmidt
1977 *Rock of the Ancestors: namôa koni*. Suakoko, Liberia.

Skougstad, Norman
1978 *Traditional Sculptures from Upper Volta*. New York.

Thompson, Robert Farris
1971 *Black Gods and Kings: Yoruba Art at UCLA*. Los Angeles.
1974 *African Art in Motion: Icon and Act*. Los Angeles.

Vander Heyden, Marcia
1977 "The Epa Mask and Ceremony." *African Arts* 10(2):14–21.

Vansina, Jan
1955 "Initiation Rituals of the Bushong." *Africa* 25(2):138–155.

Vogel, Susan M.
 1973 "People of Wood: Baule Figure Sculpture." *The Art Journal* 33:23–36.
 1977 *Baule Art as an Expression of a World View*. University Microfilms.
Vogel, Susan M. (ed.)
 1981 *For Spirits and Kings: African Art from the Tishman Collection*. New York.
Walker
 1967 *Art of the Congo*. Walker Art Center. Minneapolis, Minnesota.
Wembah–Rashid, J.A.R.
 1971 "Isinyago and Midimu: Masked Dancers of Tanzania and Mozambique." *African Arts* 4(2):38–44.
Weule, Karl
 1908 *Native Life in East Africa*, trans. by Alice Werner, 1909.
Willcox, A.R.
 1965 *Rock Paintings of the Drakensberg*. London.
Wittmer, Marcilene
 1977 *Cameroon*. Charlotte, North Carolina.
Zahan, D.
 1960 *Sociétés d'Initiation Bambara*, vol. 1. Paris.
 1974 *The Bambara*. Leiden.

Staff of the Museum of Cultural History

Director	*Christopher B. Donnan*
Associate Director	*Doran H. Ross*
Curator of Folk Art and Textiles	*Patricia B. Altman*
Consulting Curator of Costumes and Textiles	*Patricia Anawalt*
Curator of Archaeology ·	*Douglas V. Armstrong*
Editor	*Irina Averkieff*
Accountant	*Millicent Besser*
Collections Manager	*Robert V. Childs*
Librarian	*Phillip M. Douglas*
Principal Clerk	*Betsy R. Escandor*
Conservator	*Benita Johnson*
Exhibition Designer	*George Johnson*
Registrar	*Sarah Jane Kennington*
Publications Director	*Darlene Moses Olympius*
Curator of Education	*Betsy D. Quick*
Photographer	*Richard Todd*
Administrative Assistant	*Barbara Underwood*
Development Coordinator	*Emily M. Woodward*

Monograph Presentation

Studio Photography*	*Robert Woolard*
Editing	*Susan Swiss*
Design & Coordination	*Robert Woolard*
Production Assistance	*UCLA Publication Services*
Typography	*Freedmen's Organization*
Printing	*Penn Lithographics, Inc.*

* Selected studio photographs by Richard Todd and Larry DuPont.

DATE DUE

DEC 1 2 2005

MAY 0 8 2006